BENIN

Royal Art of Africa

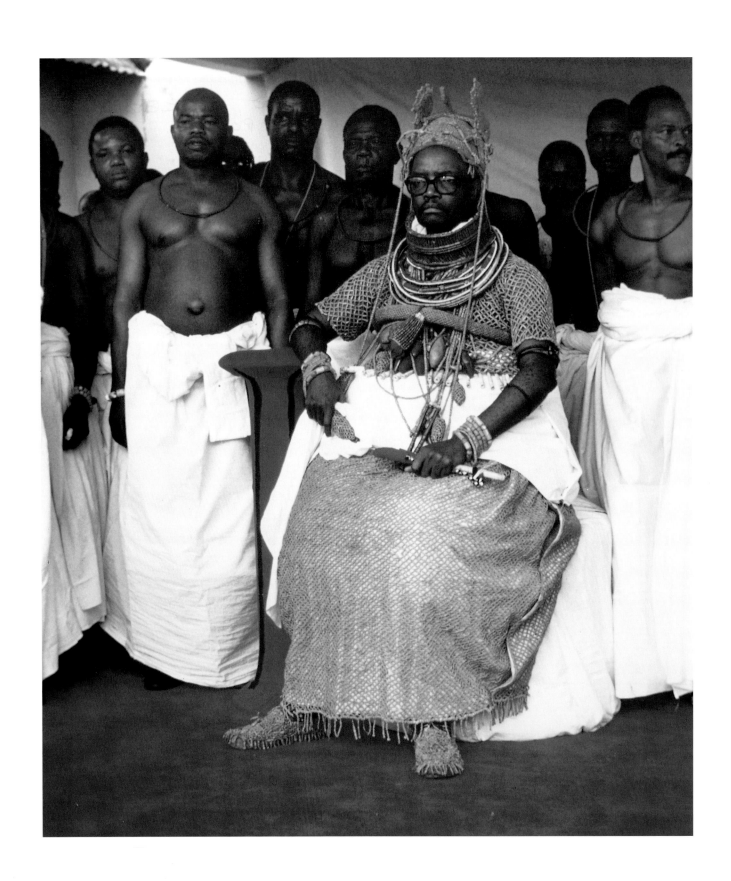

Armand Duchâteau

BENIN

Royal Art of Africa from
the Museum für Völkerkunde, Vienna

Prestel

Benin: Royal Art of Africa from the Museum für Völkerkunde, Vienna, was published in conjunction with the exhibition organized by The Museum of Fine Arts, Houston, in collaboration with The Cleveland Museum of Art, The Baltimore Museum of Art, and Seattle Art Museum, held at:

The Museum of Fine Arts, Houston
20 February – 3 April 1994

The Cleveland Museum of Art
3 May – 31 July 1994

The Baltimore Museum of Art
7 September – 30 October 1994

Seattle Art Museum
17 December 1994 – 12 February 1995

The exhibition "Benin: Royal Art of Africa from the Museum für Völkerkunde, Vienna," and the accompanying catalogue are sponsored by Swarovski.

In Houston, the exhibition is supported by a grant from the Texas Commission on the Arts.

Library of Congress Cataloging-in-Publication Data

Duchâteau, Armand
 [Benin, Kunst einer Königskultur. English]
 Benin : royal art of Africa from the Museum für Völkerkunde, Vienna / by Armand Duchâteau.
 p. cm.
 Exhibition held at The Museum of Fine Arts, Houston, Feb. 20 – April 3, 1994; The Cleveland Museum of Art, May 3 – July 31, 1994; The Baltimore Museum of Art, Sept. 7 – Oct. 30, 1994; Seattle Art Museum, Dec. 17, 1994 – Feb. 12, 1995.
 Includes bibliographical references.
 ISBN 0-89090-058-2 (softcover); ISBN 3-7913-1368-1 (hardcover):
 1. Art, Benin-Exhibitions. 2. Art, Primitive-Benin-Exhibitions. 3. Decorative arts-Benin-Exhibitions. 4. Art-Austria-Vienna-Exhibitions. 5. Decorative arts-Austria-Vienna-Exhibitions. 6. Museum für Völkerkunde (Austria)-Exhibitions.
 I. Title.
 N7399.D3D813 1993 93-33986
 709'.6683'074 – dc20 CIP

Front cover: *Head of an Oba*, late 16th/early 17th century (cat. 22)

Back cover: *Messenger* (or *Court Official*), late 16th century (cat. 3)

Frontispiece: Oba Erediauwa at Igue Ceremony, Benin City, Nigeria, ca. 1980. Photograph by Joseph Nevadomsky

Prestel-Verlag
16 West 22nd Street, New York, NY 10010, USA, Tel. (212) 627 8199; Fax (212) 627 9866 and Mandlstrasse 26, 80802 Munich, Germany, Tel. (89) 3 81 70 90; Fax (89) 38 17 09 35

Distributed in continental Europe by Prestel-Verlag, Verlegerdienst München GmbH & Co. KG, Gutenbergstrasse 1, 82205 Gilching, Germany, Tel. (81 05) 38 81 17; Fax (81 05) 38 81 00

Distributed in the USA and Canada on behalf of Prestel by te Neues Publishing Company, 16 West 22nd Street, New York, NY 10010, USA, Tel. (212) 627 9090; Fax (212) 627 9511

Distributed in Japan on behalf of Prestel by YOHAN Western Publications Distribution Agency, 14–9 Okubo 3-chome, Shinjuku-ku, Tokyo 169, Japan, Tel. (3) 320 80181; Fax (3) 320 90288

Distributed in the United Kingdom, Ireland, and all remaining countries on behalf of Prestel by Thames & Hudson Limited, 30–34 Bloomsbury Street, London WC1B 3 QP, England, Tel. (71) 636 5488; Fax (71) 636 1695

Translated from the German by David T. Miller, New York
Copyedited by Simon Haviland
Typeset by Max Vornehm GmbH, Munich
Color separations by Fotolito Longo, Frangart, Italy
Printed and bound by Passavia Druckerei GmbH, Passau

Printed in Germany

ISBN 0-89090-058-2 (softcover edition, not available to the trade)
ISBN 3-7913-1368-1 (hardcover edition)

Contents

To Kristin and Philippine
In Memoriam Margriet

Directors' Foreword

This publication presents to American audiences for the first time the great collection of Benin art from the Museum für Völkerkunde in Vienna. Among the oldest and finest African collections in Europe, the Benin holdings of the Museum für Völkerkunde were acquired at the turn of the century, when the large influx of Benin objects into Europe sparked a great enthusiasm for the virtuosity and sophistication of this culture's art. The Benin bronzes (now more correctly called "brasses") especially inspired awe, as indicated by the comments of Felix von Luschan, the eminent Austrian scholar of Benin art, who wrote, "Benvenuto Cellini could not have cast them better, and nobody else either, before or since"

In this comprehensive and detailed volume, Dr. Armand Duchâteau, curator of Vienna's African collection, traces the history of this centuries-old royal kingdom, located in present-day Nigeria, and outlines the intertwined religious and political belief-systems that gave rise to these beautiful objects. The cast brass heads, figures, plaques and altars, the carved ivory tusks, figures, and bracelets, and the wooden staffs, all have their precise function and meaning located in the complex of rituals ensuring the power of the king (*Oba*) and the well-being of society. This publication includes the two most famous Benin objects in the Museum für Völkerkunde's collection – the brass figures of dwarfs, called by the distinguished scholar William Fagg "the finest of all Benin bronze figures."

The staffs at each participating museum contributed a great deal of time and expertise to the planning and execution of the publication. We thank the Museum für Völkerkunde for making its collection available to us and Dr. Duchâteau for writing such an excellent book. We are particulary grateful to coordinating curator Janet Landay of the Museum of Fine Arts, Houston, as well as to Anne-Louise Schaffer, Margaret Young-Sanchez, Frederick Lamp, and Pamela McClusky. This volume would not have been possible without the tireless efforts of Diane Lovejoy and the publications department at the Museum of Fine Arts, and the talented editors and designers at Prestel-Verlag, Munich.

Finally, we are aware that the Benin culture is very much alive at the present time. Many of the rituals and ceremonies for which the objects in this exhibition were originally made continue to be practiced by the current Oba of Benin, His Highness, Omo N'Oba N'Edo Uku Akpolokpolo, Erediauwa, and his court. Our hope is that the care and respect with which we have treated these works meet with the approval of the people of Benin. We dedicate this book to them.

Peter C. Marzio
The Museum of Fine Arts, Houston

Robert P. Bergman
The Cleveland Museum of Art

Arnold L. Lehman
The Baltimore Museum of Art

Gail E. Joice, Interim Director
Seattle Art Museum

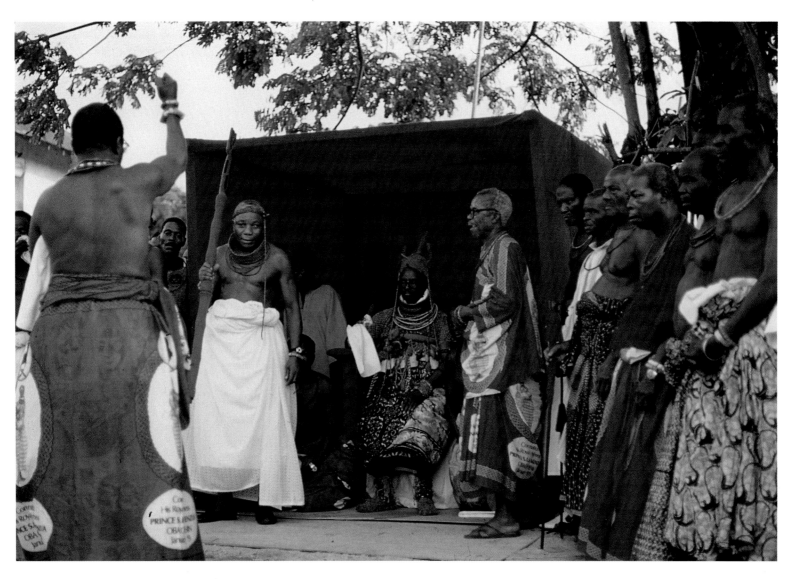

1 The Oba at Emobo Cleansing the City of Evil (I), ca. 1985. Photograph by Joseph Nevadomsky

The History of the Kingdom of Benin

The Geographical Situation of the City and Kingdom of Benin

The original inhabitants of Benin called themselves, as well as their capital and language, Edo, as the present-day inhabitants still do. It is assumed that the Edo have inhabited this region—which is bordered to the north by the Igbirra and Igala, to the south by the Itsekiri and Ijaw, to the west by the Yoruba, and to the east by the Igbo—for slightly more than a thousand years. The ancient kingdom of Benin, however, did not rule over, or encompass, the entire Edo-speaking population. Neither was it by any means limited only to Edo, as it included Yoruba, Igbo, Ijaw, and Itsekiri ethnic groups.

Except for smaller groups, the Edo-speaking Etsako peoples to the north, as well as the Isoko and Urhobo to the south, offered frequent and lengthy resistance to efforts aimed at incorporating them into the kingdom of Benin. Although non-Edo regions were required to contribute to the military in wartime, to pay tribute, and to ensure trade with Benin, they otherwise were more or less autonomous in government and administrative matters. National insignias sent by the Oba of Benin to other kings were used to legitimize the other rulers' reigns.

The kingdom of Benin proper consisted of the capital city and several hundred villages; these ranged in size from the smallest, of about three or four hundred inhabitants, to the largest, of up to four thousand, who mainly grew yams as their primary source of food. The authority of the Benin kings extended over a very large area, which at the time of its greatest expansion in the sixteenth century encompassed the region of the Ekiti Yoruba in the northwest, reached to Ouidah in the west in the present-day Republic of Benin, and stretched to the Niger River in the east.

Benin City, the capital, with a population of some 160,000, lies approximately 250 km east of Lagos (6°19' N, 5°37' E) on a sandy plain in the middle of the tropical rain forest of western Nigeria. This plain is crossed by numerous small rivers and streams flowing south toward the rim of the Niger Delta. Swamps covered with tidal deposits characterize the landscape to the south and west. The climate of this tropical forest region is warm and humid.

The Beginnings of the Benin Dynasty

Apart from a few archaeological finds,[1] our knowledge of the early period of the kingdom of Benin, before 1485 (the year of the arrival of the Portuguese), is dependent on oral traditions, many of which were recorded and published particularly by the Benin chronicler Chief Jacob U. Egharevba.[2] As is so often the case with the foundation of early states, the origin of Benin lies in the realm of myth.[3]

According to Edo tradition, the foundation of their state was the work of a god whom they called Osanobua. Osanobua sent his sons to live on earth. They were allowed to choose something useful to take along on their journey. Each sought an attribute or object, such as magic or wealth, which he believed would serve him well on earth. The youngest, however, was counseled by a bird to take a useless snail shell with him. Upon their arrival, the sons of Osanobua discovered—to their chagrin—that the earth was entirely covered with water. What they had chosen to bring with them from the sky (*Iso*) for their stay on earth (*Agbon*) was useless. At that moment the bird who counseled the youngest son commanded him to turn over the snail shell. When he did so, an endless mass of sand flowed out of it until the water was finally filled, and a huge stretch of land was formed. Thus the youngest son of Osanobua became the ruler over all of the earth. His brothers were forced to lease or buy land from him in order to establish new states themselves. Since a myth never lacks a historical foundation, here is a historical reference to the first ruler of the Benin people—an *Ogiso*, Ruler of the Sky, ancestor of all future kings, who also had to be recognized as such.

The few genuine historical references from this early period are still based on assumptions. Early tribes likely came at different times from the geographic region of the Sudan.[4] They were the forefathers of the present-day Edo and lived under the rule of local chiefs in some 130 settlements politically independent of each other.[5] The discovery of various Stone Age tools during farm work around Benin City indicates that a different ethnic group had probably inhabited the region before the arrival of these later waves of immigrants.[6]

This influx of migrants from the north and east occurred somewhat before A. D. 800. It is likely that the Edo—or a ruling caste—entered the forest belt and area of present-day Benin at this time too. Gradually various political institutions took shape. The year 900[7] marked the appearance of the first dynasty, that of the Ogiso, the Rulers of the Sky[8] (ogie = ruler, king; iso = sky), which grew out of a council of elders that had popular backing.[9] This first dynasty supposedly consisted of thirty-one rulers,[10] with the first Ogie (king), Igodo, giving Benin its name, Igodomigodo ("City of Cities" or "Land of Igodo").[11] His successor, Ere, introduced important reforms such as the Ughoron, the royal chroniclers, who through their recitations preserved the dates of death and the most important events during the reign of individual rulers. The making of symbolic clay figures served the same function.[12]

Ere also laid the foundation of the group of so-called King Makers (Uzama) of the first dynasty. It is even thought that the establishment of guilds—such as those of the woodcarvers, weavers, potters, carpenters, and leather workers—can be traced back to him.[13] Furthermore, Ere is credited with the introduction of various emblems of royalty, such as the rectangular royal throne (agba), round leather fans, round containers of bark and hide, and the ceremonial sword (ada). This sword was one of the objects placed on an ancestral altar and symbolized the ancestors' power over the course of events in the kingdom.[14] Ankle and neck rings made of pearls and forged or embossed brass also belonged to the royal insignia.[15]

With the exception of Ere and the last Ogiso, Owodo, little is known about the other rulers of this period. It has been said of the kings that they sent their sons to the surrounding villages in order to ensure the necessary renewal of their submission to each new Ogiso through tributes and oaths of allegiance.[16]

Although different writers have placed the end of the Ogiso dynasty between 1150[17] and approximately 1250–1300,[18] the latter date is more likely correct.[19] Despite the lack of exact historical references to the Ogiso period, they apparently were of fundamental importance on the artistic level and with regard to skilled crafts for the later religious, social, and political life of Benin. Even the creation of commemorative ancestral heads, honoring predecessors while serving as altar decorations, is thought to have originated in the period of the Ogiso dynasty, with the first examples probably being made out of clay or wood.[20]

The expulsion of the incompetent Ogiso, Owodo, likely marked the end of this period, which was followed by a kind of interregnum. Although succession based on the right of primogeniture was generally recognized within the family, efforts were now made to enable all of the chiefs to elect the Ogiso. When, however, the first elected ruler, Evian, tried to have his son chosen as his successor, the people rejected this intrigue.[21] It appears to have been a failed attempt to establish a new dynasty.

The New Dynasty of the Obas

The founding of the Oranmiyan dynasty marked the final division between the tradition of historical personages and the earlier myths. In order to solve the problem of succession arising after the Ogiso dynasty, the Edo elders turned to a foreigner. The Oni (king) of Ife was asked to send a prince to Benin to rule. As ruler of Ife, the Oni (Oghene) was the cosmic center of the Yoruba; Ife is viewed by most states on the Bight of Benin as the source of Divine Kingship. According to oral tradition, the Oni doubted whether the Benin people would treat properly the son whom he wished to send. Thus, in order to test their loyalty, he sent seven lice to be looked after by them. For three years the lice were cared for and then returned to the king of Ife. The Oni, convinced of the trustworthiness of the people of Benin, thereupon sent his son, Oranmiyan, to rule.[22]

Oranmiyan, who neither spoke the language of the Edo nor knew their customs, was unable to adjust to his new surroundings, let alone successfully rule Benin. After Erinmwinde, a daughter of a village chief, became pregnant by him, he returned to Ife. Erinmwinde gave birth to a son, Eweka I; the new Oba, as the kings were henceforth called, would rule Benin.

This peaceful legend does not always appear to be supported by other oral traditions. It seems more likely to have been a violent conquest. Thus, after years of war, an exhausted Oranmiyan apparently returned home, leaving his son to fight on.[23] R. E. Bradbury, too, believes that even before Oranmiyan, other princes had tried in vain to rule Benin.[24] The power of the king was not consolidated until Ewedo, fourth Oba of the new dynasty, was able to free himself from the domination of the exceedingly powerful Uzama, the King Makers, by imposing on them the transfer of the royal palace to its present site, so that the king and his Uzama would be separated from each other by a wall.[25] Even today this transfer is symbolically reenacted during every coronation ceremony. Ewedo also reserved for himself the right to bestow titles, thus giving himself an effective tool for ensuring his almost unlimited position of power. He also restricted the earlier symbols of authority used by his dignitaries, such as the ada, a ceremonial sword that only the Oba was still allowed to claim as a symbol of power. It was later carried by pages during public appearances of the king. He permitted highly ranked dignitaries to carry this sword only outside the palace grounds. Ewedo implemented fundamental changes on both political and religious levels as he organized the kingdom and centralized his power.

Although it is hardly possible today to determine what historical facts are linked to the myths associated with the foundation of the new Benin dynasty, its symbolism is clearly of continued importance for the Benin kingdom of the future. Emphasis is placed both on the foreign origin of the dynasty—which, however, was desired by the highest dignitaries, the Uzama—and on its assimilation into Edo culture. On the one hand, the first ruler of this dynasty had his roots in the highest holy region

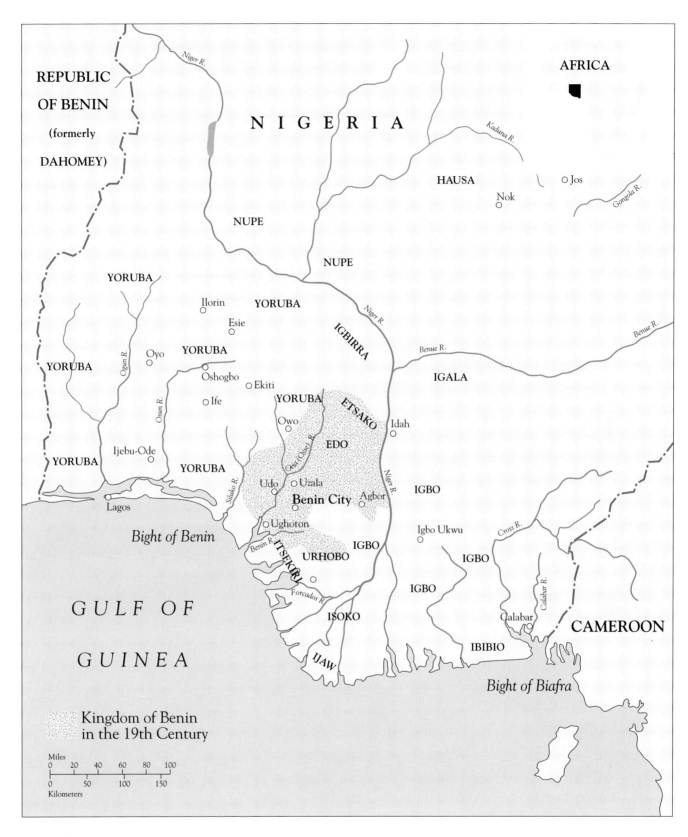

REPUBLIC
OF BENIN
(formerly
DAHOMEY)

Niger R.

N I G E R I A

AFRICA

Kaduna R.

HAUSA

○ Jos

Nok
○

Gongola R.

NUPE

NUPE

YORUBA

Ilorin
○

Niger R.

YORUBA

Esie
○

IGBIRRA

Benue R.

IGALA

Benue R.

YORUBA

Ogun R.

Oyo
○

YORUBA

Osun R.

Oshogbo
○

○ Ekiti

YORUBA

ETSAKO

YORUBA

○ Ife

Owo
○

Idah
○

EDO

Old Osse R.

YORUBA

Ijebu-Ode
○

YORUBA

Siluko R.

Udo
○

○ Uzala

Benin City

Agbor
○

IGBO

Niger R.

YORUBA

Lagos
○

Bight of Benin

Ughoton
○

IGBO

Igbo Ukwu
○

IGBO

Cross R.

Benin R.

ITSEKIRI

URHOBO

IGBO

G U L F O F

G U I N E A

Forcados R.

ISOKO

IGBO

Calabar R.

Calabar
○

CAMEROON

IBIBIO

IJAW

Bight of Biafra

Kingdom of Benin
in the 19th Century

Miles
0 20 40 60 80 100

0 50 100 150
Kilometers

2 Map of Benin Region

11

of power through his links with Ife, the religious center of the Yoruba. On the other hand, he had ties with the Edo, since he was born to an Edo woman.[26]

During the rule of the next Oba, Oguola, in the mid fourteenth century, brasscasting was introduced from Ife; the art of brasscasting is described later (see pp. 35–43). A period of expansion followed the stabilization of the center of the kingdom by the first Oba of Benin.

The Expansion of the Kingdom

The fifteenth and sixteenth centuries are referred to as the Age of the Warrior Kings (Ewuare, Ozolua, Esigie, Orhogbua, and Ehengbuda), a period that also left its mark on the works of art created during this time.[27] Ewuare is described as "a great magician, doctor, traveler, and warrior," who conquered many cities and villages.[28] During his reign the kingdom expanded deep into the Yoruba regions to the west and into Igbo territory to the east as far as the Niger, a natural barrier that even later was never crossed. The southern expansion has only been vaguely described.[29] It is not, however, unreasonable to assume that the kingdom's wealth came from the south, the sea.[30] Warfare became an essential and permanent element of the kingdom, whether to subdue a local uprising or to enlarge its territory.[31]

The changes that Ewuare made to the internal organization, such as political centralization and restructuring in the administrative field, were important for the stability of the kingdom. He consolidated the settlements in the area of present-day Benin City and built a huge wall and ditch around the inner city, erecting nine gates supposedly endowed with magic to guard the palace from its enemies.[32] The old city of mud buildings was burnt to the ground during the course of Ewuare's dispute with his brother over succession and was rebuilt by him in the packed-mud style of the Yoruba. Presumably Ewuare, too, planned and carried out the division of the town into two parts: the precinct of the Oba (ogbe) on the one hand and the actual town—consisting of districts for the royal craftsmen and ritual specialists—on the other. The final location of the palace, which was to become the political and religious center of the kingdom, also dates from this time. The name Benin was changed to Edo. Ewuare also instigated wide-ranging reforms in the top echelons of the kingdom, including the creation of the Town Chiefs (Eghaevbo n'Ore; Ore = town), who were led by the Iyase as their supreme military commander. He furthermore established the palace association (Eghaevbo n'Ogbe; Ogbe = palace precinct).[33] At the same time the dominant political role of the Uzama was reduced by enforcing the rule of primogeniture (succession by the eldest son) and by appointing the crown prince (Edaiken) during his lifetime to the Uzama too.[34]

Ewuare also tried to endow the throne with an even greater religious identity. It was probably during his rule that yearly ceremonies were introduced for the protection and purification of

the kingdom, as well as for honoring the royal ancestors (Ugie Erha Oba) and strengthening the mystical powers of the king (Igue).[35] At the same time, much thought was given to the rich ceremonial clothing of the Oba and his court. The northern expansion of the kingdom led to a growth in trade with the Yoruba, Nupe, and Hausa. Among the various articles traded, and of particular importance, were agate beads and pebbles. The Arabian geographer Al Bekri (eleventh century) reports that they were found between Taddemekket and Gadames and reached the Hausa and Nupe by way of the trans-Saharan trade. Benin's demand was particularly great for the precious stones from Nupe craftsmen that were also brought by Yoruba traders to Ilorin, where a center for imported agate and ornamental beads developed. Beads of agate were a necessary component of ceremonial clothing, since they were regarded as emblems of prestige and rank. They were part of the state treasury, together with red coral, which Ewuare supposedly stole from Olokun (god of the waters). Ewuare founded the Iwebo, a palace association of dignitaries, responsible for the safekeeping of the agate beads and the guarding of the royal insignia and clothing.[36]

The question remains unanswered whether the legend of Ewuare and Olokun's coral is a reference to direct or indirect contact with the Portuguese, since Ewuare's journey to Olokun's palace is said to have taken him through Ughoton (Gwato).[37] According to the Portuguese historian Antonio Galvão, Ruy de Sequeira traveled to the kingdom of Benin in 1472.[38] Although it is unclear whether he went to Benin City itself or merely to the port of Ughoton, one can assume that he obtained his information about the kingdom of Benin only at the locations in the Bight of Benin where he landed.

The death of Ewuare in the mid fifteenth century was followed by a period of great unrest and weak rulers. The Oba Ozolua, who ascended the throne in 1481 and was known as the "Great Warrior" in the history of Benin,[39] not only had to bring back under his rule disloyal towns and regions, but also had to subdue rebellious groups in his palace precinct. During his rule a watershed event took place in Benin's development: the arrival of the Portuguese João Afonso d'Aveiro in the "Great City of Benin"[40] in 1486.[41] The first commercial relations were thus established—the first contacts that would later have so many consequences.

The Arrival of the Europeans

The initial contacts with the Portuguese made available for the first time reliable written documents about Benin's history. However, the outstanding and unifying characteristic of Portuguese authors in the Age of Expansion in the fifteenth and sixteenth centuries was the precise terseness of their accounts; instead of detailed descriptions of foreign cultures, they wrote rather about the policies of their own government. Authors such as Duarte Pacheco Pereira, Ruy de Pina, and João de Bar-

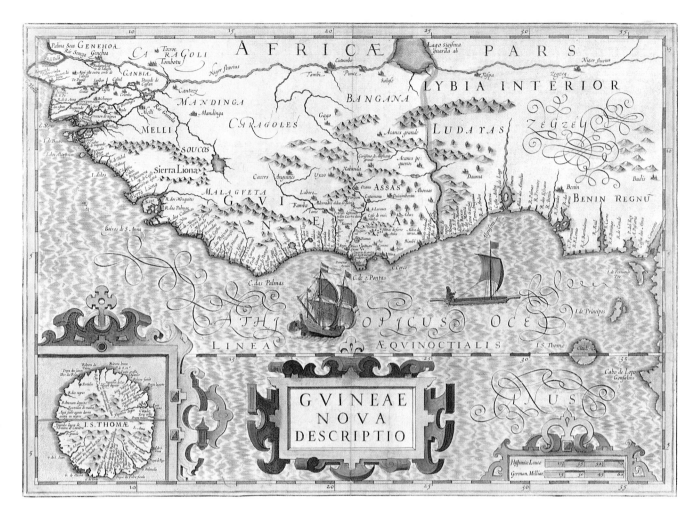

ros were government officials primarily interested in facilitating sea travel, advantageous trade relations, and missionary activity and chronicling the history of their kings, who reported successes in the newly discovered or newly accessible regions. Nonetheless, these reports on the history of Benin in the fifteenth and sixteenth centuries are of the utmost importance.

Although actual contact with Benin dates only from 1486, many European goods certainly were there already, as Portuguese explorers like João de Santarem, Pedro Escobar, and Fernão do Poo had bartered with the native population along the coast for the food they needed.

It is probable that João Afonso d'Aveiro and his companions sailed up the Rio Formosa to Ughoton (Gwato). Ughoton was already under the control of Benin and could have been used as a starting point for journeys through the thick tropical jungle to Benin City. Portuguese reports allow the conclusion that the Europeans were warmly received at the court there. D'Aveiro was accompanied on his return voyage by an emissary of the Oba, the chief of the port town Ughoton (Ohen n'Ughoton). The visit of this "ambassador" in Portugal, where he was described as a man "who could speak very well,"[42] created quite a sensation. He was honored at large feasts and exposed to the extent of Portugal's power and wealth. Weighed down with presents for himself and the ruler of Benin, he was then sent home.

Despite Portuguese intentions to Christianize the kingdom, the first efforts of the Portuguese at missionary work remained fruitless. Instead, both sides were interested more in active commercial relations, and trade in slaves, ivory, and pepper soon flourished. While Europeans were allowed to buy unlimited amounts of red pepper from the king's representative, black pepper—which had a special function in royal ritual—could not be purchased.[43] The king also held a monopoly on ivory, which could not be sold without his consent. In the meantime, Ozolua continued his military campaigns, conquering Ijebu,[44] which as a further contact point with the Portuguese would be of significant economic interest. The campaigns against neighboring peoples furthermore proved to be of importance also for the slave trade,[45] because no Edo, apart from women, were allowed to be sold as slaves, although there were slaves in Benin, namely those of the Oba and other dignitaries. Both groups of slaves came from the ranks of war prisoners and debtors. The Oba received the largest share; the rest were apportioned among the military commanders according to their rank. They in turn could sell their slaves to Europeans with the consent of the king, who was given a share of the proceeds. Since slaves and women in the king's royal household were kept more for prestige than to serve his personal needs, the king himself rarely sold slaves. Thus the slave trade remained strictly supervised. Many Benin slaves were exchanged for gold in Elmina, in

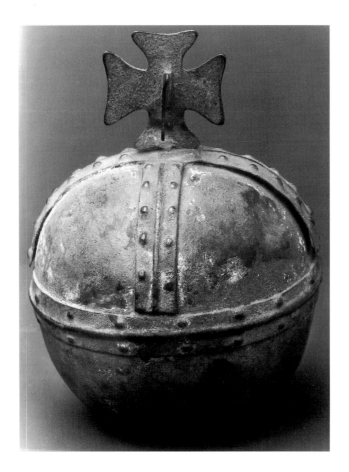

4 *Imperial Orb.*
Late 18th century(?).
Copper alloy.
(Cat. 97)

present-day Ghana.[46] The unchecked sale of slaves did not begin until the end of the eighteenth century and continued into the nineteenth century, mainly after slave trading had been forbidden.

Trade in general flourished particularly during the rule of the Europhile Oba Esigie (in the early sixteenth century). By 1498, merchant ships in Portugal were already being fitted for trade with Benin,[47] and Florentine merchants were leasing trading rights from the Portuguese crown.[48] As a result of this commercial activity, new trading centers sprung up along the coast. The Portuguese traded *manillas* (copper or brass bangles) for slaves in Benin and other conquered regions, such as Ijebu and in villages along the Escravos and Forcados rivers.[49] The Portuguese also obtained "blue shells with red stripes," which were called *coris* by the local inhabitants along the Gold Coast and which they exported, along with slaves, for gold.[50] These blue beads varied in size and were in great demand on the Gold Coast and probably came from Ife, then the most important production center. Caravan trade with Arabian merchants across the Sahara presumably also brought blue beads and other glass jewelry to the south.[51]

Although blue glass beads in Benin did not have the same significance as they did in the region of the Itsekiri, where they were worn in coronation ceremonies, they were only allowed to be worn on the hip, throat, and arms of dignitaries at festive occasions. In 1522, the value of five *coris* was fixed at one *manilla*, whereas one slave was worth fifty-three *manillas*.[52] By comparison, large amounts of coral were imported.

Portuguese trading activity was rather abruptly ended by a decree of King Manuel II of Portugal, who forbade the purchase of Benin pepper in order to eliminate any private competition with the royal monopoly of the Indian pepper trade. The organized slave trade, however, continued in Elmina and on the island of São Tomé. Imported goods in Benin, such as cloth, coral, *manillas*, and horsehair (a symbol of authority) from tails and manes,[53] remained virtually exclusively in the hands of the Oba and his court—a fact reflected in court art.

The intensity of trade with the Europeans led to a reorganization of the palace. Thus Oba Esigie expanded the palace association of the Iwebo by the introduction of two new titles, the *Uwangue*[54] and the *Eribo*. It was their duty to manage the trade with the European merchants, who were housed during their stay in Benin in a residence (*Ugha-Ebo*) reserved for them in the town precinct of the Iwebo, which was under the administration of the Uwangue.[55]

The short-lived missionary period at the beginning of the sixteenth century also left its mark on the early history of Benin. Although the Oba by no means intended to allow himself to be baptized out of religious fervor, he did request that Portugal send missionaries, who actually came. Apparently his sentiments had more to do with making himself seem more powerful in the eyes of his neighbors.[56] At that time the Oba was being severely harassed by his enemies, and he hoped to have the same success as did the Congo king in securing Portuguese backing and firearms.[57] It seems that the Portuguese in his country led him to believe that baptism would bring him not only grace but also firearms.[57] In a letter to the Oba, dated 21 November 1514, King Manuel writes: "When we shall see you have accepted, as a good and loyal Christian, the doctrine of Christ, . . . then it shall be our pleasure to offer assistance against your enemies, be it with firearms or cannons or with other utensils of war, of which, as your ambassador shall confirm, we have very many. These items we may not send you at present, as we are forbidden by the Law of God."[58] In any case, it does look as if religious zeal was promoted by the promise of weapons. In 1515 the Portuguese missionaries in Benin were received in a friendly fashion, and a church was even built.[59] Nonetheless, rumors continued of the Oba being involved in military actions outside of the city and of his being accompanied during his pursuit of enemy armies by Europeans whose cannons were even said to have helped secure victory.[60]

The Oba did not allow himself to be baptized. He did decree, however, that his son should consent to be christened and learn to read. In lands where they were active, Portuguese missionaries used a small book, *Cartelha para ensinar a ler* (Booklet for Reading Instructions), for facilitating cultural contact with Portugal.[61] The idea, though, of an Oba converting to Catholicism was doomed to failure, since, in order even to ascend the throne, the new heir apparent was required to fulfill what the Christians considered "heathen" burial rites and sacrifices to his royal ancestors as part of protracted ritual ceremonies. Either he accepted his office and betrayed his new religion

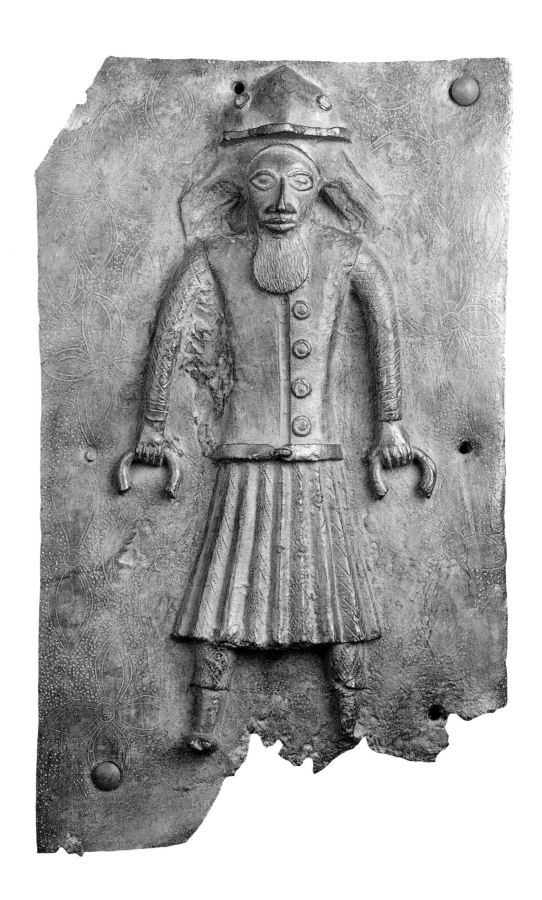

5 *Plaque with a*
European Carrying
Manillas. 17th cen-
tury. Brass.
(Cat. 45)

or he renounced his right, which in turn would unavoidably lead to a fight for the throne.

The missionaries' initial efforts complicate the problem of the portrayal of the cross in Benin art. Where it came from, and what purpose it served, remains unclear. What is certain is that through the Portuguese missionaries one form of the cross was introduced to Benin during Esigie's reign, while other crosses were ascribed to Ewuare and his predecessors, indicating perhaps a more northerly origin.[62] The 1540 account of the Benin envoy to the Portuguese court stating that every Benin ruler received his insignia—with a bronze cross beneath it—from an overlord (*Ogane*) in the east,[63] "who was revered like a pope and who functioned as a sort of invisible high priest," has given rise to theories about some kind of link with the "Jerusalem Cross" of Abyssinia.[64] The early crosses, including the circled crosses used as background ornamentation on plaques (fig. 7), are viewed by modern researchers rather as symbols having cosmological significance. Thus they may represent the four cardinal directions of the world, or the four days of the week, or the four divisions of the day—morning, afternoon, evening, night—set at the time of creation.[65] Be that as it may, the cross as a supportive element of the Christian churches in early times became a part of Edo symbolism.

About 1540, missionary work came to a bitter end, probably as the result of a chill in economic relations. The only baptized king, probably Orhogbua, rigorously forbade all activity by missionaries in his land.[66] In 1538 three missionaries sent by King John III of Portugal had even been imprisoned and mistreated.[67] For more than a century thereafter, no further efforts were made to establish missions in Benin. The Portuguese, who needed more and more slaves for their possessions in South America, found themselves cut off from their supply. The kingdom of Benin appeared to be too well organized for the Portuguese merchants, who were more concerned with making quick profits, and the Oba had increasingly less interest in being a compliant tool of Portugal. The comprehensive protocol was both bothersome and inhibiting to the merchants. Upon calling at the port of Ughoton, even before leaving their ships, merchants were required to give presents to various dignitaries and envoys of the Oba. No sooner had they arrived on land than they had to endure a ceremonial foot washing in the house of the Ohen Olokun. The same routine was repeated in the palace of the *Ezomo* (one of the two supreme military commanders), who in turn had to be richly showered with gifts to avoid his preventing a meeting with the Oba.[68] Trade was much less tedious on the Gold Coast or in the kingdom of the Itsekiri, where it was only necessary to "generously" pay off a Town Chief and his go-betweens.

Nevertheless, the Portuguese became an "integral part of a visual vocabulary of power and wealth."[69] They were a kind of catalyst for the cultural, political, and economic development of Benin. Not only were slaves and pepper from Benin and other coastal states brought to Europe, but many ivory carvings, such as saltcellars, spoons, and hunting horns, which also found their

6 *Tusk with Eleven Rows of Carved Figures*, detail. Ca. 1820–50. Ivory. (Cat. 79)

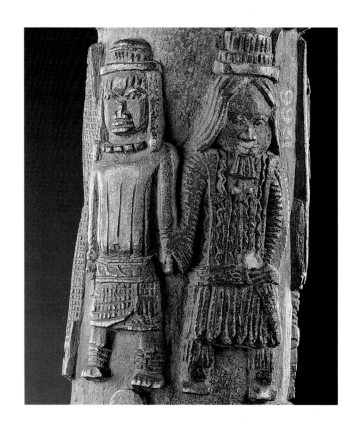

way into the curio cabinets of Portuguese and other European nobility.[70] As early as the beginning of the sixteenth century, Pacheco Pereira commented on the skill of ivory carvers along the African coast of present-day Sierra Leone and Guinea-Bissau; works of these ivory carvers are known today as Afro-Portuguese art.

Other early sources on Africa indicate that the inhabitants on the coast or along the river banks, for whom water had a particular significance, were especially inclined to see a religious meaning in the first Europeans.[71] In Benin the arrival of the Portuguese, laden with luxurious goods from faraway lands, was viewed in the light of complex mythological aspects surrounding the god Olokun, ruler of the waters and bringer of wealth; it may even have been the origin of the Olokun legends.[72] Numerous representations of the Portuguese can be found not only in the ivory art of Benin (tusks, statuettes, bracelets), but especially on the cast brass plaques and bells, as well as on textiles and the skirts of dignitaries and others (fig. 8). Often they are depicted together with animals from Olokun's world, such as snakes, mudfish, and crocodiles. Their close contact with the court can be distinctly seen in depictions of them with dignitaries and court officials on ivory tusks and cast brass plaques (fig. 6).

Before long, other European nations joined the Portuguese in their interest in Benin. In 1526 French ships caused trouble on São Tomé,[73] and in 1533 they attacked Portuguese ships in the Bight of Benin. The year 1539 marked the beginning of French trade—primarily for pepper—with Benin.[74]

The first English undertaking, organized by Thomas Wyndham, a merchant, relied on two turncoat Portuguese seamen, Antonio Anes Pinteado and Francisco Rodrigues, who offered

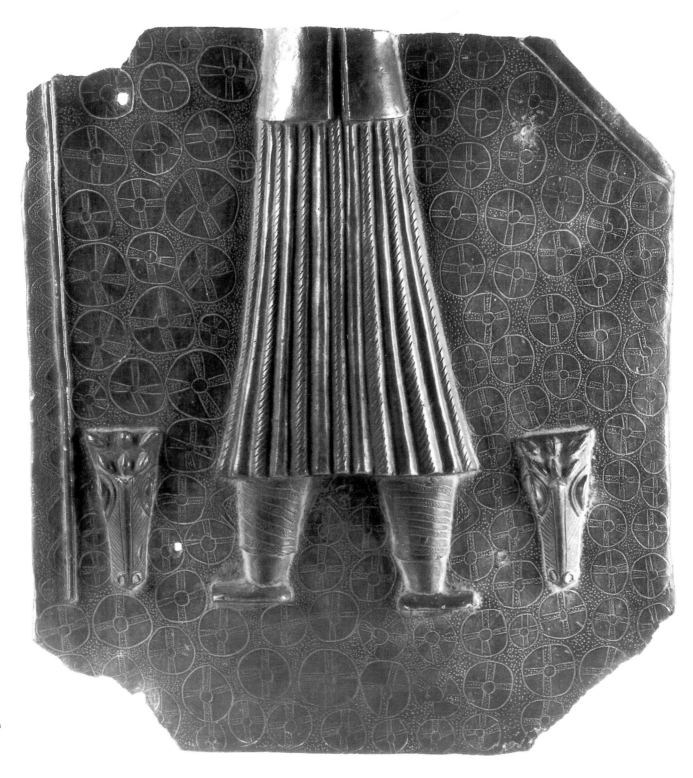

7 *Plaque with the Bottom Half of a European.* Late 16th century. Brass. (Cat. 47)

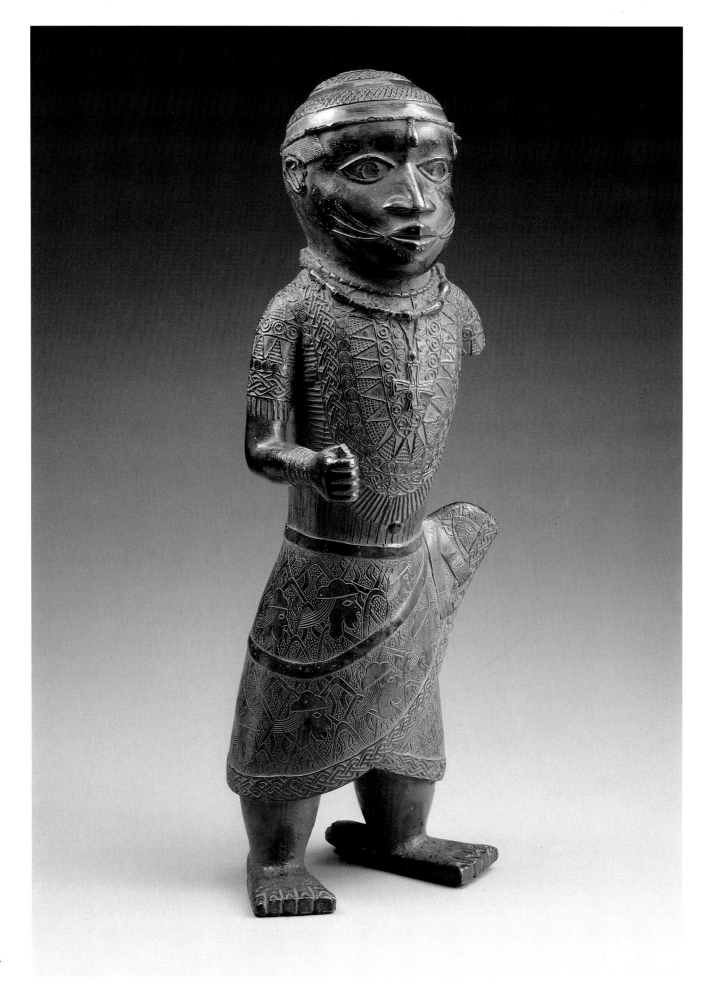

8 *Messenger or*
(Court Official).
Late 16th century.
Brass. (Cat. 3)

their knowledge of the coast of West Africa and the customs of the Edo to the English.[75] They reached Benin in 1553 and were received by the Oba, probably Orhogbua (ca. 1540–65), who conversed with them in Portuguese—a language he had learned as a child—and who promised to deliver the desired pepper within thirty days. The Oba kept his promise, but the English were not able to load it all; Wyndham and a large number of his crew had died of fever within the waiting period. The survivors fled from Benin in panic, even leaving behind several crew members in the process. Thus, the first English expedition ended in failure and left no marks in Benin history.[76] There are no references to the English in Benin during the three decades following the tragic end of the Wyndham expedition, although English activity in the Gulf of Guinea continued unabated.

The next attempt by the English to establish commercial contact with Benin began in 1588, with the Benin River being reached on 14 February of the following year. The undertaking was led by James Welsh, who was accompanied by the merchant Anthony Ingram. He was given the task of dealing with the Edo, and in this function he negotiated with a *Fiador* (an official intermediary between the Europeans and the Oba) for purchasing pepper and ivory. Although this trip, too, was marked by heavy losses due to tropical diseases, Welsh embarked on a second "Benin trip" in 1590. Both expeditions yielded valuable details on the economic conditions in Benin during that period. One finds descriptions in their travel journals of the cultivation of cotton on such a large scale that it was even possible to export cloth made from this material to England. Bast fiber, mats, baskets, ceramics, and ivory spoons were offered to English merchants in exchange for *manillas*, glass beads, and coral. *Manillas* and cowrie shells were still recognized as currency. Iron products, glass beads, and *manillas* were limited, however, to a small group of consumers in the palace. Metal in every form was a monopoly of the king and could only be passed on with his permission to dignitaries for private use. Even a sword could only be manufactured on the king's orders. By the same token, imported European textiles and coral were reserved for a chosen few and were worn primarily for prestige.

At the end of the sixteenth century, Dutch ships started out from the Gold Coast in an attempt to establish commercial relations throughout the entire West African coastal region. Their initial failure at expelling the Portuguese from Elmina Castle in 1596 was balanced by their success in the Bight of Biafra, where they could trade with virtually no interference, as there existed no defensive systems such as forts. Commercial activity in the early seventeenth century gradually shifted from Benin City to the rivers and coast, above all to the towns of Gwato and Arbo (Arogbo?),[77] which resulted in other Edo peoples starting to trade with the Europeans despite their obligation to pay tribute to, and recognize the supremacy of, the Oba.

The Dutch are the best source of information concerning the early seventeenth century in Benin. One of the first Dutchmen to travel to Benin in approximately 1600—a man known only by the initials D. R.—compiled an extremely informative

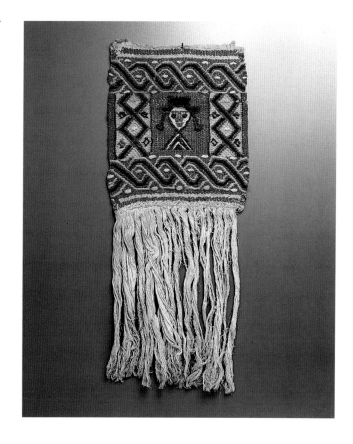

9 *Hip Insignia with a European Head.* 18th century. Brocaded cotton. (Cat. 100)

report that up to the present day has remained obligatory reading for anyone interested in the history of Benin.[78] Deeply impressed, he described a great city with "a very tall Bulwark, very thick, made of earth, with a very deep and wide Moat, which is, however, dry and full of tall Trees."[79] One could only enter the city through guarded wooden gates that were closed in the evenings. D. R. also commented on broad, straight streets whose entire length he could not traverse as he was continually kept under surveillance by Edo guards.[80] He also observed a stable in the palace. Horses were a symbol of prestige[81] and appear here for the first time in a report about Benin. In his account he mentions Dutch horses being greatly in demand, a comment seeming to indicate their importation from Europe, although nowhere else are European imports of that kind mentioned.[82] Court officials carried broad swords on leather straps across their shoulders (see fig. 10). Swords, lances, and shields belonged to their armament.

The Oba (probably Ehengbuda), who only rarely showed himself to Europeans and who entrusted his dignitaries with commercial proceedings, hardly appeared in this account. Owing to his limited freedom of movement, D. R. could only briefly study a few of the inner courts of the palace.[83] This inability to move about freely in sections of the palace and in domestic dwellings of dignitaries where brass objects were kept probably also explains why there is no mention of altars or other sacred objects.

Among his vigilant observations is a passage about unclothed boys and girls that expands on earlier descriptions of this custom,[84] particularly his observation that they put on

clothes as soon as they were permitted to do so. Decorative scarification, also mentioned in earlier accounts,[85] was described in detail by D.R. His description is in complete agreement with representations on plaques (see fig. 11).

The portrayal of a nude youth is often linked with an oral tradition about the only son of Ehengbuda, the later Oba Ohuan (ca. 1606). According to tradition, he was born a girl and only later became a man through medicine.[86] In other sources this is diluted to describe Ohuan as being "pretty and maidenly so that people did indeed think he was a girl."[87] In the first version, Ohuan had to publicly present himself naked after his transformation,[88] and in the other,[89] his father, Ehengbuda, in order to end the rumors of Ohuan being a girl, arranged to have his son walk naked from Uselu to Benin so that all could convince themselves of his manhood. These accounts would seem to indi-

cate that Ohuan had feminine traits and that the Edo even then questioned his ability to rule. Ohuan's reign was brief, and he died without offspring; as it is phrased in oral accounts, he "could not pass on the royal tradition to his successor."[90]

The death of Ohuan confronted the Edo with a seemingly unsolvable problem. As he was an only son, it was not even possible for a brother to follow in succession and thus keep the throne in the royal family. A unique account of this particular period would later arouse further European interest in Benin. A Dutch doctor, Olfert Dapper, who was particularly interested in the geography and history of regions outside of Europe, but who himself never traveled to Africa, published in Amsterdam in 1668 his famous work, *Naukeurige Beschrijvinge der Afrikaensche Gewesten . . .*, a compendium of his knowledge about Africa that he had gathered from all available written and oral reports.

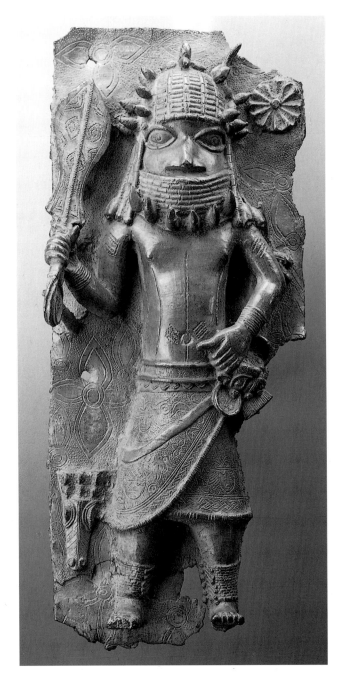

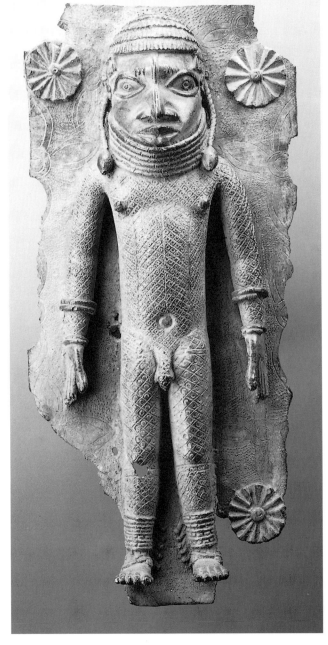

10 *Plaque with a Dignitary Holding a Ceremonial Sword.* 17th century. Brass. (Cat. 33)

11 *Plaque with a Nude Boy.* Late 17th century. Brass. (Cat. 57)

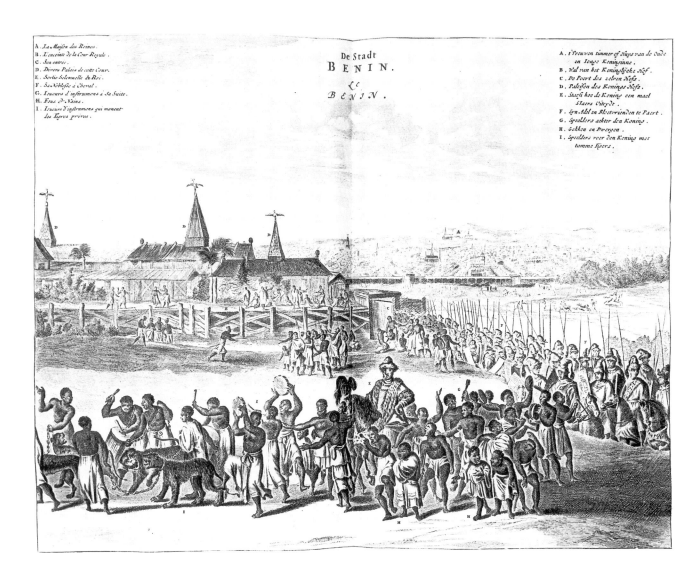

A. La Maison des Reines.
B. L'enceinte de la Cour Royale.
C. Son entrée.
D. Divers Palais de cette Cour.
E. Sortie Solemnelle du Roi.
F. Sa Noblesse à Cheval.
G. Joueurs d'instrumens à Sa Suite.
H. Fous & Nains.
I. Joueurs d'instrumens qui menent
les Ligres privez.

De Stadt
BENIN.
&c
BENIN.

A. 't Vrouwen timmer of Huys van de Oude
en Jonge Koninginne.
B. Wal van het Koninglijcke Hof.
C. De Poort des selven Hofs.
D. Paleisen des Konings Hofs.
E. Staets hoe de Koning een mael
'S Iaers Uytrydt.
F. Syn Adel en Bloetvrienden te Paert.
G. Speelders achter den Koning.
H. Gekken en Dwergen.
I. Speelders voor den Koning met
tamme Tijgers.

12 *Benin City.*
Illustrated in
Dapper 1668. Pho-
totek, Museum für
Völkerkunde,
Vienna (22.228)

Although Dapper also relied on earlier authors, much of what he wrote about Benin had not appeared previously—for instance, the regulation of succession to the throne, the system for determining who could succeed, and the relationship between burial rites and hereditary succession. Through Dapper one learns that in Benin it was not always the oldest son of the Oba who was next in line.[91] For the first time the titles of the local dignitaries are mentioned, as well as the close relationship of the Oba to the court and cult.[92]

Dapper's famous account of Benin City is the first to describe the existence and use of the cast brass plaques: "The roof of the same sits on top of wooden pillars, which from bottom to top are covered with brass, upon which are depicted their war deeds and battles."[93] The illustrator of the book closely followed Dapper's text on Benin and even included several important details. In his portrayal of the Oba's attendants one recognizes the court jesters, tame leopards, and musicians seen in these plaques (fig. 12).

It follows from Dapper's description that, although the organization of trade had changed little since the beginning of the seventeenth century, the focal points of trade had gradually shifted to the rivers (Formosa, Escravos, and Forcados) and

along the coast. As a result of the increasing wealth of these regions, the importance of their relationship to Benin City correspondingly declined. Since all branches of the royal family could equally claim a right to Ohuan's throne, corruption and internal disorder led to an accelerated decline of the kingdom.[94] The Dutch merchant David van Nyendael wrote in 1699 that Benin was only a village, even though court etiquette among king and dignitaries, as well as trading customs, were maintained.

The martial success of the Iyase, the leader of the Town Chiefs, led to the latter's increasing self confidence and thus to conflict with the Oba. The attempt of Ehengbuda (late sixteenth century) personally to seize command of the army ended in failure and in the decision of the military commanders to abolish the Oba's right to command.[95] More and more, he was pushed out of the secular world and into the world of cult.

Thus the continuance of court etiquette and cult customs at court was ensured. Van Nyendael described an altar next to, and behind, the throne and noticed ivory tusks sitting on "eleven [men's] heads cast in copper" behind a curtain. He saw a snake made out of copper hanging head down from a tower on the roof, "the most beautiful sight he ever saw." During his visit

three dignitaries and a sword carrier were present.[96] The distinct loss of authority and charisma by the Oba made life difficult for the series of seven shadowy and inconspicuous rulers that followed him in the seventeenth century.

The succession to the throne and important decisions were increasingly in the hands of the most powerful Palace Chiefs.[97] The internal power struggle between the Palace and Town Chiefs at the end of the seventeenth century led to civil war at intervals, lasting for two decades. In 1696, the Capuchin missionary Guiseppe Maria de Busseto wrote to the Sacra Congregazione in Rome: "Nothing worth doing is possible at present in Benin, as it has been almost completely destroyed by wars through which the Negroes have mutually decimated each other for more than seven years."[98] Commercial relations, however, continued without interruption and the same goods were traded as in earlier times: cotton products for the Gold Coast, female slaves, leopard skins, peppers, blue glass beads, and agate. By the same token, the prohibition against selling Edo men as slaves was still maintained in the eighteenth century. In exchange, the Edo imported European textiles, iron, glass beads, cowries, *manillas*, mirrors, and alcohol.[99]

During the reign of Ewuakpe (late seventeenth—early eighteenth century), the last of the seven weak rulers, one of the two leading military commanders, Iyase ne Ode, rose against him. After the Oba's death, the latter supported the rival of the royal heir, Akenzua I, who was only able to eliminate his rival through the assistance of the Ezomo, the other military commander, a member of the Uzama. A last shimmer of the splendor of old Benin began about 1715 with Oba Akenzua I (ca. 1715). He succeeded in putting down the rebellious Iyase (leader of the Town Chiefs and supreme commander of the army) and boosting the power of the Ezomo. His further accomplishments were the reestablishment of the succession of the oldest son of the king to the throne, and the full exploitation of Benin's favorable location for trade. Many sources of income, which during the unrest towards the end of the seventeenth century had been usurped by the Town Chiefs, were again put under the control of the Oba; this—combined with revenue from the intensive trade with the Dutch, to whom the Oba presented himself as an equal partner[100]—made him one of the richest rulers ever to reign over Benin. Instead of allowing himself to be involved in wars, as did the Obas of the sixteenth century, Akenzua and his successors retreated into the palace, where the authority of the kings rested more on their function as guardians of prosperity and security, as well as on the strength of their religious position. This renewed increase in wealth also left its mark on art, especially since huge amounts of copper and brass could be imported. It was the heyday of a new kind of art embodied in the "altars to the hand" (see fig. 13), the royal scepters, and images of the victorious Akenzua I.[101] The religious impulse also changed the character of the art of brasscasting from a certain naturalism to a rigid stylized form.

The English explorer Richard Burton[102] and the Italian Giovanni Belzoni, who went to Benin as representatives of Brit-

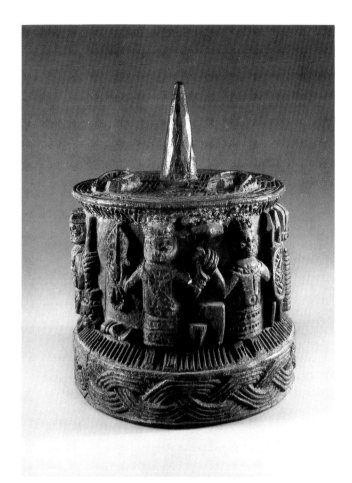

13 *Altar to the Hand.* 19th century. Wood. (Cat. 67)

ish commercial interests, reported on the wealth of ivory art in Benin, which had always served as part of the ancestral altars (bearers of royal power). In one account from the year 1823 one reads: "The tombs are decorated by as many large elephant's teeth as can be set in the space; these are elegantly carved in the manner of the ancients, and the socket of the tooth is introduced into the crown of the head. . . ."[103]

The abolition of the slave trade and the slump in the ivory trade with the Dutch meant the beginning of Benin's final decline. Benin could have found an alternative, since the slave trade had never been its main source of income, and since not all routes leading from the sea or along the rivers were under the control of the Itsekiri. However, a greater obstacle to an economic breakthrough was the lack of production and marketing in commercially viable quantities. In addition, an increasingly greater danger was posed by the neighboring states, which through unauthorized trade had become stronger and more confident and were freeing themselves more and more from Benin's control. A growing number of attacks by the Nupe in the north interrupted many trade routes. Problems with the Oyo kingdom interfered with trade contacts along the Oki-Igbo route. Coming from the coast, the British pushed ever deeper inland, with the Royal Niger Company stifling contacts east of the kingdom. The rulers reacted to these massive threats by retreating even further behind their palace walls into a disastrous isolation and by breaking off all commercial contacts with the Europeans and

neighboring states. They decided to seek refuge in a "manipulation of the political system, i.e., they created more and more titles for dignitaries, and human sacrifices became more numerous until Oba Ovonramwen [1896] completely lost control over his kingdom, even to the degree that, according to several eyewitness reports, he no longer was able to deter chiefs from attacking the British expedition of 1897".[104]

The British Punitive Expedition

In the second half of the nineteenth century a new product from the tropics, palm oil, gave rise to additional British settlements along the coast of the Bight of Benin and on the Benin River and its tributaries. The more trade grew, the more pressing the problem became for the British government to provide protection. Great Britain's procrastination was brought to an end, however, by the energetic activity of John Beecroft, the first British consul in the Bights of Benin and Biafra, who acted on behalf of British interests. Lagos and other regions on the coast preferred to maintain good and profitable relations with the British instead of with a distant Benin. Increasingly Benin was pushed back to its original heartland. The loss of political dominance over neighboring regions and the many rebellions within the Oba's own palace building led again to a shift in the ruler's authority from the political arena back to the ritual. With the Oba increasingly isolated as a sacred ruler, ritual etiquette now included a growing number of human sacrifices. Before long, all accounts and descriptions of the court of Benin reported on this practice extensively.[105] Until 1884 the British government exhibited hardly any interest either in maintaining commercial relations with Benin or in claiming the region for itself. In that year an agreement making the coast of the Bight of Benin a British protectorate was signed by Edward Hewett, the British consul, and several Itsekiri chiefs. British traders called for a similar agreement with the Oba of Benin in order to better safeguard their commercial interests, particularly as German and Dutch trading posts had been spotted in the area of the Benin River. The announced visit of the British consul was repeatedly put off so that no British delegation reached Benin before 1888, the year of Oba Adolo's death. In 1890, the British consul, G. Annesly, paid a brief visit, but met with no success in winning over Oba Ovonramwen for such an agreement. It was only in 1892 that the vice-consul, Captain Henry Gallwey (later Galway), succeeded in getting a very hesitant Oba to sign. The latter found himself in a difficult situation, as he was being threatened by Gallwey on the one hand, and on the other he was under the influence of sinister prophecies of an Ife ruler and a man who had been selected for sacrifice. Both had prophesied that a catastrophe would befall Benin.[106] The Oba refused to touch the quill with which the treaty was to be signed, as he "was in the midst of an important ritual."[107] It is not likely that anyone at court was aware of the ramifications of the agreement by which the independence of the kingdom was *de facto* surren-

dered.[108] Hopes for a flourishing trade after the signing of the accord were not fulfilled, since the Oba reportedly had shipments of goods blocked, presumably for religious reasons, and thus voices became louder to find a solution once and for all.[109] Among English authorities and merchants, Benin increasingly had the reputation of a state where human sacrifice and destructive commercial conditions prevailed.

Despite the demands of Ralph Moor, the consul-general of the Niger Coast Protectorate, for a punitive expedition, the Foreign Office in London was not convinced and expressed its desire that efforts should be made to reach a peaceful solution. The young deputy consul-general, James Phillips, hoped to use Moor's return to Great Britain to settle the affair in Benin by deposing and vanquishing the Oba. To this end he requested permission in a letter to the Foreign Office on 16 November 1896.[110] The answer explained that, considering the situation in West Africa, with no prospect of military support anywhere for such an expedition, it was not desirable to initiate such an undertaking and he should consider postponing it to a later date.[111] Phillips never received this dispatch, as he had already set out on an expedition to Benin with nine countrymen and more than two hundred porters. He had sent a message to the Oba informing him that he and his escort were coming unarmed. What was actually intended remains unclear. Was the Oba to be given a last chance to agree to a peaceful solution, or was he to be coerced with the threat of removal? The question also remains unanswered why Phillips went unarmed to Benin. Perhaps he hoped in this way to circumvent London's directive prohibiting the use of force and thus quickly achieve a positive result in Moor's absence, which certainly could have enhanced his career.

The messenger announcing the British visit to the Oba was sent back to Ughoton to inform Phillips that he should come a month later, since the Oba had to perform ritual ceremonies with the traditional sacrifices to his ancestors, an old tactic for informing official visitors that they were unwelcome. Phillips did not react in the normal manner. Despite efforts of an Itsekiri chief to persuade him not to follow through with his plan—it meant certain death—he insisted on pressing forward.

News of the approaching visit produced an extremely tense situation in Benin. Neither Moor's ruthless treatment of the chiefs who had dared resist his expansionist plans nor the oft-repeated British threats directed at them had been forgotten. Even after envoys had searched the British baggage in Ughoton for weapons, the Benin court was still convinced that this visit would mean war. According to statements made by witnesses during a later examination after the city's capture, the Oba and his Palace Chiefs did not agree among themselves on a course of action. The Oba felt that the British should be allowed to come, since one could still decide what their intentions were then. The chiefs rejected this view and sent out their people to attack the expedition. An accompanying chief's warning of imminent danger failed to convince Phillips to give up his planned undertaking. The tragedy was inevitable, and on 3 January 1897,

between the port city of Ughoton and Benin, the completely defenseless caravan was ambushed and virtually eliminated. Apart from a few porters, only Captain A.M. Boisragon and Ralph Locke, one of the local district commissioners, were able to escape.[112] Phillips, too, was among those who fell to the attack. The Oba realized that war was now unavoidable and attempted to prevent the worst by offering his ancestors huge numbers of human sacrifices, an event later described in great detail by members of the Punitive Expedition.[113] On 11 January news of this debacle reached London, where outrage and the desire for revenge spread throughout the country. Naval ships from Cape Town, Malta, and Gibraltar, as well as marines from Great Britain and porters from the Gold Coast (Ghana) and Sierra Leone, were quickly ordered to the Gulf of Guinea. Towards the end of the first week in February, an expedition of fifteen hundred men set out for Benin and, after several skirmishes during the capture of Ughoton and a few strategically important villages, took the city without appreciable resistance on 18 February. The city was almost completely deserted; the Oba had fled with most of his followers. Left behind was the horrifying sight of mutilated corpses, sacrificed in the last weeks by a desperate Oba, who had hoped in this way to stave off the inevitable.[114] Two days later a terrible fire broke out, destroying the remnants of what had remained from a great period in history. Fortunately, Benin's artistic treasures, which previously had been transferred to a safe place, were spared destruction.[115] The British, fearing the Oba might use his authority as the religious leader of the Edo to organize new attacks as long as he remained free, began an intensive search for him. The former Palace Chiefs were coaxed into returning by the British decision to free all slaves whose owners refused to submit to them. Thus, in order to avoid the loss of all of their slaves, a majority of the chiefs turned themselves in and agreed to recognize British rule.[116] On 5 August 1897, the Oba and his large following of warriors, chiefs, and wives finally presented themselves in the city. Two days later, together with an entourage of almost four hundred naked men, he appeared before the tent of the deputy resident in order to negotiate his surrender; he wore a white skirt and colorfully stitched leggings and was entirely covered with coral. His headpiece, fashioned after a leghorn (an Italian straw hat), was also made of the most beautiful coral beads; it was so heavy that he had to be supported from time to time by an attendant.[117] In the presence of his retinue, he was forced to suffer humiliation by surrendering publicly to the British; as was the custom, he rubbed his forehead three times over the ground. Immediately thereafter he was informed that he had been deposed as Oba. The actual trial did not begin until Moor returned from Great Britain to direct the hearings. The Palace Chiefs, who had attacked and virtually wiped out the unarmed British expedition against the will of the king, were sentenced to death. The decision was made to remove the deposed Oba temporarily from Benin and then incorporate him into the colonial administration at a later date. If he acted reasonably, he would be named to the highest post beside his British superior.

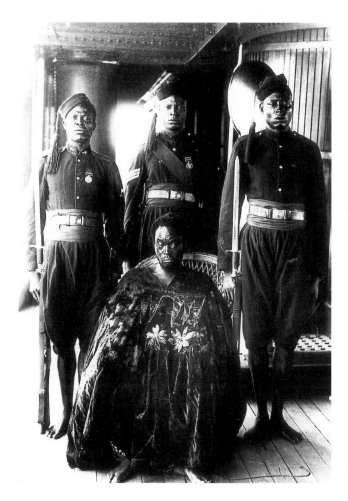

He would not, however, be allowed to act independently of his colonial masters or native chiefs.[118] The Oba was given two days to consider. If he were to flee again, however, he would forfeit his life. Instead of appearing before Moor on 9 September, the Oba fled and was recaptured, thus invalidating all previous agreements with Moor. He was immediately taken prisoner (see fig. 14) and then banned to Calabar, in southeastern Nigeria, where he died in 1914.[119]

During the Punitive Expedition the royal treasures were discovered, a part of which eventually found its way to Vienna. "The Royal Palace resembled the building of the council, but had numerous apartments. . . . The rest of the grounds consisted of medical and storage rooms. . . . In one of the buildings, however, buried beneath the dirt of ages were several hundred unique brass plaques which almost reminded one of Egyptian examples, but were cast in a wonderful manner. Other admirable castings and several magnificently carved ivory teeth were found there, too, but most of them were weathered, and only very few from more recent times were found, which, however were not carved. . . . In fact the elephant teeth and brass works we found were the only objects of value. In a well we found 41 elephant teeth. Among the other ivory pieces, a few bracelets, which resembled Chinese works, and magnificent leopards were worth noting. Several groups of brass idols and splendidly crafted stools made of brass were discovered which were cer-

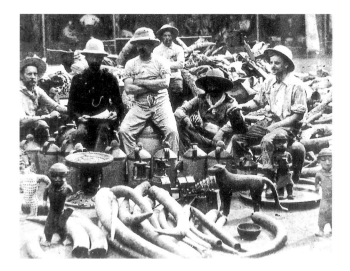

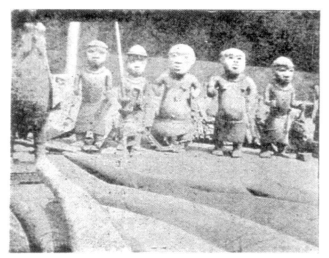

15 The British
Punitive Expedition, 1897

16 Bronze figures
of dwarfs being
transported to
Europe, 1903

tainly very old."[120] From here the treasures of Benin began their odyssey throughout the world.

The treasures were not highly appreciated at first: "There was neither silver nor gold; the ivory was weathered and the coral wasn't worth much either."[121] The later fate of this unparalleled find was most varied. Some of the pieces claimed by officers and soldiers as spoils of war were sold a few days later to merchants in Lagos; others found their way into private English collections or, via English traders, into London auction houses and from there to many museums. The British believed that the removal of all the sacred objects would also ultimately mean an end to human sacrifices and break the power of the king in the eyes of the Edo. The British government transferred a large number of objects to the British Museum in London for sale, "in order to cover the costs of the expedition." Felix von Luschan calculated that an impressive 2,400 Benin objects were eventually incorporated into numerous collections.[122] Benin without a ruler was paralyzed. Many inhabitants, including the craftsmen, fled from the city to the villages. The arts and crafts no longer flourished; in fact, they completely stagnated.

In 1914 the British allowed the oldest son of the last ruler to assume the name Eweka II and return to Benin to succeed to the throne. He was permitted to rebuild the palace and assemble skilled craftsmen around him so that they could revive ancient Benin art in the service of ancestor rituals, as well as refurbish the barren altars of the ancestors with new brass castings and ivory works. Even the earlier traditional administrative structure in the service of the cult was allowed to be reinstated—although under the watchful eyes of British colonial administrators—in order to contribute to the glory and splendor of the new ruler.

The Oba also took measures to establish a school for the arts and crafts, thus enabling artists to gain a new clientele outside of the palace, such as colonial officials and, later, tourists. For too long Palace and Town Chiefs, as well as the Uzama, had acted independently of the king. They could now neither return him to his old position nor support his own efforts. Up to the present day, the king has continued to rule Benin, although his authority is less absolute than that of his pre-twentieth-century predecessors.

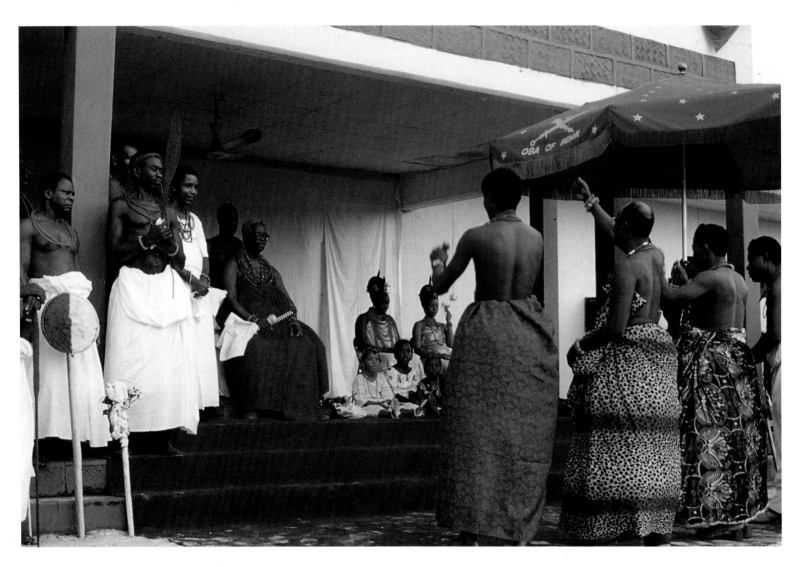

17 Uzama Nobles Salute the Oba at Igue, ca. 1984. Photograph by Joseph Nevadomsky

The Court Hierarchy

The Oba

Many aspects of the so-called Holy Kingdom can be found in the institution of the Oba (king, or ruler) of Benin. Although a sort of divine king, he is nevertheless not God. Standing at the apex of the kingdom, he can be viewed as its highest power and authority. Still, if earlier accounts are to be believed, he was not an absolute sovereign, since the course of the history of the kingdom of Benin clearly shows that repeatedly he was forced by the powerful palace associations to accept limitations on his political power.

The Oba needed the active participation of court officials in order to exercise his ritual and mystical functions. Their refusal to fulfill ritual obligations was one of the most feared weapons against the tyrannical designs of a ruler.[1] Not even in his role as a holy person could he simply abolish old traditions or laws. Although he himself was not a god, his office was nonetheless holy and, in this sense, inviolable. As holder of his office, he was guaranteed the veneration of his people. As representative of his deceased ancestors, he possessed supernatural and psychic powers; however, the office itself always stood in the foreground as the object of veneration. At state ceremonies the Oba offered sacrifices to his ancestors while being simultaneously the center of rituals whose religious character was emphasized and appreciated more than the political aspects. It is this religious aura that most closely unites the prosperity of the Oba with that of the kingdom. The center of these holy acts of worship, from which everything went forth but also returned, was Benin City, which as the origin of the state was the most stabilizing factor in the kingdom. Thus, the territory of Benin City could vary in size, and territorial expansion could decrease, without affecting in the least the authority and central power of the city where the king and his court resided. Because of the Oba's origins, his political and religious importance were inseparable. As the descendent of the divine Ife king, the Oba ruled with a divine birthright. As heir to an Edo king, since Oranmiyan begot a son by an Edo woman, he governed with the approval of the Uzama (King Makers), the same group that had "ordered" from Ife the first king of the new dynasty. This duality of divinity and mortality was expressed very well by the Edo: "We pray to him, a child of heaven, not to fall [on us] and bury [suffocate] us; we beseech him, a child of earth, not to devour [kill, conquer] us."[2]

Although the double nature of the Oba's power was a continual source of conflict, in the end it was his most important attribute.

Various Obas defended themselves against the most powerful political force in the state, the Uzama, and later against the Palace and Town Chiefs by concentrating on new ritual ceremonies underlining their power, which influenced the arts as well. As the political power of opposition groups increased over the course of time, so did the Oba become increasingly occupied with fostering the ritual importance of himself and his office. The infusion of a new force into his power raised him so completely to another, divine level, that he became unreachable to his enemies. As he was of both Edo and divine descent, the Oba was the ideal intermediary between his people, the Edo, and the spiritual region of the gods, ancestors, magical powers, and spirits, who together helped determine the kingdom's prosperity. This intermediate position between the worldly and the spiritual formed the key to his power. Accordingly, the iconography of Benin art continually reiterated the king's position of power and became a kind of aesthetic propaganda for the Oba.[3] His person was identified closely with the fertility and continued existence of the state. He was sheltered from association with normal human needs. The mentioning in his presence of sleep, food, washing, and, above all, the Oba's death was strictly prohibited. Being surrounded by secrets, as the king was, required metaphors describing these concepts. Thus kings could not be seen eating "so as not to destroy the belief of their subjects that they can live without food."[4]

The close ties with his ancestors were clearly seen in the yearly ceremonies in which the power of the Oba was renewed, since his religious and political authority could only be sanctioned through the royal ancestors. The two most important annual rituals were the Ugie Erha Oba, which honored the ancestors of the Oba, and the Igue, which renewed his powers. Both included the blessing of the head of the Oba, which emphasized the religious and political aspects of the institution of the monarchy. As guardian of law and order, he did not merely perform the ceremonies, he was also accepted in these roles by his court and the highest powers of the kingdom. On such occasions, homage to the Oba had to be rendered by all chiefs, who then received their titles anew. Not appearing at one of these ceremonies was regarded as an open rebellion and treated as such.

The Oba left the palace (cf. fig. 12, p. 21) only once or twice a year to show himself to his people. Olfert Dapper describes such a ceremony: "Only once a year does he come on a certain festival day, out of his court, before the community. And thereupon he appears on horse, in royal trappings, most splendidly adorned. Three or four hundred noblemen follow him, both on horse, as well as on foot, with a great number of musicians; who are found both in the rear, as well as in the fore, and who are heard playing all kinds of instruments, in just the same way, as seen portrayed in the previous illustration of the City of Benin. But he does not ride far from his court; rather he returns, when he has gone a short way, directly back again. Then he allows several tame leopards, that he keeps for his own pleasure, to be led around on chains, as well as many dwarfs, and deaf people, so that he is equally entertained."[5]

Only at night could the Oba leave his palace, but even then no one was permitted to see him do so. Entrance into the palace was only possible after a ritual cleansing. With few exceptions, primogeniture was the rule (at least since the time of Oba Ewuakpe). If the deceased monarch had no male offspring, the throne could be given to one of his brothers. A son could only inherit the title and a major part of the possessions when the burial ceremonies for the deceased Oba had been duly fulfilled. "The supreme obligation of a senior son is to 'bury' (re) his father and to 'plant' (ko) him, that is to instal or rededicate a shrine at which to 'serve' him as an ancestor."[6]

In view of the many wives that the king had, it was not always clear which son was actually the firstborn. In the oral traditions there are several accounts of this sort. The death of a king was traditionally kept secret for a while. Presumably this was an old custom from the time when there was still no officially named crown prince (Edaiken), i. e., somewhat before the middle of the fifteenth century. The Uzama used this transitional period to agree on a successor, who was usually the eldest son. When the death of a ruler was officially announced, the royal successor left his residence outside of the city and carried out a series of ceremonies that lasted up to a year. The most important task of the successor to the throne was the erection and dedication of an ancestral altar honoring the deceased Oba. Only after completing these ceremonies could he ascend the throne. In order to secure his position, a newly crowned Oba sent his brothers out to the towns and villages, where they received hereditary administrative posts. In this way, potential rivals were removed and the provinces were linked more closely to the new king. The provinces and villages were tied closely to the throne in a mystical way, too. By order of the Oba, cult ceremonies were performed dealing mostly with mythical heroic figures who were often closely linked with earlier rulers. Frequently these mythical figures transformed themselves into mountains, hills, ponds, and rivers that were revered. Larger feasts needed the approval of the king, who often sent animals to be sacrificed and a representative to watch over the ceremony that always included a blessing for the king. The upkeep of the king and his many court officials, servants, and wives was paid out of tribute levied in his name on all parts of the kingdom. All slaves belonged to the king. They were his to dispose of, and generally he presented most of them to his military commanders. As already mentioned, all commercial relations with Europeans needed his permission in principle, a fact that often resulted in substantial difficulties and delays.

In the center of all this activity stood the royal palace, which was described by the first European travelers as most impressive:[7] "The castle of the king is square, and stands on the right side of the city, when one enters through the gate of Gotton. It is indeed so large as the city of Harlem, and is completely surrounded with a special wall. It is divided into many magnificent apartments, and has beautiful and long square galleries, which are about as large as the Exchange in Amsterdam. But one is larger than the other. The roof of the same sits on top of wooden pillars, which from bottom to top are covered with brass, upon which are depicted their war deeds and battles. Everything is kept very clean. Most royal apartments are covered with palm leaves, instead of square boards: and every gable is adorned with a turret, ending in a point. On it stands a bird, cast in copper, with extended wings, artistically made after a living model. The city has thirty quite straight avenues. Each is about 120 feet wide. And into them run many wide, as well as somewhat narrower, shorter streets. . . . The houses . . . are washed and polished until they gleam, so that they shine as a mirror, . . . and are furnished as in some areas of this region [Holland]."[8]

As already mentioned, D. R. saw the stalls of the king's best horses and observed as well "that it seems that the King has many Warriors . . . and that the King also has very many Noblemen. . . . When a Nobleman comes to Court, he comes on Horseback. They sit on their Horses as the women do in our Country, and on both sides they have a Man to whom they hold on. They have as many Servants walking behind them as befits their status. Some Servants have great Shields with which they protect the Nobleman against the Sun and they go alongside the Nobleman, apart from the two to whom he holds on. The others follow behind, making music: some play Drums, others Horns and Flutes, and some have a hollow piece of Iron on which they tap. The Horse is led by one man and thus he rides to the Court, accompanied by music. The very great Noblemen do something different when they ride to Court: they have little Nets, of the kind with which Men in our country go to the Fish-market, and this little net is filled with things which they tap with their hand, so that they rattle as if the little Net were filled with big Nuts. A Nobleman has many Servants who go behind him with such Nets."[9]

The palace was mentioned even in early accounts as the center of cult ceremonies. Van Nyendael reported on "human likenesses" that were described by fellow travelers as representing merchants, soldiers, marksmen, etc., and "human heads of copper, with an elephant tusk on each; these are the gods of the king." In the palace district he also noticed "a tower with a snake" and an "audience chamber," where he saw and heard the

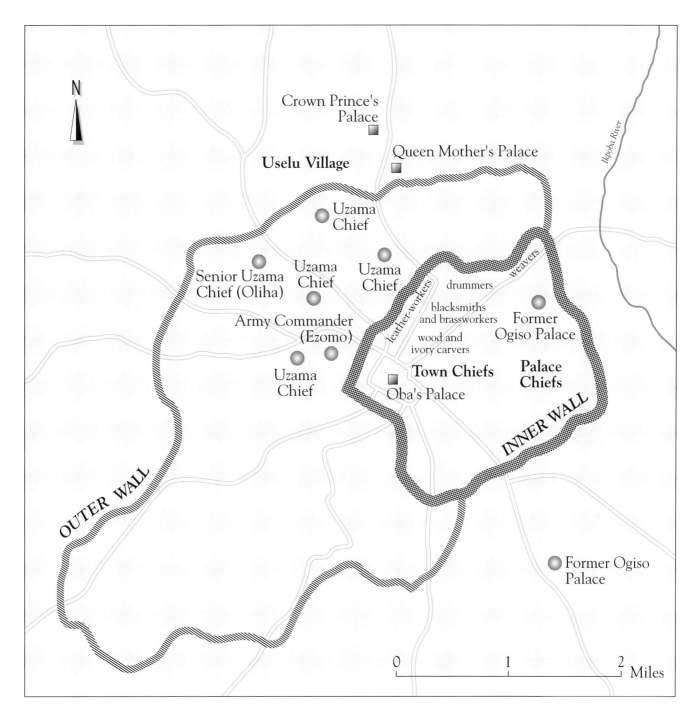

Crown Prince's
Palace

Queen Mother's Palace

Uselu Village

Uzama
Chief

weavers

Senior Uzama
Chief (Oliha)

Uzama
Chief

Uzama
Chief

leather-workers

drummers

blacksmiths
and brassworkers

Former
Ogiso Palace

Army Commander
(Ezomo)

wood and
ivory carvers

Town Chiefs

**Palace
Chiefs**

Uzama
Chief

Oba's Palace

INNER WALL

Ikpoba River

OUTER WALL

Former Ogiso
Palace

N

0 1 2 Miles

18 Benin City in the nineteenth century

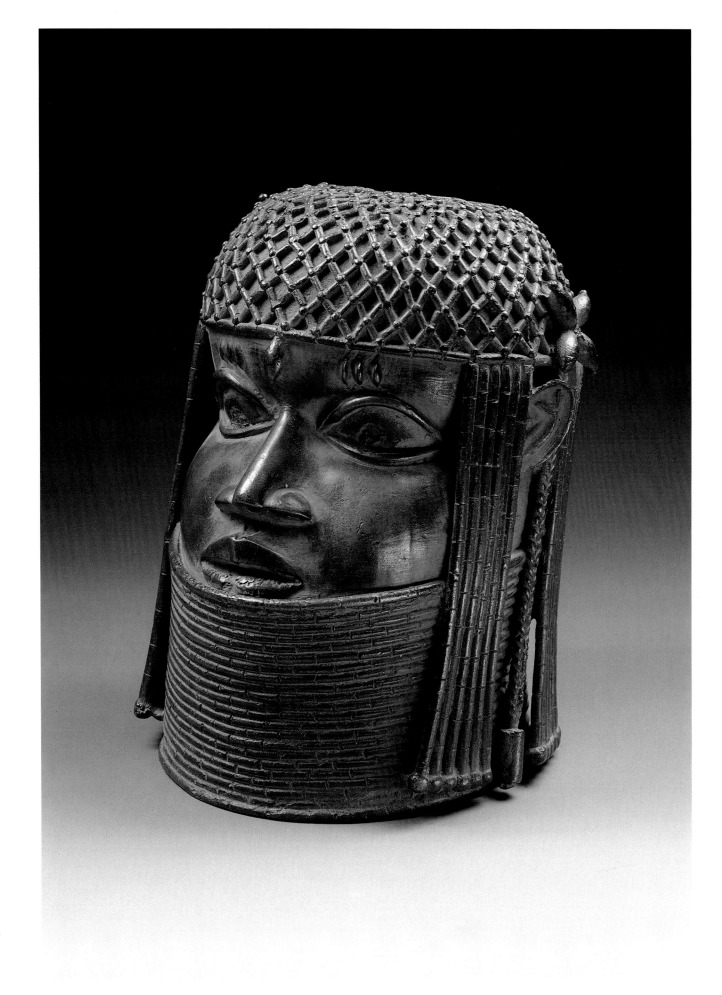

19 *Head of an
Oba.* Late 16th
century. Brass.
(Cat. 21)

king—in the presence of three "Great Men." The king sat on an ivory bench. Van Nyendael further noticed "seven polished ivory teeth upon ivory pedestals of the sort with which the king usually honored all his gods."[10] It was the privilege of the king alone to honor his ancestors with cast brass heads on the altars. They attested to the power of the head to ensure success in life. Brass had a complex, symbolic significance in Benin. By neither corroding nor rusting, it symbolized the permanence and continuity of the monarchy. Its shiny reddish color was believed to keep evil forces at bay. The many elephant tusks were reminders of the king's exclusive claim to ivory.[11]

An important event at court was the Coral Ceremony. Only the king could possess royal coral and beads—a fact that in earlier times had even led to conflict among pretenders to the throne.[12] King Esigie (sixteenth century) waged war against his brother Aruanran in order to secure possession of the royal coral, which not only served as ornamentation, but also was believed to possess the power of making anything said in its presence come true. Among other things, it gave the king the power to pronounce an irrevocable curse, and secured for the monarchy both mystical abilities and the right to punish. "When the king is wearing this heavy beaded costume, he does not shake or blink but stays still and unmoving. As soon as he sits down on the throne he is not a human being but a god."[13] The Bead Festival (*Ugie Ivie*) was established by Oba Esigie in the sixteenth century to commemorate the struggle between himself and his brother Aruanran for the royal beads. During the ceremony, all of the king's beads, as well as those of his wives and the dignitaries, had to be laid on the palace altar honoring Oba Ewuare.[14] According to tradition, Ewuare stole the first beads of the Benin kings from the god of water, Olokun, thus creating the foundation for the palace of the Oba, the king of the earth. The beads also had to be regularly infused with new strength, that is to say, with sacrificial blood—at first from humans and later from animals. In this way the beads became an essential component of the king's mystical powers. Van Nyendael mentions the festival in his account without, however, recognizing its significance.[15]

Other important festivals in the palace district serve the purpose of purifying the earth and, thus, ensuring a good harvest or promoting the fertility of the kingdom by fending off evil spirits that could cause miscarriages. The most important of these festivals, though, as mentioned above, are the Ugie Erha Oba, dedicated to the deceased Obas, and the Igue, which ensures the renewal of the king's mystical powers. Both were celebrated by Oba Ewuare for the first time in the fifteenth century. The Ugie Erha Oba honoring the royal ancestors emphasizes, above all, mystical superiority. Before his father's altar, the Oba accepts homage from the individual chiefs. He renews their titles and gives them a few presents, such as palm wine and kola nuts; their acceptance means recognition of the political power structure and his autocratic rule. A dignitary's absence from this ritual means that he no longer acknowledges the Oba as the highest authority. Many sacrifices are needed in the course of a festival to dispel evil forces and, most importantly, to ensure the benev-

olence of the king's deceased father for the prosperity of the new Oba and the entire land. Unlike the Ugie Erha Oba, the Igue is primarily concerned with the living Oba and the renewal of his spiritual powers. Magical substances from the forest are applied to the king's body, and animals believed to have special powers are sacrificed to the king's head, the center of his wisdom, in order to strengthen his vitality and, thus, guarantee for his people and for his land a fruitful year.[16]

The Queen Mother

Among the many dignitaries at the court of Benin, the Queen Mother (*Iyoba*) has a unique position. Dapper is the first to mention her: "The prince honors his mother exceptionally, he undertakes nothing of importance without having sought her counsel. However, I do not know by what law they are not allowed to be seen. Therefore, the Queen Mother lives in a beautiful house outside the city, where she is served by a large number of women and girls."[17]

Traditional accounts tell us that Idia, the mother of Esigie, successor to the throne in the early sixteenth century, played an important role in her son's struggle with his brother Aruanran for the throne by helping him with her magical powers. She further helped him in his war against the Ata of Idah, the ruler of the Igala to the northeast of the kingdom. Approximately three years after her son's accession to the throne, she was given the title of Iyoba and her own palace in the nearby village of Uselu, located to the north of Benin City. According to traditional accounts, in earlier times the mother of a ruler had to be killed after her son's selection "so that she could not start a revolution against the new Oba or use her magical powers against the people."[18] She had the same rights and privileges as a Town Chief; various villages were required to pay tribute to her and to contribute to the maintenance of her palace grounds and the cultivation of her fields. In her own domain she decided over life and death. She could even safely grant asylum; Spanish missionaries, who, by violently attacking the king's sacrifice of humans in the palace district, had maneuvered themselves into a difficult position, were able to leave Benin with her assistance.[19] Although it was forbidden for the Queen Mother to see her son, uninterrupted contact with him was maintained through messengers. After her death she received her own altar furnished with a commemorative sculpture of her head. A special symbol of her rank was the tall cap made out of strings of coral and beads that covered her coiffure and was known as a "chicken's beak."[20] In later times the headpiece became additionally adorned with thorny rosettes made of beads, long strings of beads, and large, cylindrically shaped coral beads.[21]

From the eighteenth and nineteenth century on, one finds square and cylindrical altarpieces with representations of the Queen Mother accompanied by high dignitaries, musicians, and female attendants. Especially striking were the decorative garments of the Queen Mother (fig. 20), which were only worn at

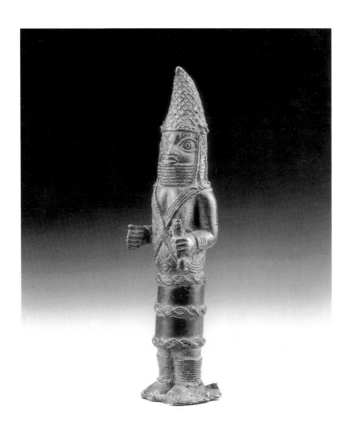

20 *Queen Mother.*
Late 18th century.
Brass. (Cat. 8)

special ceremonies or festivals. They are a clear indication of the specific role of this woman in the life of her son. Being the one woman of many chosen to bear the future king, she was believed to possess the necessary magical powers that would later be placed at the disposal of her son, so that he might conquer all rivals to the throne. After his accession, the Queen Mother would aid him in other matters, as had the prototype of all Queen Mothers, Idia, the mother of Oba Esigie.[22]

The king also held an annual commemorative ceremony honoring the Queen Mother at her altar, during which a sacrifice was made to her. The ceremony, however, was of a purely private nature.[23]

The Palace Associations

Although the kings appeared to be absolute rulers standing at the head of an administrative hierarchy, they were usually to a greater or lesser degree dependent on their advisors and on the various associations of the chiefs. Individual groups such as the Palace Chiefs (Eghaevbo n'Ogbe) and the Town Chiefs (Eghaevbo n'Ore) played a major role in governmental business.

At the beginning of the second dynasty the *Uzama n'Ihinron* constituted the most powerful group. The larger villages and important regions of the kingdom were ruled by the *Enigie*, whose titles were hereditary and were acquired through blood relations or family connections with the monarch derived through marriage. Their administration, however, was in the

service of Benin. Each of these regions had an individual in Benin who was responsible for ensuring the payment of tribute to the king. Less important areas were administered by village elders (*Edionwere*), whose titles could not be passed on to their heirs.[24]

Although the positions were hereditary, the king retained for himself the right to confer the title on each individual Uzama, who, before he could assume his office, had to go through a sort of apprenticeship at the royal court. The Uzama were officially installed in their office by the king at the royal palace, who thus gave them power to decide over the life and death of their subjects. The presentation of a ceremonial sword (*eben*; fig. 21) marked the close of the ceremony. The king only rarely conferred hereditary titles so that he always retained the possibility of filling various offices with people of his choice. He could not, however, take back an office once it had been awarded or privileges had been granted. By marrying the numerous daughters of local dignitaries, the kings succeeded in winning over the loyalty of these dignitaries to the throne.[25]

Led by the *Oliha*,[26] the seven Uzama were regarded as the successors of the ancient Benin dignitaries of the Ogiso dynasty, who in their search for a new ruler had turned to the king of Ife. As "guardians of tradition," they had an important position within the kingdom, especially at the coronation of the new king, who received the crown from the hands of the senior Uzama, the Oliha.[27] One of their seven members was the Edaiken, the crown prince. With the exception of that of the Edaiken, their titles were passed on to their eldest sons. Apart from one member, the *Oloton*, they lived outside the inner walls of Benin City. The title "King Makers" does not mean that they chose the new successor to the throne, but rather that they prepared the ceremonial framework for the coronation. It was also their duty to guard the most important entrances to the city and to collect certain taxes. In addition, individual Uzama chiefs had other specific tasks. The Oliha, for example, who conducted the crowning of the king, was also the priest of the Uzama ancestral altar. The Ezomo, one of the two supreme military commanders, possessed great authority and from the eighteenth century on was the most powerful man after the king. With the increasing influence of the Town and Palace Chiefs over time, the power of the Uzama declined, and they concentrated more and more on important ceremonial tasks.

The Town Chiefs had important functions in the administration of the entire territory of the state; they were responsible for tax collection, served as intermediaries between the court and the villages, and recruited warriors in times of war. Created by King Ewuare, they were apparently intended to be more than a counterweight to the Uzama. They formed a hierarchical class of feudal lords, led by military commanders. Socially inferior relatives and offspring of the Oba also belonged to this group. The term Eghaevbo means "dividers of the land" and refers to their function as liege lords. Only one title, that of the second supreme commander, the Iyase, could be inherited; other titles were acquired only through special qualities, usually wealth.[28]

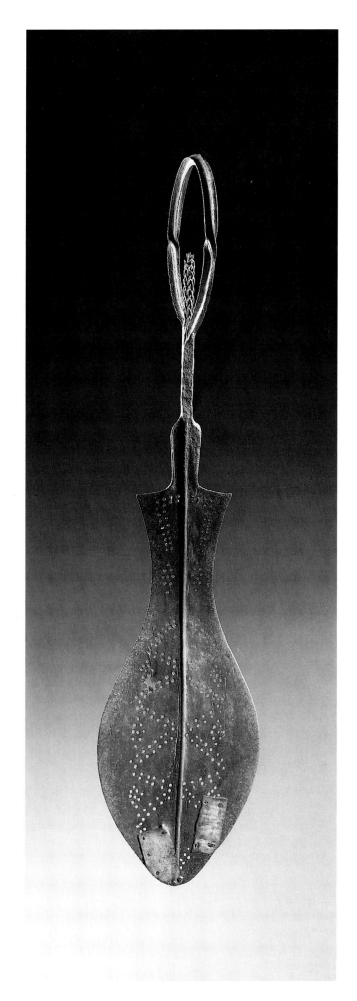

Aside from the Iyase, some of them held important positions within the army and thus had the opportunity to obtain war booty to enhance their own personal wealth. Not being allowed to reside in the palace district, they instead lived on the opposite side of the broad main road that cut the city in two.

This measure probably arose in part from the Oba's distrust of the powerful military commander, the Iyase, who often clashed with him and even staged a revolt. The Palace Chiefs consisted of a hierarchy with three groups at the top. The Court Chamberlains (Iwebo) were responsible for the royal insignia, throne, jewelry, and clothing of the king. Some chiefs of this group acted as mediators in disagreements within the palace district. Two of them, the Eribo and the Uwangue, were appointed by the king to conduct commercial dealings with the Europeans. Another chief, the *Ihaza*, had ritual functions, representing the Oba at festivals in order to keep evil spirits away from him, and even following him to the grave.

The second association of Palace Chiefs was the *Iweguae*. Led by the *Esere*, they fulfilled the personal needs of the king, such as managing his household and directing servants, pages (sword bearers), cooks, and cleaning personnel. They also oversaw the storage rooms where tribute, paid in the form of food, was stockpiled. The private rooms of the king were in the section of the palace reserved for the Iweguae. The third association of Palace Chiefs, the *Ibiwe*, was led by the *Ineh*. They had the task of ensuring the welfare and discipline of the Oba's wives, slaves, and children. The royal harem also came under their domain. Several members of this association were said to have come from the maternal side of the king's family.[29]

In addition to these three main associations of royal society, there were also a few subordinate ones. The *Efa*, for example, were responsible for carrying out sacrifices to the earth and for ritually cleansing the palace. The important brasscasters' guilds (with the *Ineh n'Igun Eronmwon* as their highest dignitary), the various groups of blacksmiths, woodcarvers, heralds, doctors and seers, leatherworkers, public executioners and the *Iwaranmwen*, who carried out annual sacrifices, all belonged to their respective groups. The court chroniclers (*Ihogbe*), thought to have come to Benin with the first Ife prince, formed a special palace association. It was their task to remember and pass on the names of the kings and to possess detailed knowledge about the kingdom.

With the exception of a few artisan guilds, like the leatherworkers who were not bound to the court, all these associations lived in their own quarters, grouped around the palace. Although membership in one of these associations was usually hereditary, every member had to go through several steps, each requiring the payment of a fee, participate in special initiation ceremonies, and, finally, obtain the Oba's blessing, before achieving his final position. By continually partaking in the Oba's life, the influence of these members on state affairs was significant. Despite not having their own fiefs, they served as the representatives of the Oba in villages directly under his control.[30]

22　Bini bronze caster modelling wax over clay core, Benin City, Nigeria, 1971. Photograph by Eliot Elisofon,
National Museum of African Art, Eliot Elisofon Photographic Archives, Smithsonian Institution

The Art of Brasscasting

Metal Technology and Trade

The most renowned examples of Benin art are the extraordinary cast sculptures of brass and bronze, which metals will here be referred to collectively as "brass."[1] Even in 1897 after the capture of Benin City, when its numerous objects of art inspired widespread astonishment and wonder, many questions were asked. After all, nowhere else in all of sub-Sahara Africa could any parallels be found. At first Europeans were unwilling to believe that works of such high quality as the Benin brass castings were the products of West African peoples. Thus attempts were soon made to dismiss Benin brass art as being of Portuguese or Portuguese-Indian origin. When in 1910 Leo Frobenius found some artfully worked heads—one cast in brass, and the others in terra-cotta—approximately twelve miles northwest of Benin City, it was hypothesized that their origins could be traced to the antiquity of the Mediterranean region.[2] Although he certainly did not think it was "a 'new' Negro art introduced by Portuguese seamen," Frobenius also did not, on the other hand, believe it to be a kind of "high Negro art native to the region." On the contrary, he regarded it as a "style in Negro lands which in the course of centuries and millennia had degenerated from art into artistic skillfulness."[3]

The skills needed for metal casting were well known in the Old World, and the area where brasscasting was practiced stretched in Africa from Senegal on the Atlantic coast to Lake Chad on Nigeria's northeastern border. In Mauritania copper had been processed since 500 B.C., and unfinished brass had reached West Africa from the Mediterranean countries via trans-Saharan routes by the eleventh century. At Igbo Ukwu, in Eastern Nigeria, brass objects have been found dating to the ninth and tenth centuries. Brass has a long tradition in West Africa, being used from Mali to the coast of Guinea and from Liberia to the Lower Congo; more than one thousand years ago it began to be used in limited areas as court art. The method of lost-wax casting was introduced primarily for use with copper alloys and was rarely used to produce gold objects. The required metals of tin, zinc, and, above all, copper were rare; this subsequently led to a dependence on trans-Saharan trade. This is likely the way that casting based on the lost-wax technique was introduced. Even if Arabs from the Mediterranean region brought the technology for brasscasting to Mali and Upper Guinea, the art created with this know-how was indigenous and, as in the case of Benin, probably the product of a long artistic tradition.

The production method of lost-wax casting means that each mold can be used only once, since it is necessary to break the mold to obtain the casting. Brass alloys (copper and zinc) and those of bronze (copper and tin) are the metals most often used in Benin castings. Because of its viscosity, pure copper makes up only 75 to 90 percent of the alloy used in casting objects. The lost-wax technique basically requires three materials: a metal alloy, very pure beeswax for forming the model, and clay mixed with diverse organic substances, such as goat's hair or chaff, for the mold. By heating and turning it in fire, the clay mold becomes porous, which allows gases released during the casting process to escape and thus, hopefully, prevents cracks or flaws from forming in the metal alloy.

The model is made either completely out of wax or, for hollow castings, of a thin layer of wax surrounding a clay core. The solidified wax figure is then covered with a thick coating of clay applied in layers; the first layer is usually a thin-bodied paste of finely pulverized clay and charcoal powder that vaporizes when the mold is heated and in this way prevents the formation of small air bubbles. Each layer is allowed to dry in the shade for several days before the next one is applied. Wax rods projecting from the model melt when heated, thus forming drainage channels (sprues) in the mold. Once the mold is dry, it is heated, so that the wax melts and flows out through the sprues. With small objects chunks of the metal to be used are placed in a hemispherical clay bowl that is cemented to the sprue after the wax has flowed out. The entire assemblage is then placed over a fire until the metal has melted. Then the mold is turned over with long iron poles, and the molten metal runs into its hollow interior. When the mold has cooled, the clay jacket is carefully broken so that the casting can be treated further. The joining together of the melting pot and the clay mold is supposed to ensure a predominately even temperature in the mold and metal so that cracks do not appear in the clay.

Larger castings cannot be poured in this way, however, as the mold and casting would be too heavy. For this reason the mold is firmly anchored in the ground and the liquid metal is

poured from above into the sprues—a method requiring great mastery of casting techniques.

Without question, brass existed in Benin before the arrival of the Portuguese. The metals used in the production of Ife brass objects apparently came from Azlik (Ades region), a royal source of copper.[4] It can be assumed that the raw material for Benin brass objects also came from the same region. The copper mentioned in an account of Ibn Battuta (1353) was mined in Takedda, in the southern Middle Sahara, and exported to Gobir and Bornu; copper may also have reached Benin in this way, since Edo contacts with these regions have been verified.[5] It is also quite possible that the metal came to the region south of the Niger via trade within sub-Saharan Africa or from the trans-Saharan trade. The existence of commercial relations between Hausa towns and Nupe is known, and goods may have been brought to Benin along these routes to the north and north-west.[6] European copper, too, is said to have come across North Africa to Mali by the twelfth century.[7] The Niari Basin in the northern region of Lower Zaire is sometimes mentioned as a supplier of copper,[8] but such a distant northwest connection in pre-European times is considered rather unlikely. Aside from those in Takkeda, deposits in Dikra (present-day Nioro), in Mali, are the only other sources in the southern Saharan region that might come into question as suppliers of copper to Benin. Owing to commercial contacts with Europeans on the coast of Guinea, trade by land, which was always marred by a degree of uncertainty with regard to quantity, quality, and other matters, was abandoned. The Portuguese recognized early on the importance of the European production of metal for African markets. Huge amounts of copper, bronze, and, in particular, brass products were already being exported to the peripheral areas of the Gulf of Guinea by the fifteenth century.[9] At the beginning of the sixteenth century enormous quantities of brass bangles, or *manillas*, were being exported directly to Africa by sea.

Many copper and brass products, such as kettles, bowls, and basins, went not only to Elmina, in present-day Ghana, but also to Benin. In Portuguese archives from 1510 one can read about 16,000 *manillas de latam* (brass bangles) in a single shipment "for the slave and pepper trade on the rivers of the named island [São Tomé]."[10] Pacheco Pereira reported in 1505 that for twelve to fifteen, or even eight to ten, *manillas* one could get a slave; an elephant tusk could be bought for only one *manilla*.[11] This price would soon rise to fifty. During the early sixteenth century, the Edo showed increasing interest in purchasing metals like copper, bronze objects, *manillas*, and metal chains for melting down and recasting.[12]

In contrast, European objects of copper were unsuitable for casting and consequently not used as raw material for brass and bronze.[13] Although the lead used in the metal alloys of the *manillas* and of the many cast Benin objects was probably from the same source, the conclusion cannot be drawn that all *manillas* were melted down for casting.[14] Some undoubtedly were, while others were probably used for trading within West Africa. In the middle of the fifteenth century, the Portuguese obtained their

metal, mainly in the form of *manillas*, from Venice. But at the end of the century they bought from German commercial firms such as the Ravensburger Handelsgesellschaft, which regularly exported brass goods in the form of buttons, basins, bowls, and *manillas* to Lisbon, where they were stacked in magazines at the Casa da Mina for export to West Africa. In 1548 the Portuguese signed a contract with the trading house Fugger in Antwerp for the delivery of a "thousand cast brass bangles [*manillas de latam*], as well as ten thousand pans, pots and bowls of brass, to be delivered to Lisbon within three years." They were all intended for trade with West Africa.[15]

In approximately 1530, the Portuguese, according to some reports, had begun exporting *manillas* from the Congo to the Guinea Coast.[16] In the seventeenth century *manillas* came from Angola. Copper from Shaba (Katanga) that reached the coast by land was processed in Luanda. Crude copper alloys in the form of jewelry, metal containers, and so on, might have already reached Benin through trade within Africa. Aside from the earliest period, Europeans on the Atlantic coast of West Africa traded large amounts of materials containing zinc for slaves, ivory, and gold. Among the items traded, metal basins and other containers, as well as rings of brass or bronze, were much in demand. Despite the abundance of tin in Nigeria, relatively little was used there. It is occasionally mentioned in connection with early European imports. Knowledge about lead can also be traced to contacts with the Arabian or European world.[17]

Most Benin castings are made of alloys of brass and lead containing differing proportions of zinc, copper, and tin with traces of nickel, arsenic, antimony, and bismuth. Lead has the advantage of making the alloy very fluid when heated while, at the same time, softening brass so that it becomes more elastic. The disadvantage, however, is that the resulting casting becomes brittle, leading in turn to many cracks—especially in the plaques—thus explaining why there are so few intact pieces. Metallurgical analyses of two Benin heads in the collection of

the Museum für Völkerkunde revealed that the brass alloys consisted primarily of the elements copper and zinc. In contrast to some other heads, both of these show only small traces of antimony. The conclusion can be drawn from the analyses that "both alloys were cast at high temperatures in a highly fluid state and then rapidly cooled."[18] The composition of the two heads analyzed ranged from 75.3 to 77.7 percent Cu, 19.3 to 21.7 percent Zn, 1.85 to 1.93 percent Pb, and 0.76 to 0.93 percent Sn.

The few items consisting of copper alloys from Benin dating from the thirteenth and fourteenth centuries are smaller objects that were not cast, but forged. Thus it is likely that they represent an early stage of metal technology in Benin.[19]

Brasscasters held a unique position among the artisans of Benin. They were a royal guild, since they were directly under the king's control and their workshops were inside the palace grounds. Within their group were subgroups of different origins that were founded at different times. The oldest line appears to have come from Ife. According to one tradition, the brasscasters came every year to Benin to offer the king their services until Oba Oguola was finally able to convince them to stay and granted their leader, Igueghae, the title of Ineh n'Igun. Another oral tradition holds that they were indigenous to Benin and already active during the Ogiso period.[20] One of their main tasks was to portray the glory and power of the court in their works. Even today there is no way of determining whether an individual piece was the creation of a single master or of several workers. A sort of title of nobility was granted to those who especially distinguished themselves through their work.[21]

The foundation of the brasscasters' guild is closely related to the beginning of brasscasting in Benin. One local tradition again mentions in this context Oba Oguola, who requested from the Oni (ruler) of Ife that he send the master caster Igueghae to Benin to teach the Edo brasscasting.[22] Igueghae is viewed as the founder of the association of Benin casters and was elevated to the realm of the sacred. He enjoyed the respect of the dignitaries and members of the association. Joined by fellow guild members, the Ineh, the hereditary head of the association, made a sacrifice to Igueghae once a year on the day of the memorial service for his father. On the shrine were a row of terra-cotta heads that were said to have been brought by Igueghae from Ife as models for his lessons. Individual researchers do not agree on a date for the beginning of brasscasting or for the reign of Oguola. Although some believe that the time around the year 1290 is likely, others are more inclined to date it one hundred years later.[23]

The most important patron and customer for brass sculpture was the ruler of Benin.[24] The monopolization of brass placed it, together with ivory, at the top of the scale of valuable materials. With some exceptions, castings were, and remained into the twentieth century, destined for the Oba and his closest relatives. In the beginning, they were made primarily for the cult of the royal ancestors. In the course of time, due to increasing imports of metal, production slowly expanded to include several other items that, strictly speaking, were no longer cult objects:

for example, accessories used by dignitaries in ritual ceremonies at court or by those attempting to gain royal privileges for themselves. Only smaller brass objects, such as jewelry, were somewhat more common, but even these were limited to court personnel. In general, the use of brass (or bronze) was limited to individuals of the highest social class and fulfilled special ceremonial needs.[25] The actual artistic products of the casters—the heads, plaques, figures, and altars to the hand—were demonstrations of the power and wealth of the court, as well as embodiments of the stability of the ruling order. As such, they do not aim primarily to depict the individual traits of the persons portrayed. On the contrary, emphasis is placed on identifying these individuals through the objects they carry, their clothing and accessories, their hairstyles and headpieces, their scarification, and their bearing. The motifs and themes of court art found on carved tusks and brass plaque reliefs are "not detailed narratives, but rather statements reduced to key words or sometimes even to pictographs."[26]

Chronological Development

As has already been seen in other areas, while the origin and dating of the beginning of brasscasting is rooted in mythology, it is not without historical reference. Once again, it is true that "the Benin people relate such events as wars and conquests, the founding of social and political institutions, the creation of titles and titlegroups, the planning of Benin City, the progess of ritual and occupational specialization, developments in bronzecasting, and the introduction of new cults to the reigns of specific Obas."[27] Placing these events within a reconstructed dynastic genealogy allows, at best, a coherent outline of the great periods in the history of Benin. "More than this cannot be expected," adds Bradbury, one of the most knowledgeable authorities on the history of Benin, with composure.[28]

Another common oral tradition refers not only to the spiritual links with Ife, but also to how the technology of brasscasting was brought to Benin from there. The Oba of Benin sent envoys to a ruler, the Ogane, who was both priest and king—to inform him of the death of his predecessor and to request that his office might be conferred upon him. The envoys were given a staff, a head decoration in the form of a Spanish helmet, and a pectoral cross for the new Oba. After their arrival in 1485, the Portuguese suspected that this ruler, "who was held in such great respect by the heathen princes in the region of Benin, as we respect the pope,"[29] was the legendary Prester John, who was believed to have resided somewhere in the East. A direct connection was later perceived between this Ogane and the Oni of Ife, the spiritual head of the Yoruba.

The first attempts at constructing a chronology of the art of brasscasting in Benin were based on formal differences observed in a number of Benin heads. For a long time it was assumed that Benin court art was the degenerative and decadent product of ancient Ife influences. According to this view, Ife naturalism

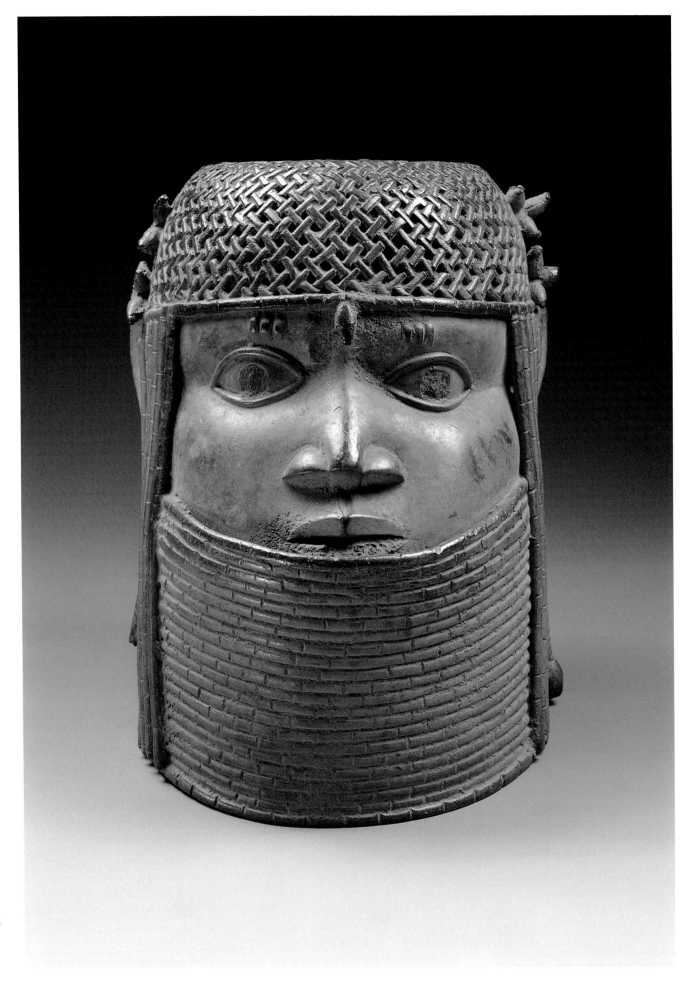

24–26 *Head of an Oba*. Late 16th/ early 17th century. Brass. (Cat. 22)

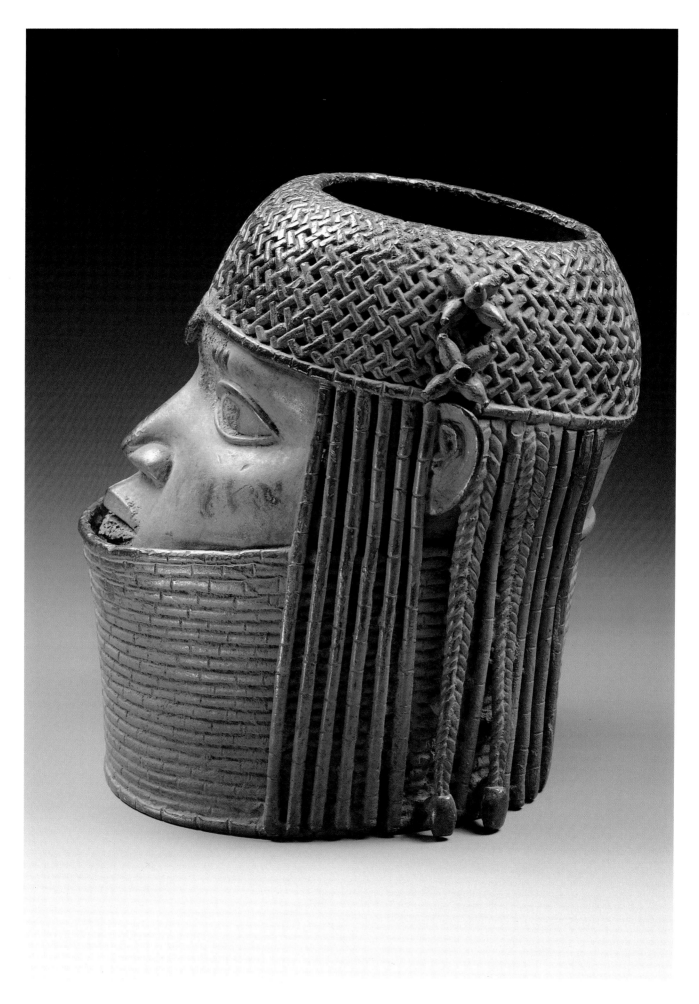

survived for only a short time.[30] William Fagg states that court art can be divided into three periods.[31] The earliest, thin-walled castings reveal stylistic similarities with the brass objects of ancient Ife. Research based on oral tradition dates this type to about 1500.[32] In the middle period—probably in the seventeenth and early eighteenth centuries—artistic standards departed from the direct influence of ancient Ife. Sculpture became increasingly schematic, while it lost its earlier subtleness. Instead, it attained a high degree of expressiveness and independence which departed from earlier influences. This is the classic period of Benin court art. A growing emphasis on details at the expense of delicate form is characteristic of the third period, which may have begun about the mid eighteenth century. Aside from a few outstanding masterpieces, a general political and cultural decline in the nineteenth century resulted in a corresponding deterioration of the arts.

Based on this chronology, the two Benin court dwarfs in the Museum für Völkerkunde are probably products of the earlier periods, from which there are hardly any other examples of sculptured figures. "But the two magnificent figures of achondroplastic dwarfs in the Vienna Museum, representing royal jesters, are as naturalistic (especially in one case) as any Ife works and should probably be placed in this period."[33]

Another British scholar, Philip Dark, expands on Fagg's method for establishing the chronology of the heads. He divides them into five types.[34] The first two types are noticeably smaller than later heads, are thin-walled, and have relatively naturalistic facial features (early fifteenth to mid sixteenth century). The full face can be seen in type one. The collar made of coral bead strands closely hugs the neck and throat and does not go over the chin. The latticework bead head covering is missing. The hair is styled in layered rows of short ringlets.

Rolled-down collars are characteristic for type two (first half of the sixteenth century). Type three heads (late sixteenth to mid eighteenth century) are larger and heavier, with high collars of coral beads ending just below the mouth (figs. 24–26). The beaded latticework net on the head is decorated additionally with rose-shaped clusters of beads and single, cylinder-shaped coral; long strands hang from the head over the temples and parts of the neck. The "swollen" cheeks and large eyes are particularly striking.

A protruding flange surrounding the lower section of the head is a common feature not only of type three but also of type four (mid eighteenth to early nineteenth century), as well as of type five heads (nineteenth to early twentieth century), which are substantially larger and heavier. This last type includes even more exaggerated facial features, as well as upright wings and slightly bent rods of beads that reach in front of the eye sockets. The upright wings were introduced during the rule of Oba Osemwede (ca. 1815–50).

Both classifications assume that the Ife influenced the Benin people on an artistic level, and that the art of Benin is characterized by a progressive decadence, from idealized naturalism to exaggerated idealization. More recent interpretations

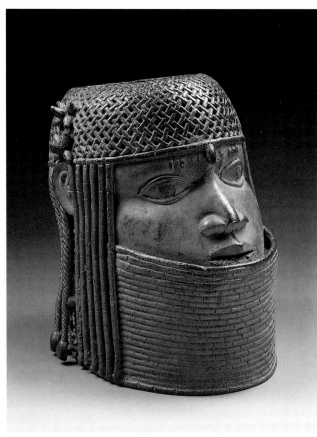

26

question the validity of these theories (see also p. 45). Paula Ben-Amos, for example, suggests that the heads traditionally identified as dating from the first period (type one) were not of Obas, but rather were trophy heads representing conquered military commanders. It follows, therefore, that they need not be linked either to a certain age in a chronology of Benin heads, or even that they must be considered when classifying the heads of Obas.

Some time before the British Punitive Expedition in 1897, the German businessman Erdmann photographed a tall iron staff with hooks, from which hung heads similar to those of type one. Contemporary scholars identify it as an Osun staff (Osun is the god of medicine).[35]

A different classification system allows the heads of Queen Mothers to be divided into those without flanges (type six, sixteenth century) and those with flanges (type seven, mid eighteenth to nineteenth century).[36] Here, too, the chronology is not always clear. The lack of written documentation in Benin makes it difficult to establish a sound chronology for the various works of art. Through utilizing techniques of modern technology to analyze the materials employed in Benin art, one may hope to date the works of art more accurately.[37]

The unmistakable Portuguese influence on Benin art can be seen most clearly in the rectangular plaques. Accordingly, relief plaques provide important clues for determining the chronology of Benin art. Sculptures in the round were often made before, during, or after the period of the plaques. Several reasons

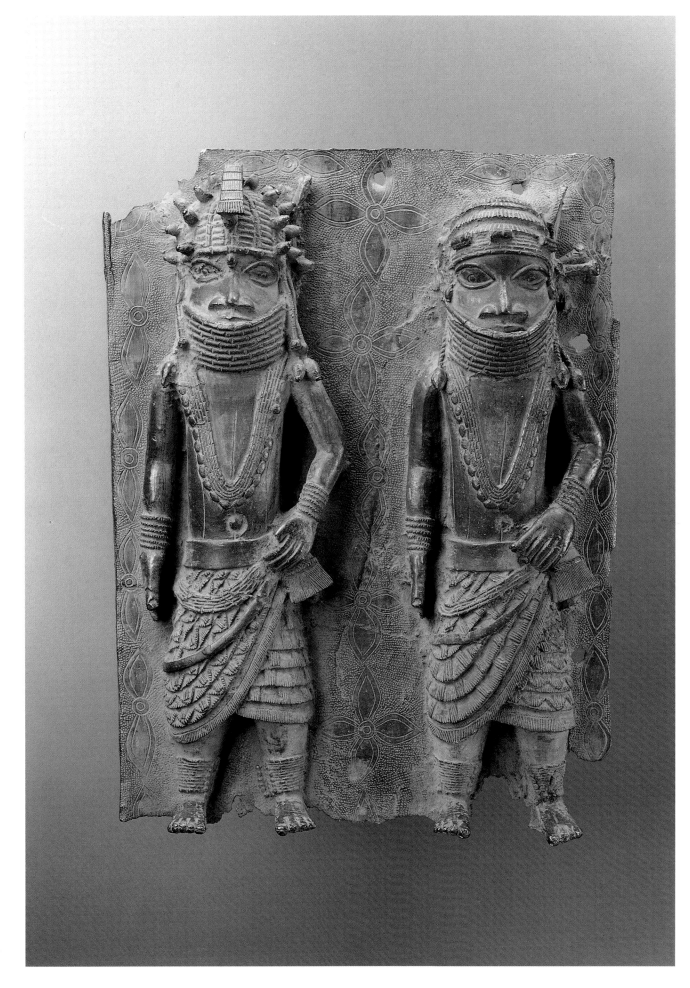

27 *Plaque with
Two Dignitaries.*
17th century. Brass.
(Cat. 36)

support using wall plaques to determine the chronology of Benin art. Accounts in European sources, such as Dapper, report on the existence of these plaques in the palace.[38] The representations of Europeans are a further aid, and historical events can occasionally also be ascribed to the reigns of specific Obas.

The beginning of the manufacture of plaques is also linked to a tradition that can hardly be confirmed.[39] A certain Ahammangiwa, who is said to have come to Benin with the "whites" (Portuguese) during the reign of Esigie, supposedly made brasscastings and plaques for the Obas, who assigned to him "plenty of boys as apprentices." Upon returning from a military campaign against the Igbo with their captured king and prisoners of war, Esigie's successor, Orhogbua, asked Ahammangiwa whether

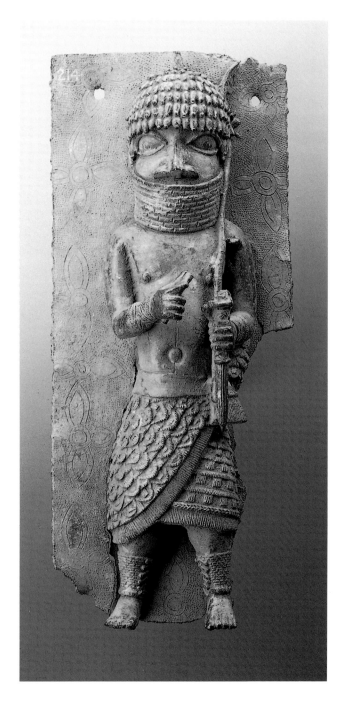

28 *Plaque with a Dignitary Holding a Staff.* 17th century. Brass. (Cat. 35)

he could "create [images of] them in bronze." "We shall try," replied the latter. After the plaques were completed, "they nailed the representations on the walls of his house."

This narrative, related to Captain E. P. S. Roupell (an officer in the British Punitive Expedition) by inhabitants of Benin,[40] was the source of many interpretations ranging from cautious explanations[41] to the assumption that Ahammangiwa was a "light-skinned Hausa man"[42] or even a "German bronzecaster who, through the intervention of German brass manufacturers at the court of the Negro king Esigie, . . . was brought along by the Portuguese."[43]

To the present day, however, neither any documents supporting this tradition nor any personal references on plaques or other castings made by Ahammangiwa have been found. The question remains unanswered whether it is Esigie's and Orhogbua's war against the Igbo that is being commemorated here, or whether this tradition is more concerned with the origin of the lost-wax method or the manufacturing of plaques.

An examination of the weapons and Europeans depicted on these plaques places them in a period ranging from the mid sixteenth to the early eighteenth century. However, the Europeans may be viewed as an archetype for an approximate period of time, since the clothing is often either vague or false, indicating that later plaques may simply have been slightly altered copies of earlier representations of individuals. "The clothing and weapons of all these Europeans have without exception been distorted; such breeches were never worn in Europe. Nor did there exist doublets with buttons but without corresponding buttonholes, or such spears and swords," writes von Luschan.[44]

By another method of classification, plaques can be divided stylistically into three periods. Based on the composition of the reliefs, plaques of the first type appear to be two-dimensional. As a rule their embellishment is engraved sparingly. Figures wear neither low nor high collars; their clothing places them probably in the mid sixteenth century. Another type, described as three-dimensional, depicts figures with high collars and short lower legs and with some engraved details. They were presumably made about 1700. A third type can be placed between the two above-mentioned groups with regard to the three- and two-dimensional relation that exists between bas-reliefs and superficial decorations. The details on these plaques have been painstakingly engraved; however, the figures have collars that are not as high as those seen on three-dimensional plaques.[45]

It appears that the manufacturing of these plaques ceased by the beginning of the eighteenth century,[46] although this assumption cannot be proven conclusively . Some scholars are of the opinion that a shorter time frame ending by 1640 is more accurate, whereas others reject the view that the absence of plaques—as was the case when van Nyendael visited Benin in 1699—means they were no longer being produced and believe, in fact, that they were still being cast in the eighteenth century.[47] Many questions remain unanswered. If one accepts the tradition, barring new evidence, of brasscasting technology originating in Ife, then it is impossible to date its beginning.

29 *Bracelet with Pierced Strapwork.* 19th century. Brass. (Cat. 89)

30 *Bracelet with Pierced Strapwork.* 19th century. Brass. (Cat. 90)

Nonetheless, the assumption of a close relationship between the brass plaques of Benin and Ife art must remain purely speculative. Not even the most recent examinations of the earliest Benin heads—none of which, unfortunately, are in the possession of the Museum für Völkerkunde—confirm the standpoint of some scholars that they are closely related in style to brass heads discovered in Ife. Although both display an aston-ishing mastery of the technique of lost wax casting, the Ife heads are naturalistic and individual, whereas the Benin heads are stylized and abstract.[48] Furthermore, different alloys were used in the two cities. The discussion is continuing[49] and perhaps one day archaeological finds—together with physical examinations and other data—will allow one to construct a more exact picture of the rise and development of Benin art.

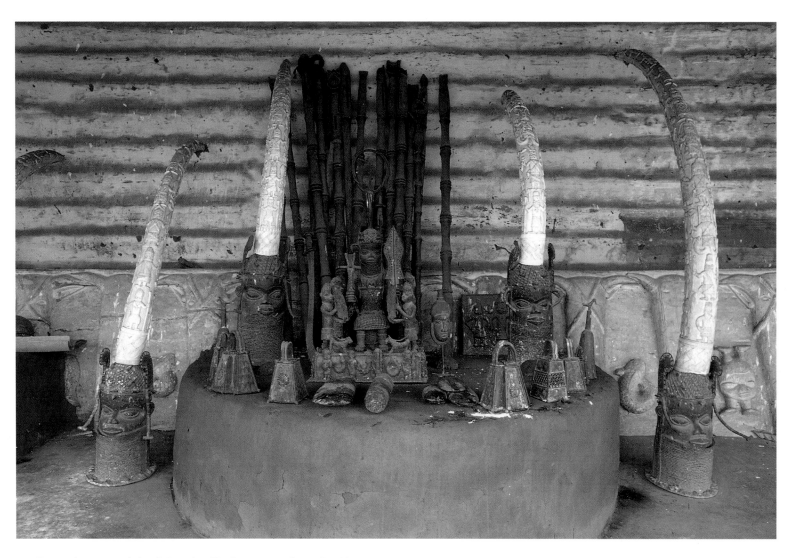

31　Benin palace ancestral altar dedicated to Oba Ovonramwen, Benin City, Nigeria, 1970.
Photograph by Eliot Elisofon, National Museum of African Art, Eliot Elisofon Photographic Archives, Smithsonian Institution

The Art of Benin and Its Symbolism

The Heads

The Benin heads are of central importance in both the religious and artistic sphere. It is thought that commemorative terra-cotta heads could be found on the ancestral altars of rulers in even the earliest period of the Ogiso dynasty.[1] While wood and terra-cotta heads could be seen on the ancestral altars of chiefs and brasscasters, cast heads of brass were reserved for the Obas, and it was a *conditio sine qua non* for the successor to the throne to erect an altar to the deceased Oba. By the first quarter of the nineteenth century, twenty-five to thirty such altars existed.

On these mud-dried shrines, as already noted by van Nyendael in 1699, were placed "eleven heads cast in copper, upon which sat decorated ivory teeth." These heads represented the deceased Oba. The Benin people believed that the head was the center of thought, judgment, hearing, sight, speech, and life. The head of the Oba took on particular significance and was believed to guarantee prosperity and health to the whole of society.[2]

In contrast to the portrait-like heads of the Ife, the heads of the Benin Obas were more abstract, impersonal faces denoting power and wealth. Although Benin heads originally were viewed as somewhat imitative of the Ife tradition of worshipping heads as part of the ancestor cult or as memorials for deceased royal ancestors,[3] a more recent theory by Ben-Amos, based primarily on oral tradition, hypothesizes that the heads traditionally identified as dating from the earliest period may have been war trophies and sacrificial objects and thus were not restricted to one historical period. In one tradition it was the custom in ancient Benin to decapitate captured kings and give their heads to the Oba, who then passed them on to his brasscasters' guild to make a casting. Not every captured warrior was privileged enough to have his head cast in brass, but only those who had offered the greatest resistance. When the son of a rebellious ruler ascended the throne, the Oba sent him a casting of his father's head to remind him of his parent's fate. In earlier times these heads were kept on the ancestral altar of the nation of Benin.[4] Fagg suggests that the naturalistic traits of the first period of Benin art (ca. 1500) indicate a relationship with Ife brasscasting, although those of the Benin people are more styl-

ized and, thus, less personal.[5] Instead they are probably expressions of an idealized concept. The artist focused his interest on the head rather than on insignia of rank or ornamentation.

The heads of fallen warriors whose images were cast in brass appear to have symbolized an even greater power of the Oba as well as to have served as perfect and lasting sacrifices. The coiffures on these heads can still be seen today among the Edo's neighbors.[6] The scarification of the forehead is thought to have signified a foreigner, which, in turn, supports the thesis that these trophies are testaments to an expanding royal dynasty. Accordingly, heads of this design would not have been limited to the early period mentioned by Fagg, but also still would have been cast as trophies in the middle or even in the late period.[7]

Changes in the form and style of Benin heads in the second, or middle period (mid sixteenth century to the end of the seventeenth century) appear to be related to a fundamental shift in the mentality and function of the ruler. The first stylistic period of heads is a reflection of the martial dynastic line. The following periods in which heads were produced with high coral collars, or later when they were manufactured without, or subsequently with protruding flanges, and from the nineteenth century on when vertical "wings" were attached to the sides, must be seen in conjunction with the appearance of the Europeans, the late consolidation of the monarchy, and the changing fate of the monarchy in later centuries. Consequently, throughout history, the brass heads of Benin may be viewed as war trophies, souvenirs, objects honoring ancestors, and as focal points of sacrificial ceremonies.[8]

The middle period is represented in the Museum für Völkerkunde by four heads that were part of royal ancestral altars in Benin. The oldest brass head in the Vienna Benin Collection (figs. 24–26, pp. 38–40) is a magnificent specimen and a perfect casting. The latticework bead crown, fitted much tighter than on the other heads, has two rosettes on each side, each rosette consisting of large, conical beads; in front of each ear hang six strands of beads, and behind each ear hang five more strands. Behind the right ear can be seen one braided plait, and behind the left, two. A conical bead hangs over the forehead, and there are three scarification marks above the eyes, which

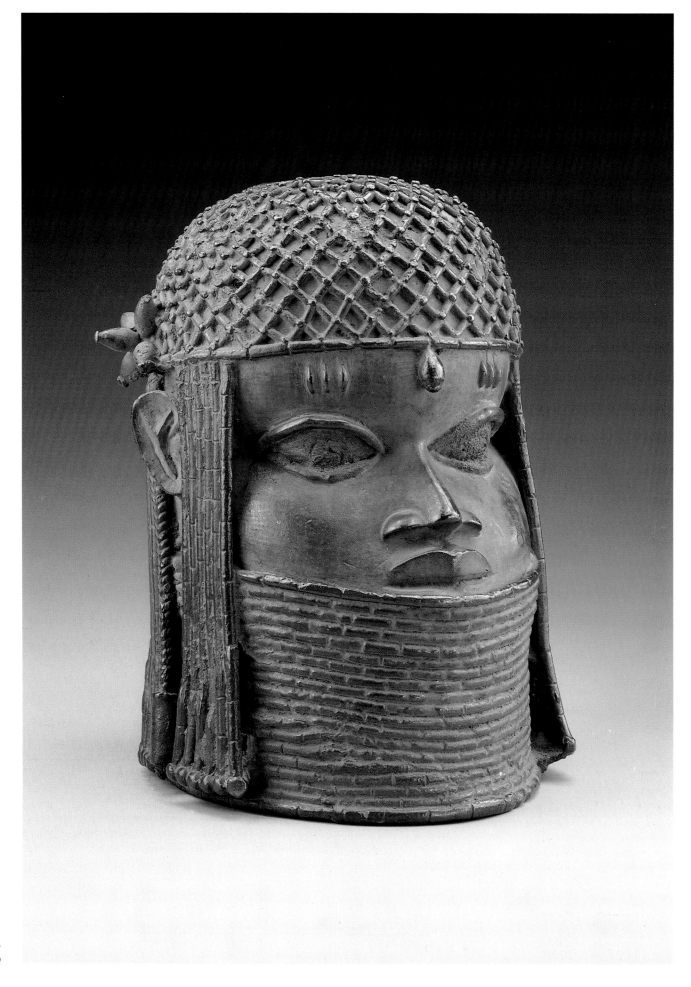

32, 33 *Head of an
Oba.* Late 16th cen-
tury. Brass. (Cat. 20)

46

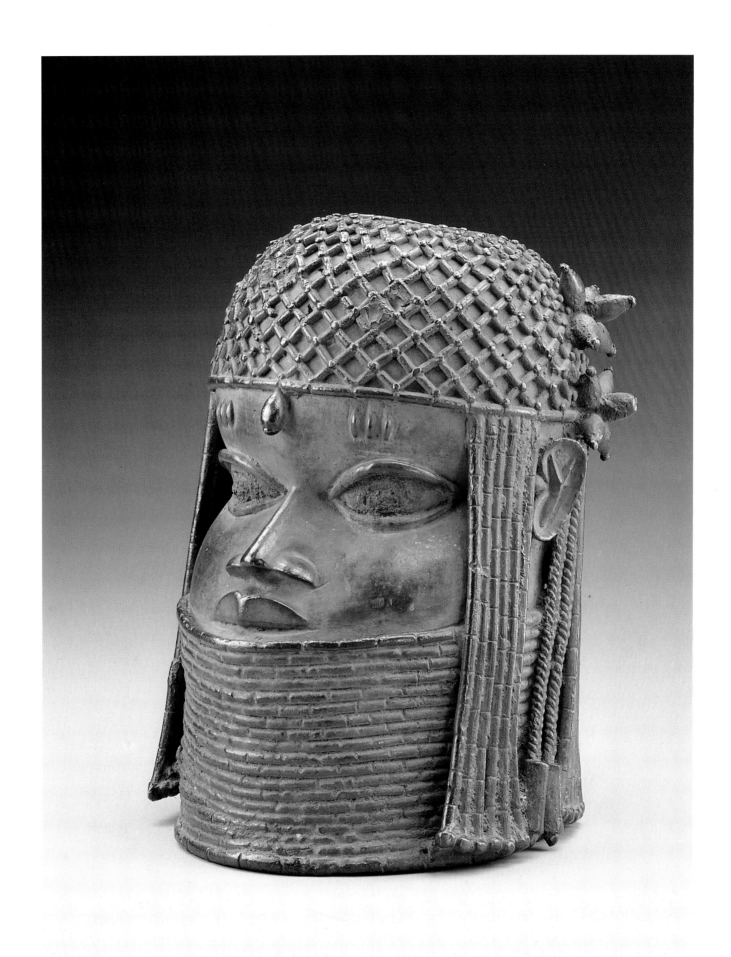

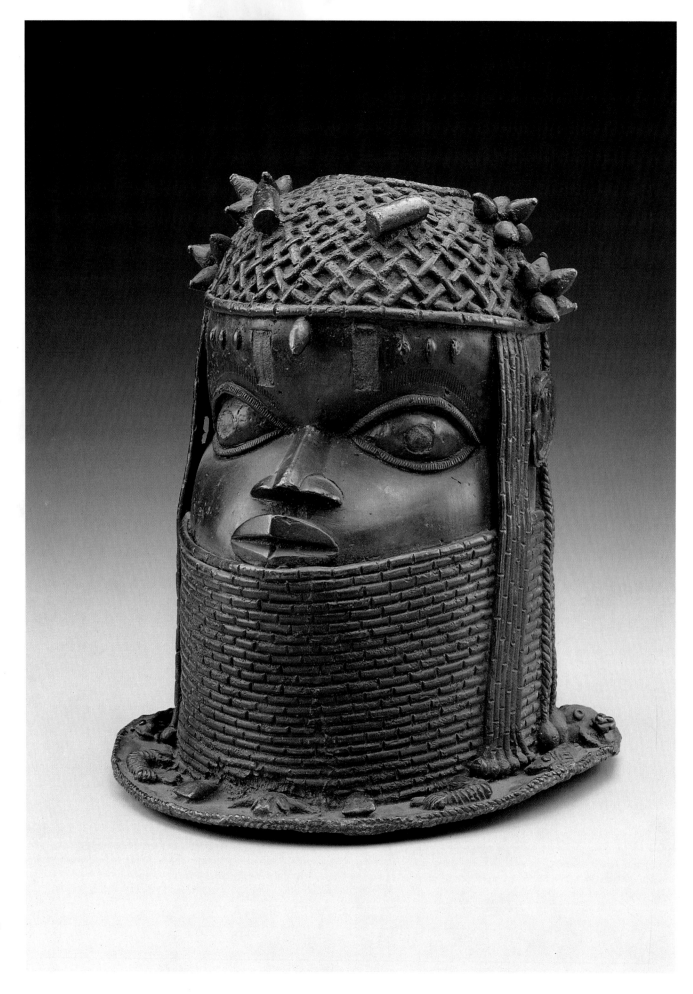

34, 35 *Head of an*
Oba (with Flange).
17th/18th century.
Brass. (Cat. 23)

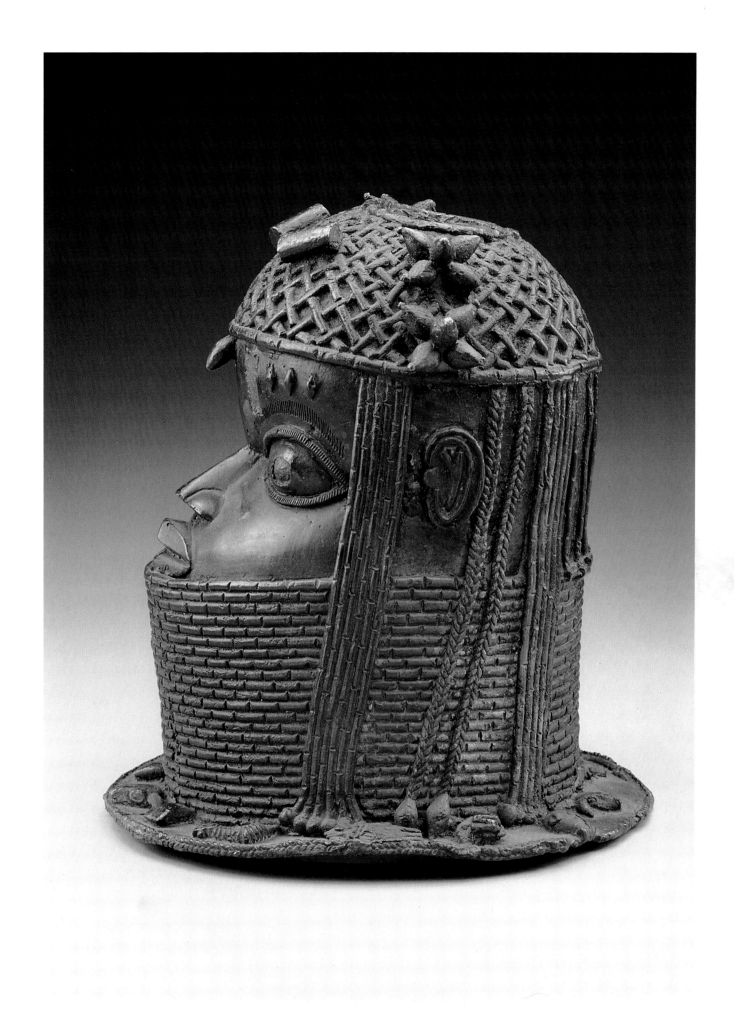

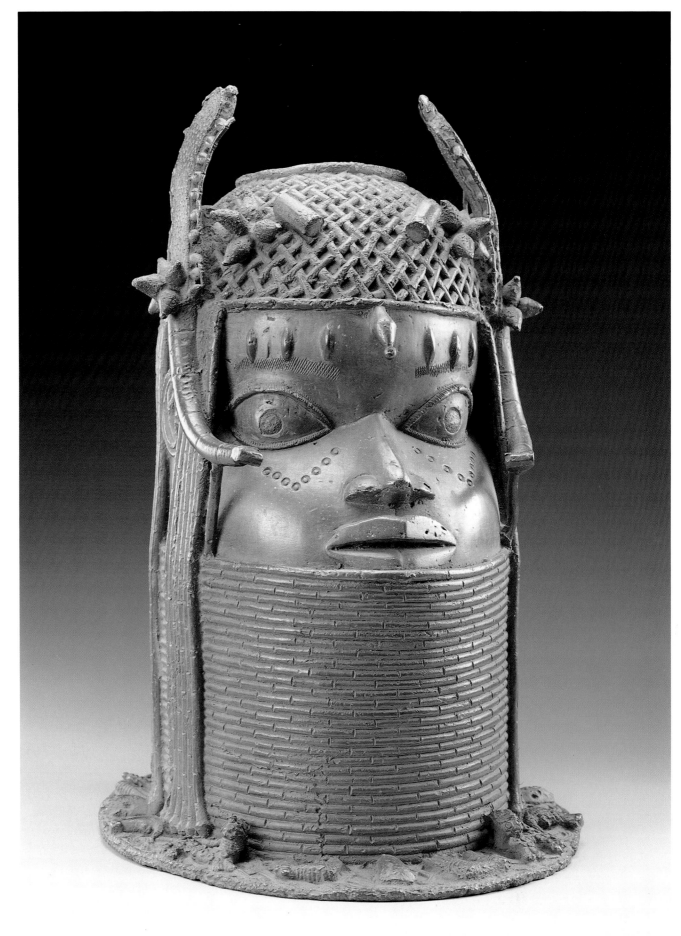

36 *Head of an Oba
(with Flange and
Wings)*. 19th cen-
tury. Brass.
(Cat. 26)

have pupils inlaid with iron.[9] All of these heads, which are covered with a thin reddish brown patina, bear typical insignia of the Oba: high collars of coral beads, flat beaded latticework caps adorned with rosettes, and large cylinder-shaped agate beads. Strands of beads ending in balls hang from the caps. On the forehead of another head (figs. 34, 35) are two parallel iron inlays for receiving sacrificial blood, which, when administered at regular intervals, was supposed to renew the power of the head. A small square segment of the face framed by the cap, bead collar, and strands of beads remains visible. Only the eyes, nose, upper lip, and part of the lower lip are uncovered. This was the period when the Portuguese first appeared. Coral beads, commemorating the first ones reported to have been stolen from the palace of the god of the waters, Olokun,[10] were viewed as national insignia of great mystical significance that were reserved for the Oba, the Queen Mother, and high officials. They, too, received new magical power each year through sacrificial blood.

The Oba's wealth grew dramatically through his monopolization of European trade. In addition, his victories over his enemies, achieved with the support of the Portuguese, greatly increased his prestige, both inside and outside of the kingdom. This historic fact was reflected in the design of brass heads whose function as enemy trophies was transformed into "a multifunctional complex of trophies and royal commemorative pieces."[11] It is also striking that elephant tusks were set into the heads of this period—a fact that is confirmed by the opening on the top of the heads. The presence of these precious ivory tusks, together with the vast quantities of coral beads, appears increasingly to symbolize the Oba's burgeoning wealth and authority. The heads of this time, characterized by the close relationship with Europe, and the elephant tusks might have been a kind of *axis mundi*, i. e., symbols of their link with the world of spirits, a focal point for the Oba to interpret the power of the ancestors to the world.[12]

In the late eighteenth and nineteenth centuries—a period corresponding to the heads of the third stylistic period—the political and military power of the Oba was undermined by a shift in trade to the Guinea coast and by rebellions of several powerful chiefs and palace associations within the kingdom. For these reasons the core of the Oba's power was increasingly transformed into a holy kingdom, with human sacrifices as part of the "cult of the head."[13]

The heads of this period (see figs. 36–39) are distinguished by even more opulent bead collars and pendants. On the protruding flange of one of them (fig. 36) can be seen no less than fifteen vivid symbols, including an elephant's trunk with a human hand, standing and reclining leopards, frogs, catfish, and "thunder stones"—all symbols of the ruler's supernatural power and authority. One can place these heads in the nineteenth century, when Oba Osemwede (ca. 1816–48) introduced royal headgear with standing "wings" on the sides.[14] Unlike earlier heads, these are larger, with stiff, highly stylized faces, embossed

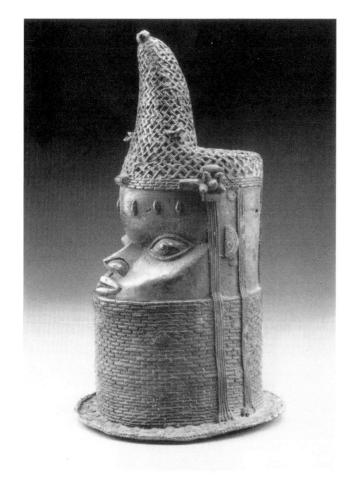

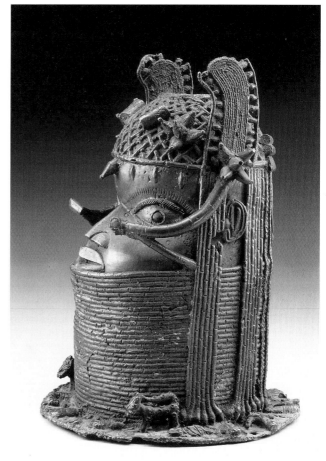

37 Head of a Queen Mother (with Flange). 19th century. Brass. (Cat. 28)

38 Head of an Oba (with Flange and Wings). 19th century. Brass. (Cat. 25)

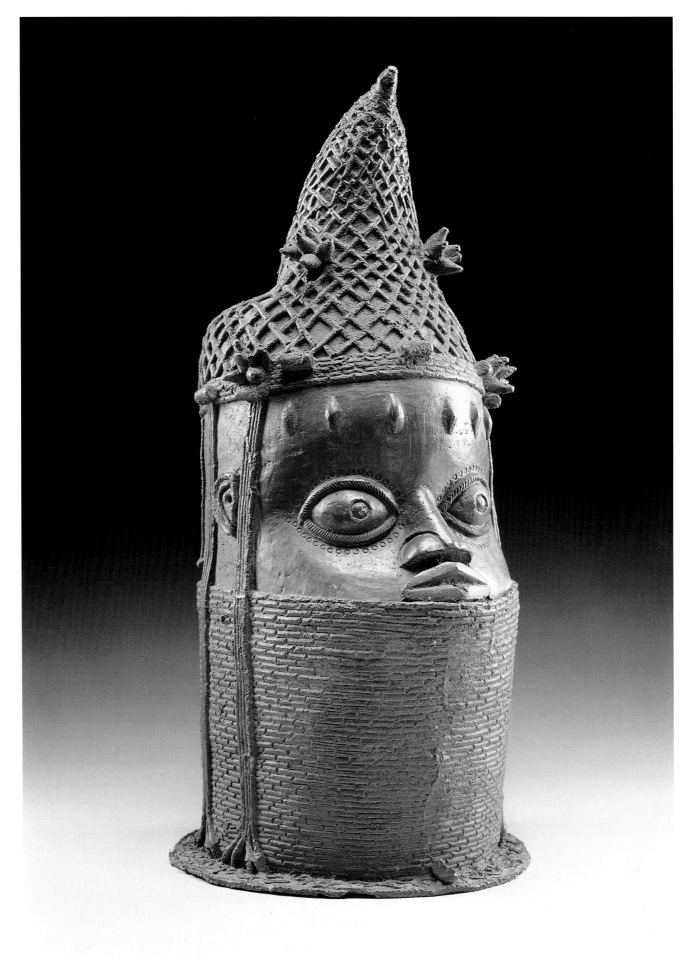

39 *Head of a*
Queen Mother
(with Flange).
19th century. Brass.
(Cat. 27)

circular eyelids and eyebrows, and decorative scars on the forehead. Fig. 37 does not have the iron pupils or inlays found on the forehead of fig. 34.

The two heads of Queen Mothers (figs. 37, 39) also date from the late period and, as is the case with earlier heads, wear pointed conical coverings. They are very richly decorated; the entire headdress is veiled in a net of stylized beads. Strands of beads hang from the rim of the cap to the flange. On fig. 39, the collar comprises no less than forty-four rows of beads. Even the back of the head has strands of beads hanging to the collar. All evidence points to the Queen Mother having still enjoyed tremendous prestige in the nineteenth century.

The Plaques

As with many other objects of Benin art, the brass plaques have been influenced by a wide variety of non-African sources. Their fundamental form is probably based on foreign models, such as the small illustrated books that may have been brought by the Portuguese. Even non-European motifs from India or the Islamic world must be considered. The themes of the plaques are concerned almost exclusively with life at court and related matters. While they complement oral literature, they rarely serve as an exact narration of historical events. In particular, the Benin objects from the Museum für Völkerkunde are largely static depictions of dignitaries, court officials, messengers, warriors, Europeans, musicians and other vassals of the king, and, finally, animals. The interpretation of individual plaques that have been removed from their original sites remains difficult. It is possible that some plaques could have been understood only when viewed in a certain sequence with others. The clothing of the figures, too, invariably gives unsatisfactory answers, as it is not always known when, and in which ceremonies, certain regalia were worn. Aside from certain court and ritual ceremonies requiring special costumes, for example, the Oba could freely choose what he wanted to wear.

Human Images

The dignitaries in the Vienna Benin Collection—with two exceptions (fig. 41 and one not illustrated)—are depicted with high, coral-bead collars. Their headdresses are covered with rows of coral beads, and coral bands encircle the ankles. Most of them wear the beads on their naked upper bodies, around their necks, or across their chests and shoulders. Their lower bodies are usually wrapped in cloth with a scale-like pattern—possibly imitating the bony plates of a pangolin—that is tucked in on the left side. Other designs include rosettes and the highly stylized heads of Europeans (figs. 41–43). These figures wear wrapped skirts; the knots are surmounted by leopard's heads. Most dignitaries carry large swords in their hands as symbols of their rank and power (figs. 40, 41). Rows of coral beads, one on top of the

other, encircle the ankles and wide bracelets encircle the wrists. Several dignitaries hold a thin wand or peeled branch in their right hand. It is called an *unwenrhiontan* (squirrel's whip), a medicine wand with the power to advise and guide its user while protecting him from any imminent danger.[15] The wealth of jewelry allows one to conclude that the depicted figures must have held high offices at court, or might even have been Obas performing rituals requiring the use of a magic wand.[16]

Two fully clothed figures (figs. 42, 43) are particularly opulent. The first (fig. 43) wears a basketlike headdress from which hang strands of beads, a large collar made out of rows of beads, and a necklace of leopard's teeth, which were believed to have protective powers. Over his stomach can be seen a highly stylized leopard's head; the garment wrapped around his lower body is embellished with leaf rosettes (quatrefoil leaves) and a highly stylized European head. Both figures have quadrangular bells on their chests and leopard-tooth necklaces. They seem to have been high-ranking warriors, as the bells were to protect them and announce their victories, while the leopard's head was supposed to terrify the enemy. Since leopards belonged exclusively to the king, only he could decide what became of the skin and teeth of an animal that had been killed.

The *Plaque with an Oba, Dignitaries, and Musicians* (fig. 44) holds an important place among depictions of dignitaries at the court of Benin. Three large male figures are separated by two smaller ones. The large figure in the middle, with his rectangular feather hat, bead collar, and leopard's teeth, is especially lavish. He wears a quadrangular bell on his chest, as do the accompanying figures. His garment is decorated with scale patterns and reaches to his knees, and his chest is decorated with snakes pointed downward. In his right hand he holds a wide ceremonial sword, while in his left he holds a spear, pointed down. He wears a bead collar and his two companions each wear a necklace with five large leopard's teeth and a mitre-shaped headdress embellished with feathers. The cropped and rounded plaited beards are also worth noting. Both figures have a stylized animal head over their stomachs. Each holds a shield in one hand. Separating the three large figures are two small musicians: one has a side-blown trumpet, the other holds two bells linked together with a chain. The musicians, too, are wearing strings of eye teeth from a predator and quadrangular bells on their chests. Judging by their outfits, the outer figures must have been important dignitaries or military commanders, with the central figure possibly depicting an Oba.

The background motifs on the plaques appear to connote special symbols. The circled cross—which is very rare and found in the Vienna collection only on the *Plaque with the Bottom Half of a European* (fig. 7, p. 17)—as well as the quatrefoil leaf that is often used as a background motif may be identified with Olokun, the god of the waters. The circled cross appears mostly on Olokun shrines, while the quatrefoil-leaf motif refers to the leaves of waterplants, which the priestesses of Olokun used in healing rites. Both seem to have been a "basic cosmological form in the Benin world of ideas." The cross design refers simultane-

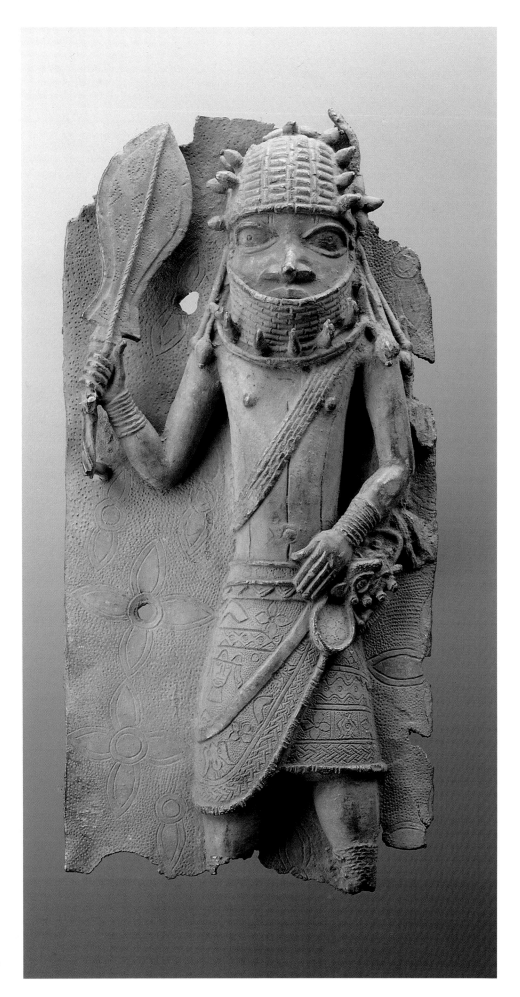

40 *Plaque with a Dignitary Holding a Ceremonial Sword.* 17th century. Brass. (Cat. 31)

54

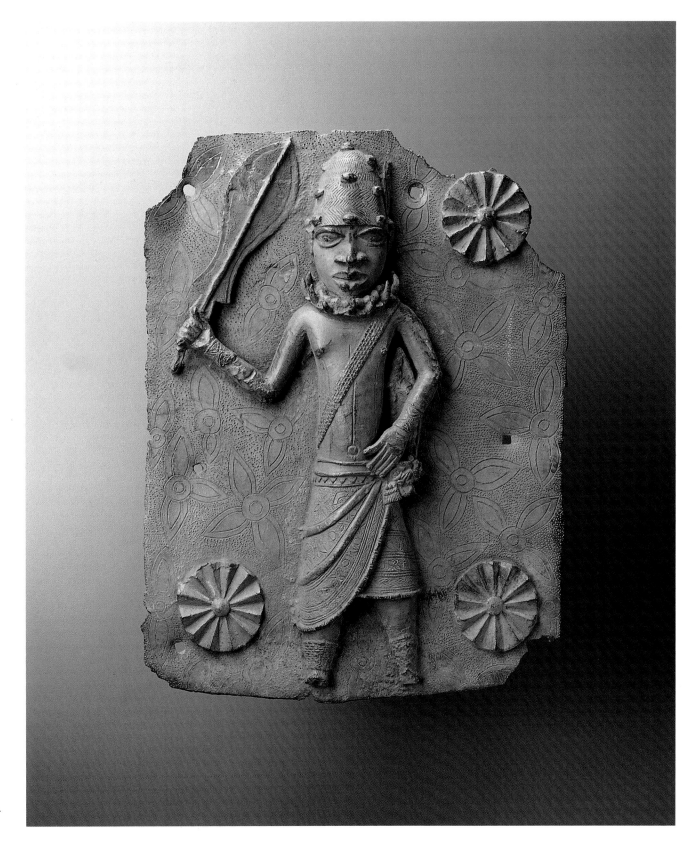

41 *Plaque with a Dignitary Holding a Ceremonial Sword.* 17th century. Brass. (Cat. 30)

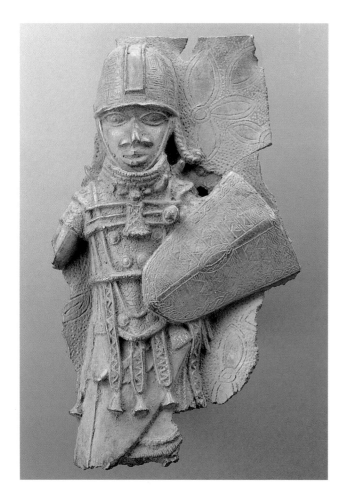

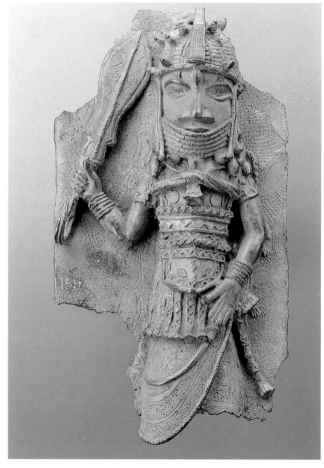

42 *Plaque with a Dignitary Holding a Shield*. 17th century. Brass. (Cat. 34)

43 *Plaque with a Dignitary Holding a Ceremonial Sword*. 17th century. Brass. (Cat. 32)

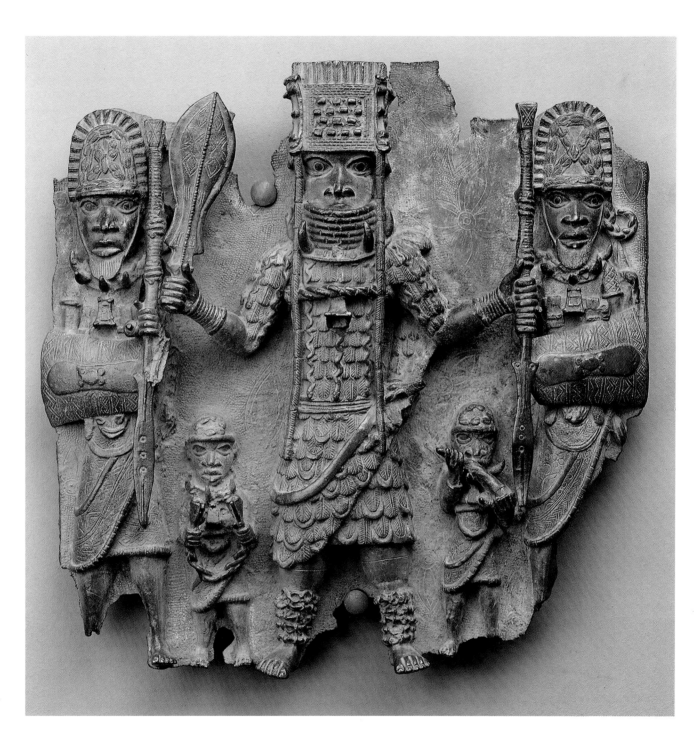

44 *Plaque with an
Oba, Dignitaries,
and Musicians.*
17th century. Brass.
(Cat. 29)

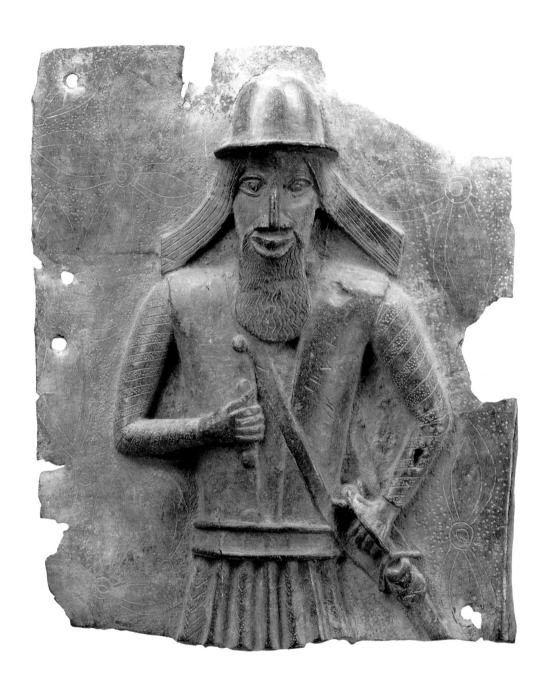

45 *Plaque with the Top Half of a European*. Early 17th century. Brass. (Cat. 46)

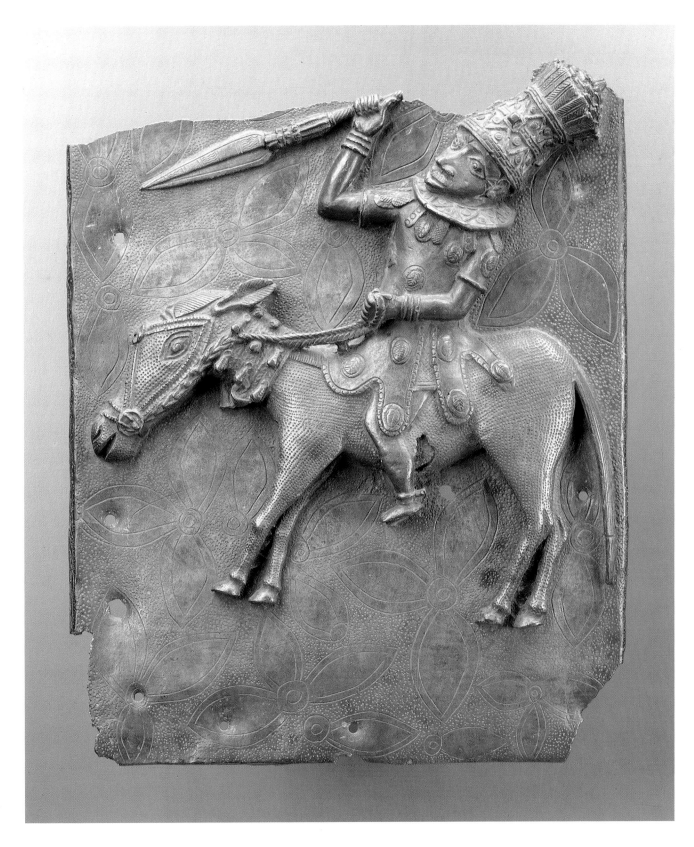

46 *Plaque with a Horse and Rider.* 17th century. Brass. (Cat. 43)

ously to the four cardinal directions of the wind, as well as to the four days of the Edo week, and to the four divisions of the day: morning, afternoon, evening, and night. The rosette, which is frequently placed in the corners of plaques, alludes to the sun—which never forgets a day and which is linked with Olokun through its sinking into the sea. The fish and crocodile motifs on the background of the plaques are, through their association with water, a further link with Olokun symbolism.[17]

The rider on the *Plaque with a Horse and Rider* (fig. 46), with his anomalous clothing, is the subject of much contention.[18] It is the only time that a lone rider appears on a plaque. One very early opinion assumed that in view of his clothing "he was hardly from Benin." However, since similar riders can be found occasionally among antiquities from Benin, it was thought that he was more likely "the ruler of a friendly neighboring people."[19] Dark, too, finds that a similar ruler is "atypical" for Benin and believes, based on his coiffure, that he might even have come from Ife.[20] On the other hand, according to Fagg, "the hat is like that still worn by the bodyguards of the Fulani Emirs of Northern Nigeria." According to the same author, "these figures are commonly said to represent visitors from the North."[21] Among the many other interpretations,[22] a more recent one seems plausible. If one assumes that the key to the rider's secret lies not in history but rather in mythology, then the plaque could be a representation of Oranmiyan from Ife, the Yoruba founder of the second dynasty. It was he who brought horses to Benin. The strangeness of the rider's clothing would

thus emphasize Oranmiyan's status as a foreigner in Benin. The figure might also represent the development from a specific Oba to an abstract "triumphal king."[23]

Motifs of Europeans on the plaques adorning the pillars of the palace were considered a remarkable novelty for African art of that period. In the *Plaque with a European and Five Manillas* (fig. 47), the Portuguese soldier carries in his right hand a so-called slow-match pike, or a stick with a trident, on which was fixed the burning fuse, to fire the cannon-shot at a safe distance. His left hand lies on the hilt of his sword. The slow-match pike and the sword identified the European as a cannoneer.

The oldest Benin plaque in the Museum für Völkerkunde (late sixteenth century) is probably the one with circled crosses in the background (fig. 7, p. 17). On it are also depicted the lower part of a Portuguese figure wearing a long pleated skirt that reaches to the top of his feet, and a crocodile head that anchors each of the lower corners. It is the bottom half of a "double plaque" whose top half is in a London collection.[24] Both pieces were cast separately, probably because their overall length (31 inches) would have made a single casting too risky.

The musicians seen on several plaques (figs. 48, 49) may very well be viewed as members of the Oba's entourage. Two plaques (fig. 48 and another one not illustrated) have figures whose clothes and headdresses greatly resemble each other and who are strikingly embellished with coral beads on their headdresses, high collars, and transverse belts. This likely documents their high position in the palace society. The plaques depict them holding small rattles formed from gourds. Court dancers, so it has been reported,[25] "held in their hands an excellent substitute for castanets. . . . These consisted of small, hollowed-out gourds with a net stretched across, and beans strung laterally to the meshes. The holes on top are for the four fingers of the right hand, with which the gourds are shaken and sometimes banged against the palm of the left hand in order to produce the rhythm accompanying the song of the dancers."[26] The musicians on the plaques seem to have only their right thumbs pressed into a hole.

The flute player or horn player (fig. 49)—"the horn players' peculiar and uniform costumes, which can be seen nowhere else, never cease to catch one's eye"[27]—wears less pretentious clothing and is a member of the Oba's retinue, or of that of an important leader or warrior. A similar horn or trumpet was repeatedly blown at beheading ceremonies. Sacrificial blood was needed for the ceremony, during which the Iwebo palace association displayed the beads and other royal jewels of the Oba in the shrine of Oba Ewuare.[28] On the *Plaque with the Bottom Half of a European* (fig. 7, p. 17) two dignitaries with absolutely identical coiffures, jewelry, and clothing are holding containers in their hands, which occasionally were thought to be stools[29]—a view that is unsupported by any evidence or by any comparable pieces. The containers, which were usually made of leather, held primarily kola nuts as gifts for the Oba. As a rule, lower dignitaries carried them for higher dignitaries. Aside from sacrificial offerings, these could contain secret ingredients or medicine for

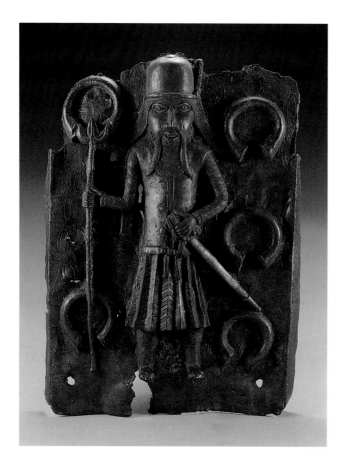

47 *Plaque with a European and Five Manillas.* 17th century. Brass. (Cat. 44)

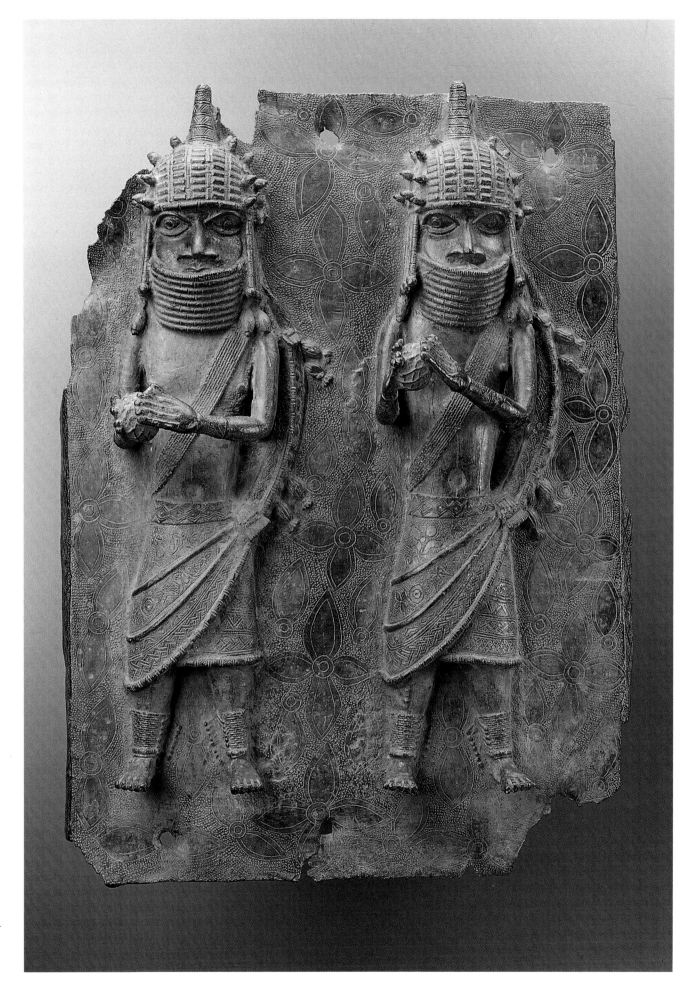

48 *Plaque with Two Musicians Holding Gourd Rattles.* 17th century. Brass. (Cat. 40)

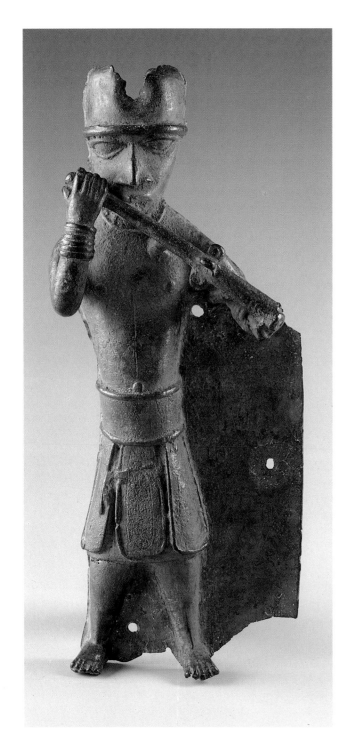

49 *Plaque with
a Flute Player.*
17th century. Brass.
(Cat. 41)

guished by naked upper bodies, bead necklaces, and loincloths trimmed with fine pleats.

The expression "frame drum" (tambourine) was chosen more out of necessity than of conviction, "so that the child at least had a name."[32] However, there are no drums with this form; even Dapper depicts drums as being big and round, and it is doubtful whether a tambourine was carried in such a fashion. It is increasingly accepted that the Europeans employed these people as messengers. They belonged presumably to the Iwebo palace association, and the Oba entrusted them to handle trade with the Europeans. Some of them also spoke Portuguese.[33]

The tablet in their right hand may thus be viewed as a bag for a "document or message concerning a transaction between Africans and Europeans."[34] Supporting this interpretation is the fact that both the bag being held, as well as the one on the *Plaque with a Leopard-Skin Pouch* (fig. 50), bear identical leopard patterns. The assumption that the square object might be a mirror used as a protective charm seems less likely.[35]

The frequently overdressed figures seen on most Benin plaques stand in marked contrast to the figure on the *Plaque with a Nude Boy* (fig. 11, p. 20). Standing with his arms hanging by his side, the naked boy has a vertical decorative scar below his nose—a trait that often can be found on many other plaques.[36] The deep lines decorating his naked body are unusual. The first impression that they might be tattoos is generally rejected, as it is considered to be completely impossible for the penis, let alone the glans, to be tattooed.[37] It is more likely to be body painting related to puberty festivals or to initiation ceremonies.[38]

This plaque is linked to references in earlier sources, such as Dapper, in which young people at court remained unclothed until they married.[39] In an account by a member of the British Punitive Expedition of 1897 one can read that when the Oba appeared before the British in August 1897 to negotiate his surrender, he was accompanied by almost four hundred stark naked men "as was their custom in the presence of the king."[40]

Finally, in observing this plaque, one is reminded of the legend of the Oba Ohuan, who was born as a girl and then transformed into a man through a magical treatment by a medicine man. In the company of the eldest son of the oldest chief, he danced naked to the palace to prove his manhood.

the medicine men who accompanied warriors on their military expeditions.[30]

The "messengers" were probably important personages in the kingdom of Benin too. The persons depicted on the two plaques in the Vienna Benin Collection (fig. 51 and one not illustrated) are strikingly similar in comportment, clothing, headdresses, and jewelry, which likely distinguished them from other palace associations. These figures have also been the object of various interpretations. "Square objects in the raised right hands of these persons," all of whom are wearing identical pot helmets and peculiar, uniform-like clothing, have been referred to collectively as "frame drums."[31] The figures are distin-

50 *Plaque with a
Leopard-Skin Pouch.*
17th century. Brass.
(Cat. 58)

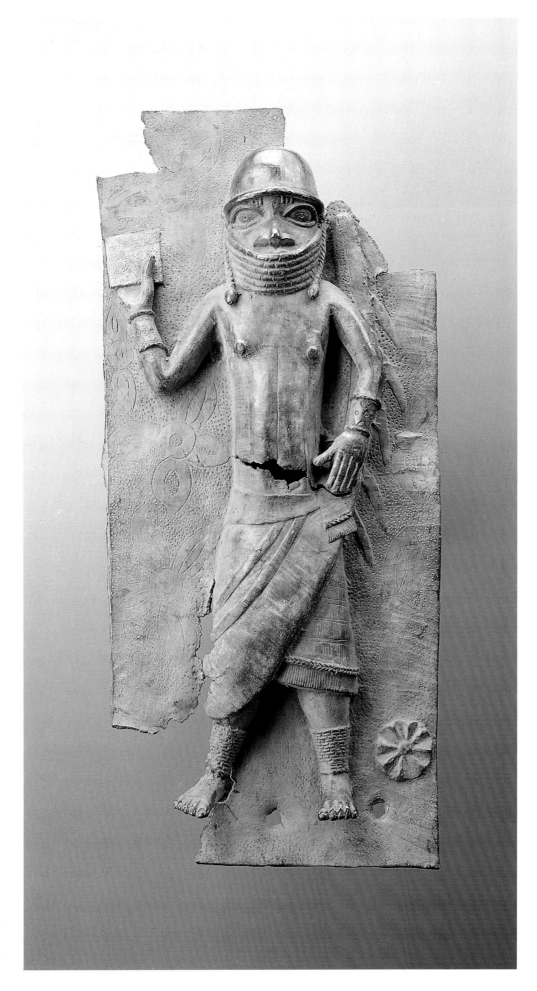

51 *Plaque with a
Messenger Holding a
Leopard-Skin Pouch.*
17th century. Brass.
(Cat. 42)

Animal Images

Crocodiles

As is the case with all other plaques, those depicting animals cannot be seen detached from the entire complex surrounding the king, since nothing can exist as a self-contained entity outside of the symbolic power of the Oba. The Oba, in turn, is the intermediary between his people and the inhabitants of the world of spirits, such as gods, ancestors, witches, and ghosts. He represents a transition between two realms, a fact repeatedly emphasized in the manifold iconography of Benin art. One of the spiritual "pillars" closely linked with the supernatural power of the Oba was the god Olokun, the son of the remote creator Osanobua. Closely identified with water, wealth, beauty, and fertility, Olokun represented a perfect whole world.

The two animals most closely connected with Olokun were the snake and the crocodile, both of which possessed a special ability: they could live on land, the region of man, and in the water, the region of Olokun. It was believed that Olokun sometimes sent these animals to punish the wicked. The crocodile, especially as a "policeman" and the most powerful animal in the water, was ideally suited to perform this task. Thus its many representations—whether in full form or simply as the head, the center of its power—were considered to serve a protective function, not only on plaques, but also on ivory objects, brass containers, and on the equipment of warriors.[41]

Figures of crocodiles can be found on ivory tusks, often accompanying images of the Oba Ohen who, according to tradition, had mudfish for legs.[42] The plaques with crocodile heads (figs. 53, 54) refer apparently to the crocodile under water that keeps only its head—the source of wisdom and organizational talent—above the surface. In this regard it functions as the metaphor of a powerful leader. However, the crocodile head alone could also allude to its being a sacrificial offering. Consequently, plaques with only one crocodile's head might be reminders of very rare, and thus all the more important, sacrifices.[43]

The particularly striking figure of a crocodile with human arms and hands (fig. 52) is another symbol of the closeness of Olokun, the lord of the waters, with the Oba, the lord of the land. Through their union, both powers seem to be establishing a formidable complex, wherein each has jurisdiction over life and death in his own region. The power of the crocodile represents the power of the Oba, whose hand has the strength of a crocodile. Similarly, an elephant's trunk ending in a hand refers to the Oba's hand, which possesses the strength and power of this animal. As the representative of the highest force in his realm, the crocodile is able to transform himself into a human being.[44]

Since the Edo believe that the souls of Olokun's children, after they are blessed, must cross water in order to pass from the world of spirits into that of man,[45] this image might represent an intermediate stage in which the souls have not yet reached the world of man. This kind of figure could also symbolize the Edo's belief that the important leaders from Osanobua's palace came to Benin via water in the form of crocodiles so that they could be born there as humans.[46]

Leopards

The leopard appears most frequently among the animals depicted on plaques, flanges of heads, breastplates, and tusks. As king of the forest, his reputation is as great as that of the Oba. Killing a leopard was one of the Oba's privileges. To this end the Oba had his own association of leopard hunters, equipped with special powers which enabled them to kill these animals without losing their own lives.[47] Slain leopards were permitted only as offerings, particularly in the cult to the Oba's head.

Animals tamed by hunters accompanied the Oba during his annual procession through the city. In this manner the Oba demonstrated his power over the king of the forest. Leopards' teeth and skin, which only the Oba could present to his military commanders, were thought to offer protection in battle, while they also confirmed his power to delegate to the recipients the right "to take life."[48] Foreign vassals, for example, were never presented with chest pendants depicting a leopard because the king reserved them for his own commanders as symbols of his control over them and their loyalty to him.[49]

In one myth the leopard was chosen not only for his vehement strength and colorful regalia (spotted fur) as king of the beasts, but also for his natural qualities that enabled him to lead an orderly and peaceful congregation of animals. Consequently, his magical and cruel side is balanced by his reserve and moderation as a leader.[50] The leopard symbolizes the complete harmony between two compelling forces—the menacing and the moderating—that every ideal leader (Oba) should have. The Oba is also called "Child of the Home Leopard"[51] and is described in a song as "Leopard, King of the World."[52] Both the Oba and the leopard possess a leader's primary characteristic: the "right to kill," which enables them to be above all life.[53]

Snakes

Although depictions of snakes in the Benin Collection of the Museum für Völkerkunde can be found on only one plaque (fig. 59) and in the form of two huge heads (figs. 60, 61), it is virtually omnipresent in Benin art, whether in the form of jewelry for the Oba and warriors (figs. 43, 44; pp. 56, 57), or as decorative motifs on pots (fig. 96, p. 131), medicine staffs, and ivory tusks. Together with the crocodile, the snake is most closely linked with Olokun, whom he serves as a messenger and playmate. According to early accounts, pythons hung from the gables of the palace roof as protective creatures and as links between the powers of the sky (Osanobua) and the earth (Oba).[54] The two heads cited above are probably based on these creatures.

The snake, which can be very dangerous, is at home both in the realm of the waters (Olokun) and on land (Oba). It is thus a bridge between two realms, and it is often regarded as a messenger of Olokun. An upright snake is integrated into the symbolism of the vertical axis connecting earth with the realm

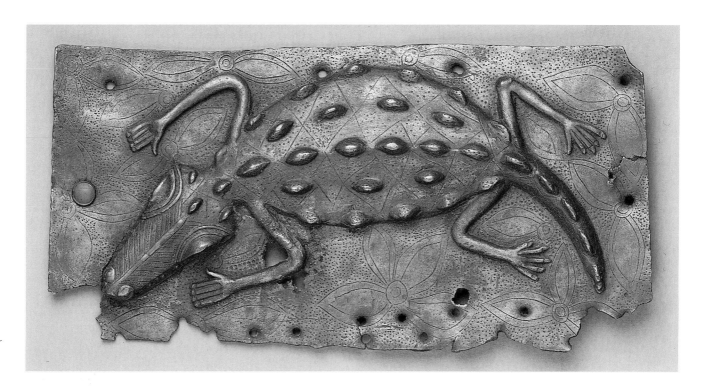

52 *Plaque with a Crocodile.* 17th century. Brass. (Cat. 49)

53 *Plaque with a Crocodile Head.* Late 16th/17th century. Brass. (Cat. 51)

54 *Plaque with a Crocodile Head.* Late 16th century. Brass. (Cat. 50)

55 *Pendant with a Leopard Head.* 17th/18th century. Ivory and iron nails. (Cat. 63)

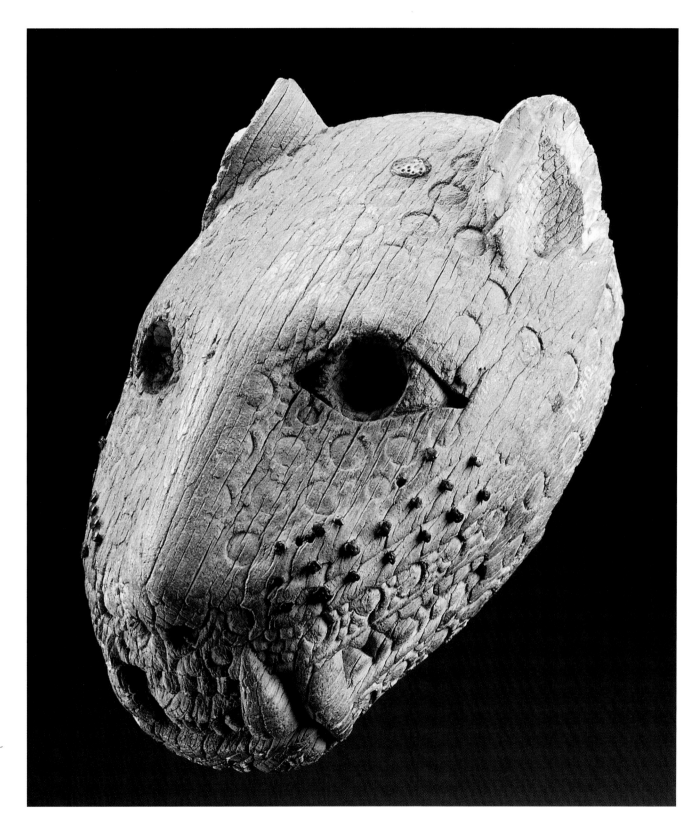

56 *Head of a Leopard.* 17th century. Ivory, brass tack, and iron nails. (Cat. 19)

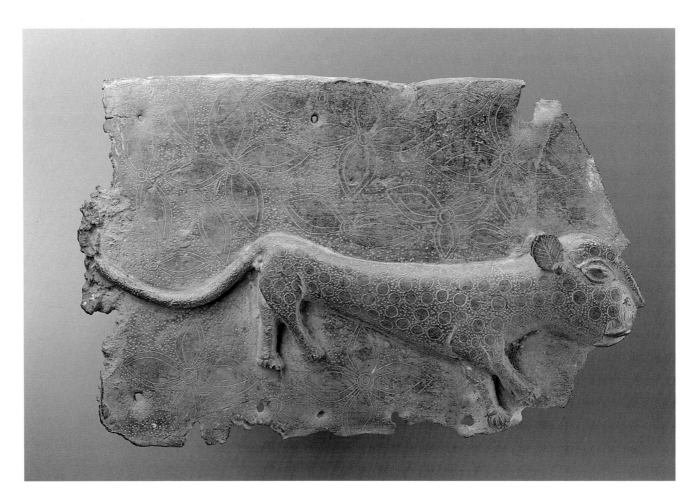

57 *Plaque with
a Leopard.*
17th century. Brass.
(Cat. 48)

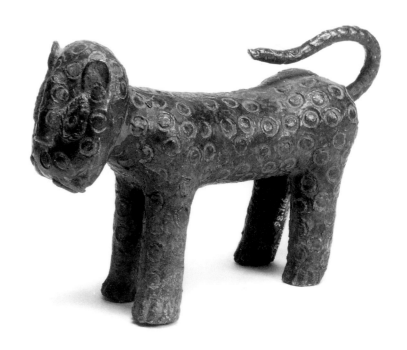

58 *Leopard.*
18th century. Brass.
(Cat. 17)

68

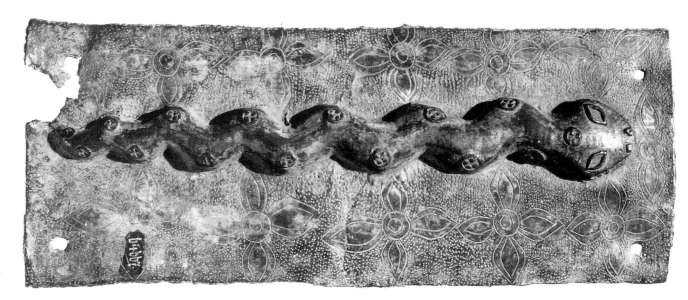

59 *Plaque with a
Snake.* 17th century.
Brass. (Cat. 52)

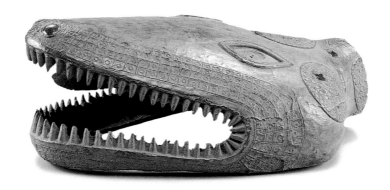

60 *Head of a
Snake.* 17th century.
Brass. (Cat. 15)

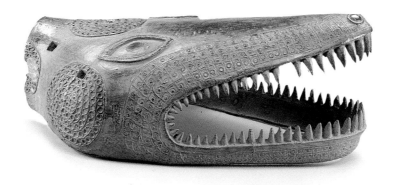

61 *Head of a
Snake.* 17th century.
Brass. (Cat. 16)

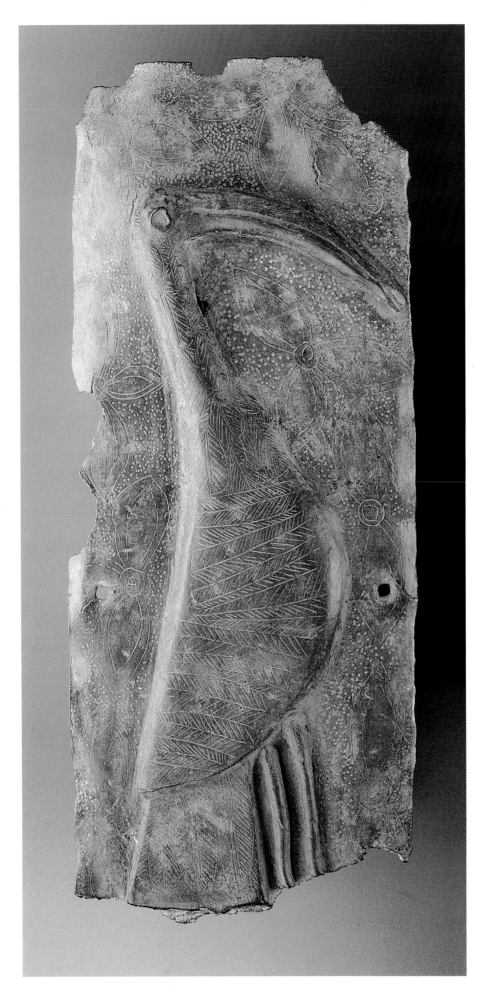

62 *Plaque with a
Bird of Prophecy.*
17th century. Brass.
(Cat. 53)

of spirits. This symbolism can be found repeatedly on many Benin objects: on medicine staffs (see fig. 83, p. 86), tusks, and brass heads, and on the coiffures of some dignitaries, priests, and Obas, which hide magical substances. As in many other African myths, the rainbow is thought to be a python joining sky and earth, a reminder of the ladder on which the creator god Osanobua descended to earth when he made Benin.[55] Among the figures on tusks (figs. 94–96, pp. 93–94) is a two-headed magical snake crossing the body of the Oba, who is then overwhelmed by the magical forces of the snake.

Birds

Birds, especially a kind of ibis, appear prominently with figures on plaques and medicine staffs.[56] It is difficult to determine the exact species of this bird. Since it was a myth, it most likely never had a counterpart in nature.[57] The figure of a bird perched atop the Oba's palace is viewed generally as a symbol for the constant fight between good and evil—the confrontation between daylight and the darkness of night, the darkness of evil, the kingdom of the night bird. The Oba, too, must guard against these evil powers. Most frequently, however, the ibis-like bird in Benin art serves as a reminder of King Esigie's victory over the Igala at the beginning of the sixteenth century. While Esigie advanced, the bird prophesied his defeat. However, he was victorious in the battle, declaring, "whoever will succeed in life should never heed the bird of prophecy."[58] Afterwards he had the bird killed and ordered his brass guild to make a cast of it. During the festival commemorating this victory, the bird—in the form of an idiophone, or self-sounding musical instrument—is carried by dignitaries and its beak is hit with a small brass rod (fig. 63). While the bird is rejected as a prophet, the power of the Oba, who rises above the fate of average human beings, is emphasized. Independent of other forces, he determines his own fate and that of his people.[59] The idiophone bird has a small ball in its beak, which might be a magical substance.

Fish

The number of fish depicted on plaques, bases of heads, altars, and carved ivory pieces are almost too numerous to count. Despite several variations they are nevertheless the same fish, or the same species—catfish or mudfish—and can be recognized immediately by their barbels.[60] That these fish belong apparently more to mythology than to natural history is supported by their highly stylized barbels, which appear even larger than the rest of the fish on carved works.[61] The primary problem of classifying them according to zoology lies in differentiating between stylistic oddities and reliable zoological characteristics. For example, it is not easy to differentiate between fins and spines, and one can assume that the Edo made *Malepterus* or *Malepterurus beninensis Murr* look uncanny by adding spines from other catfish species.[62] Although the fish seen from above (figs. 64, 66) are different from the one seen in profile (fig. 65), closer examination does not reveal any essential differences, since the body shapes, short mouths, and prominent foreheads are all identical.[63]

The Edo greatly value mudfish as the strongest, most robust, and tastiest of all fish. Through its association with the sea god (Olokun), the mudfish symbolizes prosperity, peace, and fertility. In the Niger and its tributaries are many species of mudfish (*Synodontis*), which can cover lengthy distances on land by tightly closing their gills. Thus they were favored as sacrificial animals "capable of removing every obstruction from one's

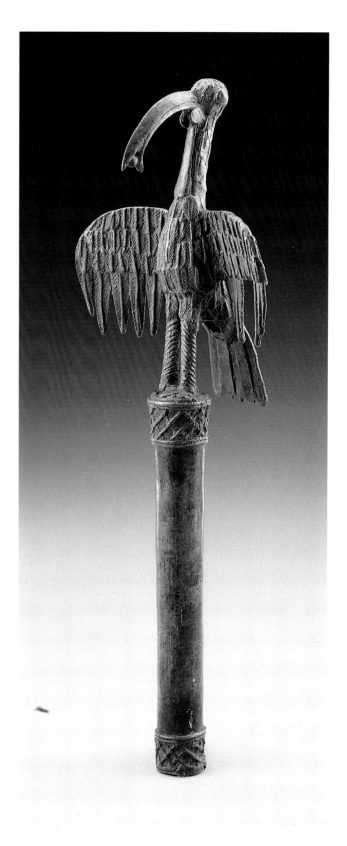

63 *Clapper with a Bird of Prophecy.* 18th/19th century. Brass. (Cat. 77)

64 *Plaque with a
Mudfish.* Late
16th/17th century.
Brass. (Cat. 54)

65 *Plaque with a
Fish.* 17th century.
Brass. (Cat. 56)

66 *Plaque with a
Mudfish.* 17th cen-
tury. Brass.
(Cat. 55)

path"—a reference to their ability to overcome any problem.[64] They were a symbol for the Oba, who could function on two levels—in his own region and in that of Olokun. Accordingly, he, too, was able to fend off an attack by the enemy crossing the water (through emissaries).[65] A particular symbol of the Oba's power may very well have been the feared *Malepterus electricus*, a very robust and long (sometimes measuring more than one yard) fish, noted for dealing a powerful electrical shock to anyone who touched it.[66]

A strikingly large number of mudfish motifs can be found on ivory tusks. One central motif, however, is the figure of a ruler with "mudfish legs," which appears no less than ten times on the four tusks in the Benin Collection. This magical figure is thought to be Oba Ohen (beginning of the fifteenth century), the father of Ewuare. When at age twenty-five the Oba's legs became paralyzed, he henceforth chose to keep his infirmity hidden.[67] In mythology Ohen, who was most closely linked with Olokun, supposedly had mudfish for legs. His spirit came on land from Olokun's kingdom so that he could rule as Oba, Lord of the Land.[68] On two ivory tusks (see, for example, fig. 95, p. 94), two crocodiles appear to be carrying Ohen across water, while a third is pulling him between mudfish and attacking an antelope. This refers to the Oba's ability to centralize his power.[69] Furthermore, it symbolizes the ancient Edo belief that the feet of the Oba carried such force that they were never allowed to touch solid ground, as any contact would cause confusion and destruction.[70]

Many other interpretations can be added to this short list on the symbolism of the "figure with the mudfish legs." The depictions on the tusks might, for example, be a reminder to the Oba of the limits of his authority, the misuse of which would not be tolerated either in the political or religious field.[71]

The Pouch

Only one plaque (fig. 50, p. 62) shows a "lifeless" object, a rectangular pouch with a strap. The large circles adorning it form not quite regular rows that are similar to those on leopard skins (cf. fig. 57, p. 68), so that we can assume the pouch was made from such hides. It is sometimes referred to as a messenger's bag.[72] Based on its size and dimensions, it indeed would have been suitable for carrying papers and letters.[73]

Three-Dimensional Figures

Dwarfs

A first, rather scant reference to the famous dwarfs now in Vienna's Benin Collection comes from H. Ling Roth, in his book *Great Benin*:[74] "While I was still in the city, two solid cast brass figures were brought in. They represented dwarfs typical of cretinism; they were without hats, and simply clothed. . . ." Reproduced on page 219 of his book was the first photograph

(5×4 cm) that the expedition doctor, Dr. Allman, took of them. No more information has become available through the years. The presence of dwarfs at the royal court was confirmed by Dapper and even depicted graphically on a copperplate engraving included in his own work.[75]

The first dwarf (fig. 67) is 23 inches high and weighs 37 lb. 15 oz. It is a complete, hollow-cast figure, with a round, relatively large head with a short beard and short curly hair, large lentil-shaped eyes, a long straight nose, and a large, somewhat open mouth. A string of closely bunched cylindrical beads and a longer necklace bearing a two-tipped conical bead encircle his neck. The very short arms reach forward and stand out at a distance from the body. The upper body is relatively long. The loins are wrapped in a narrow cloth fastened with a belt. The very thick, short legs are curled inward; they end in large, flat feet, with heels that project far to the rear. A brass alloy was used to cast the piece around a solid clay core that was removed afterwards. Remnants of the reddish clay core can still be found in both legs. A thermoluminescence test performed by the Rathgen Forschungslabor in Berlin revealed the work's astounding age, 660 years, giving it a date of 1324.[76]

The eye-catching shape of the head of the other dwarf (figs. 68–70) appears to be a natural deformity. Also worth noting are the deep-set eyes and the caved-in bridge of the nose, which is itself both short and blunt with large nostrils. The very thick lips frame a relatively small mouth, while the high cheekbones stand out noticeably. The chin is large and well formed. Two strings of beads hang around the dwarf's neck. The figure has a broad upper body, a pronounced belly, and short arms and legs. A wide, quite plain skirt covers its lower torso. The short, powerful legs terminate in flat feet with heels that project far backwards.

This figure, which is 23 1/2 inches high and weighs 32 lb. 6 oz., is also a hollow brass-alloy casting. Here, however, the clay core has been totally removed. It is likely at least as old, if not older, than the other.[77] It is one of the high points of Benin art, capturing the essential aspects of bodily comportment and spiritual expression. Its form combines great visual harmony with self-contained monumentality, and its physical impact is incomparably intense.[78] Von Luschan says that this dwarf is one "of the most priceless pieces not only in the Viennese Collection but among all objects from Benin's antiquity anywhere."[79] Fagg believes that these pieces portray dwarfs "such as used to be kept as tumblers and jesters by the Obas of Benin. Without a doubt they are the finest of all Benin bronze figures, but they are so naturalistic that it is difficult to find points of style by which to date them, though an early date seems most likely. It is even conceivable that they are Ife works."[80]

Their uniqueness makes it hard to date them exactly as there is no basis of comparison in Benin art. Equally difficult is the question of whether they are even by Edo artists, which does not exclude their certainly being a part of Benin culture.[81] Not much is known about their function at court—not even if they were really "acrobats and jugglers," as Fagg suggested. Only once

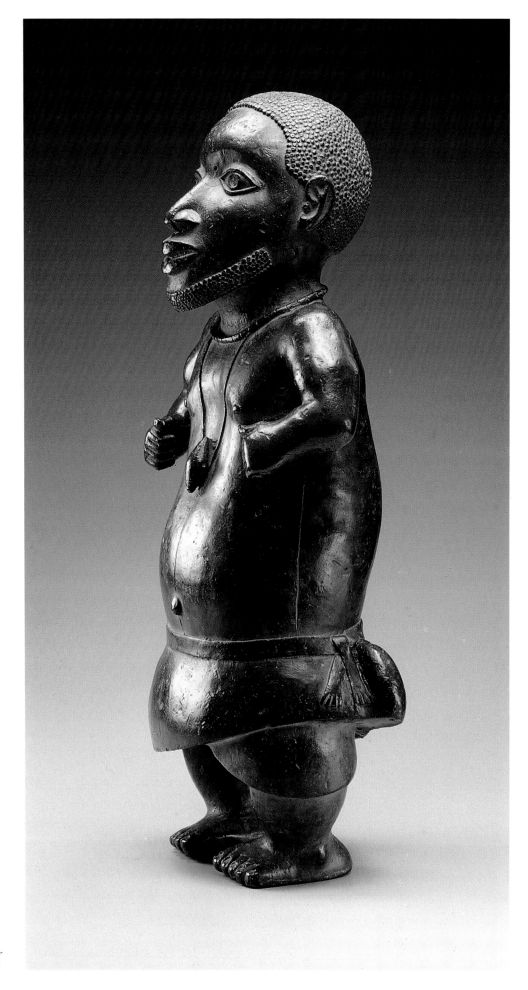

67 *Court Dwarf.*
Late 14th/15th cen-
tury. Brass. (Cat. 2)

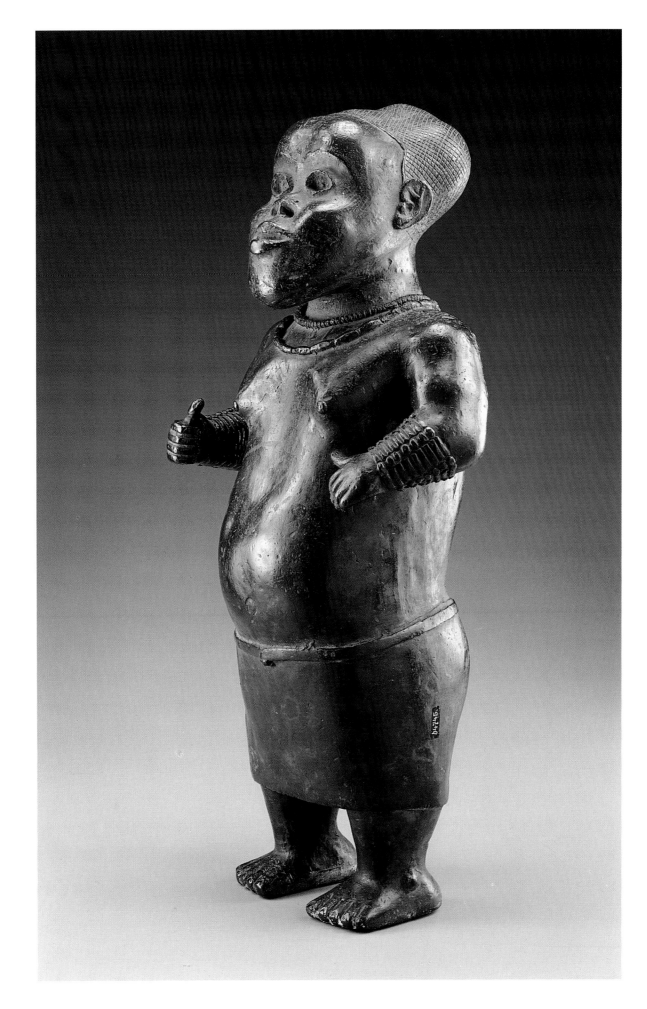

68–70 *Court Dwarf*. Late 14th/early 15th century. Brass. (Cat. 1)

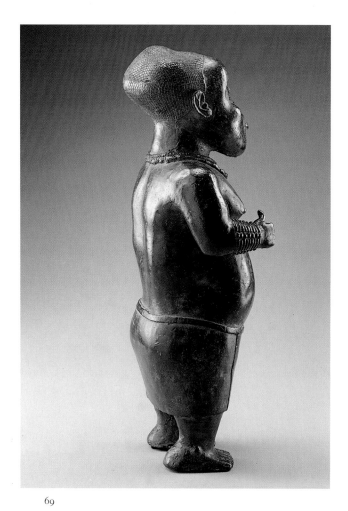

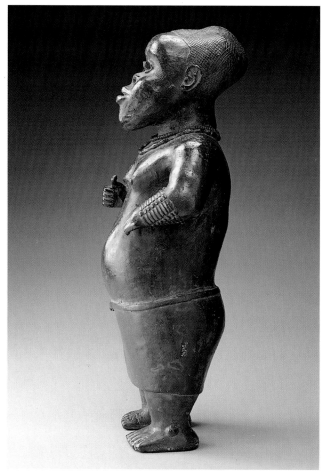

69

70

is a "court jester" (was he perhaps a dwarf?)—an old man acting as a mediator during the reign of Ozolua—mentioned in oral tradition.[82]

The Messenger or Court Official

The figure of the messenger (fig. 71), which is "one of the most beautiful of all pieces,"[83] and more recent than the other brass figures, displays a tendency to ornamental dissolution and an overemphasis of jewelry, costume, and scarification as distinguishing traits.[84] Two strings of cylindrical and double conical beads wrap around the neck of this most carefully worked piece. The clothing on the upper body is unadorned, whereas a number of stylized European heads in profile form a row on the garment draped over the lower body. The most striking features are the cross worn as a pectoral ornament and the line scars that radiate from both corners of its mouth.

Various explanations concerning the cross have been offered, ranging from its links with earlier Christian missions in Benin or the Portuguese Order of Christ, to ancient bonds with northern kingdoms, such as the Nupe. Most recent studies tend to view it as a cosmological symbol connected with the creation of the Benin world.[85]

The scars have also been explained in a variety of ways: "reminders of the whiskers of a feline predator, symbols of secret societies in Benin whose members thought themselves to be identical with certain species of feline predators."[86] They were also considered "Tapa" (Nupe) markings—a reference to Benin's links with the northern kingdoms.[87]

The person portrayed, whose missing left hand would have held an L-shaped iron hammer of the kind dedicated to Ogun (god of iron and war), might be—according to tradition—a messenger sent occasionally by the Oni of Ife[88] to the coronation of the new Oba, which, in turn, would allow the scars to be viewed as typical of the Ife.[89]

In present-day Benin the messenger is thought to depict a priest of Osanobua, the creator god. If one follows this interpretation, then the cross is a cosmological symbol referring to the creation of the world.[90] Still others believe—although without any substantiation—that the cross worn by the priests of Osanobua demonstrates the close contact with Portuguese missionaries during the rule of Oba Esigie at the beginning of the sixteenth century.[91] Finally, such figures also have been held to be members of the Ewua palace group founded by Esigie for awakening the Oba so that together they might perform the ceremony commemorating the founding of the dynasty.[92]

Although interpretations vary, this strikingly impressive figure, which possibly may have once graced the altars of Benin rulers, seems to have had only one task—to recall that its power and prestige is based solely on being an heir of Esigie, the founder of the dynasty.

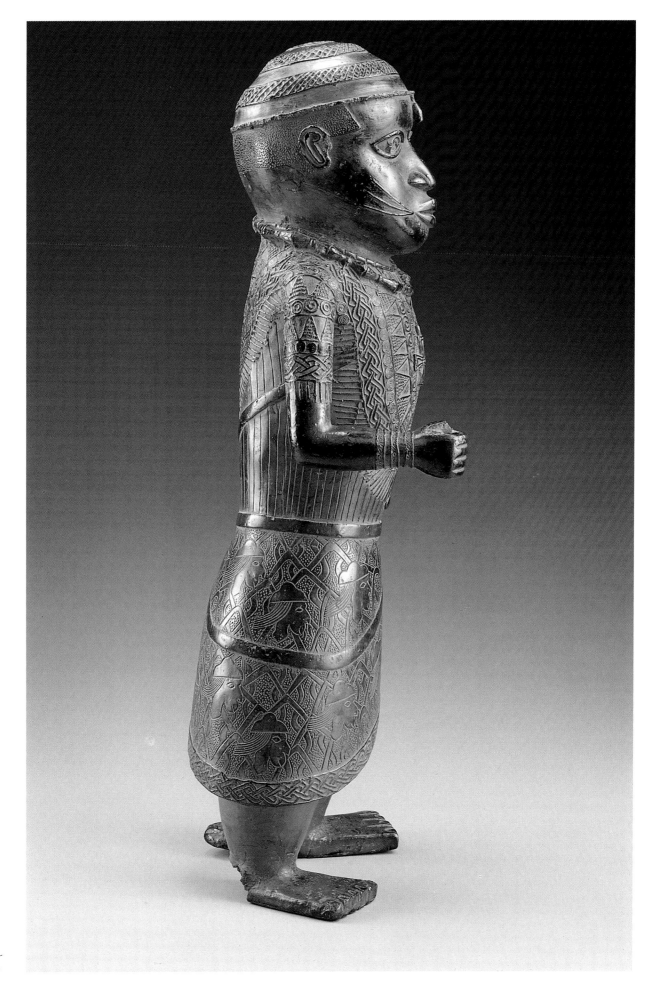

71 *Messenger* or
(Court Official).
Late 16th/17th cen-
tury. Brass. (Cat. 3)

The Cock

Among the most splendid animal figures is the cock (fig. 72), which was a part of the altars of the Queen Mothers. It stands on a base in the form of a square plate adorned with guilloche patterns and three heads of cattle (sacrificial animals); a cross in low relief is depicted in front of the claws. The harmony of fluid and delicately engraved lines covering its entire body culminates in the remarkable vivacity of the tail feathers. Between the cock's feet on the pedestal is a square hole for sacrificial offerings, such as kola nuts.

The cock's symbolic significance is not yet entirely understood. In one mythical tradition it was supposed to have been a guardian spirit and a kind of spy in the earlier Ogiso dynasty. Later traditions indicate that the altars of deceased Queen Mothers included one such cock figure.[93]

The large, sharp spurs are primarily thought to indicate the strength and superiority of the male animal.[94] As to why the representation of a male animal would decorate the altar of the Queen Mother, it would seem that Joseph Nevadomsky has an explanation. He suggests that the cock could be linked with the Oba's eldest wife, Eson.[95] Her title was "Eson, Ogordo Madagba, the cock that crows at the head of the harem"—a reference to her dominating position in the palace, as well as to her strictness and aggressive behavior. Thus it is hardly surprising for the Queen Mother—unlike other women—to have many male privileges and powers, such as her own palace, personnel, and income, the use of magical forces during martial enterprises, and so forth, even including a male symbol as a sign of respect on her altar.[96]

As the veneration of the Queen Mother increased during the rule of Esigie, it follows that the oldest cock—to which the piece in the Museum für Völkerkunde certainly belongs—must have been cast relatively shortly thereafter (in approximately the first half of the seventeenth century). This date is also borne out by the cross.

The oldest wife of the king, who was not necessarily the mother of the future successor to the throne—except when she was the eldest son's mother—was responsible for teaching court ritual and etiquette to the younger women in the harem.

Figural Pendants

Semicircular pendants were possibly worn on belts, mostly on the left hip over the knot of the wrapped skirt. Although the social and political rank of a person is usually reflected in his clothing and jewelry, the three figures on a pendant showing an Oba and two dignitaries (fig. 73) are almost identical if one overlooks the single bead worn by the one in the middle. This figure is standing on a head from which two snakes wind upwards from the corners of the mouth. This seems particularly to be a reflection of the Oba's duality with Olokun, the ruler of the waters, who was represented by snakes and frogs. Both this

pendant and one with an identical title (fig. 74) depict an Oba being supported by two attendants; just as the Oba supports his kingdom, so too should he be supported metaphorically by the most important dignitaries of the kingdom. The two attendants supporting the Oba are thought to be a reference to the balance between the Oba's power on a political and religious level, and the need for the support of his subjects: a symbol of both his superiority and his dependence.[97]

It is also assumed that these groups of three figures portray the Oba accompanied by the successor to the throne (Edaiken) and one of the military commanders (Ezomo). Both of these figures are linked to the Oba by blood: the former is presumably his eldest son and the other is thought to be the first Ezomo, his brother.[98] On the other hand, the two attendants have often been identified as Osa and Osuan (members of the high priesthood). While the royal successor and the Ezomo only assist the Oba during his coronation, Osa and Osuan are his closest attendants, who support him at every major court ceremony.[99] To summarize, here again the emphasis is on the balance of royal power, both supernatural and sociopolitical, which alone ensures the continuation and prosperity of the kingdom.

As with other similar pendants, those in the collection of the Museum have a chased ceremonial sword on the reverse side.[100] The sword's significance—whether as the insignia of the group of casters or the stamp for a group of pendants or their users—is still unclear.

In this group can also be included the representation of a head surrounded by highly stylized mudfish figures (fig. 75) and a pendant with a single frog as a central figure (fig. 76). The first pendant was worn by festively dressed chiefs on their left hip as a sign of distinction;[101] the second confronts us with the question of the frog motif in Benin art. The frog appears to be linked with Ofoe, the sinister messenger of Ogiuwu, the spirit of death and negative powers. Ofoe, whose form suggests a frog, has an oversized head with two arms and legs: the arms seem to protrude from the head, while the legs are similar to those of a frog.

Since a frog lives on land, as well as in water, it is an obvious life-force symbol too: both the powers of the Oba (land) and of Olokun (water) are united in it.[102] Thus it is a symbol of the Oba, possessor of greatest vitality. Through its connection with the spirit of death it exemplifies the king as ruler over life and death.

It is questionable whether pendant 64.677 (not illustrated) is a product of native casters, although it was found in Benin. The shape of the eyes, nose, and mouth is different from the usual Benin style. Instead, one is inclined to believe that such atypical castings, "attesting to high creative power and innovation,"[103] must belong to a hypothetical Lower Niger Industry. Many of these works of art are related in content but not in style to those of the Benin people. Consequently, the possibility must be considered that some of these pendants were the works of Edo-speaking tribes outside of Benin.[104] Nevertheless, it might be wrong to reach a decision too quickly and thereby underestimate the skill and adaptability of Benin casters, since it is not

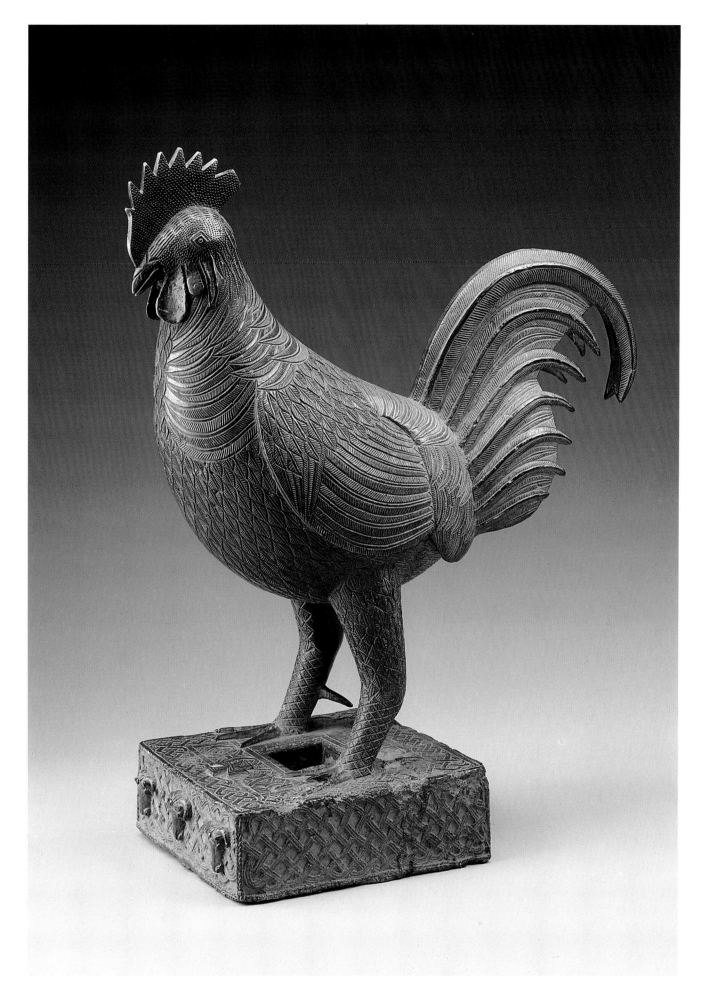

72 *Cock.*
18th century. Brass.
(Cat. 14)

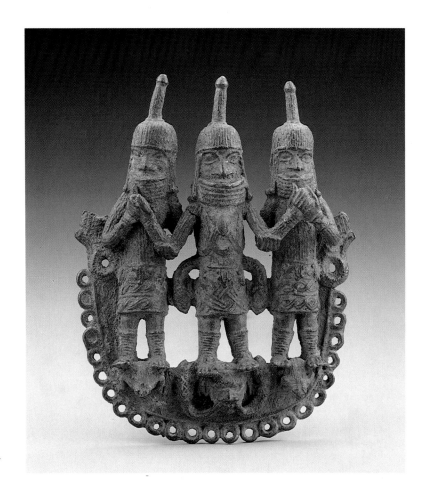

73 *Pendant with
an Oba and Two
Dignitaries.*
18th century. Brass.
(Cat. 60)

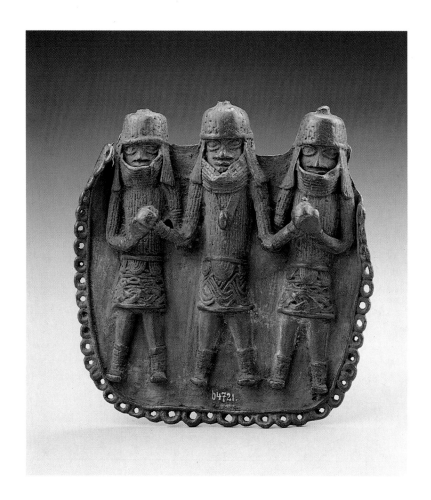

74 *Pendant with
an Oba and Two
Dignitaries.*
18th century. Brass.
(Cat. 59)

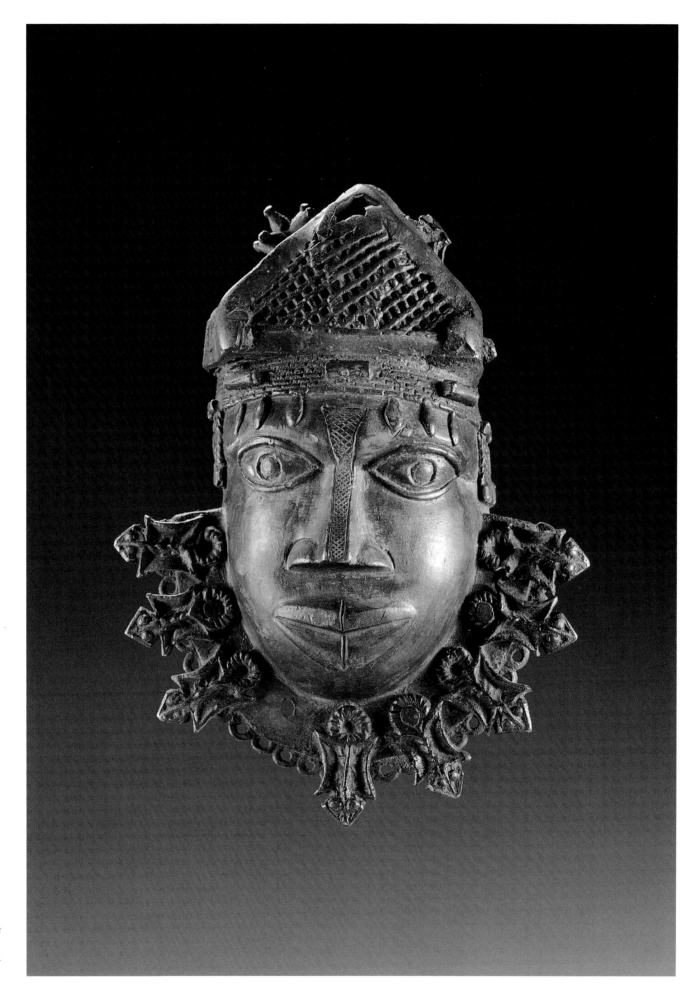

75 *Hip Ornament:*
Human Face.
19th century. Brass.
(Cat. 61)

76 *Pendant with a Frog*. Late 17th century. Brass. (Cat. 62)

easy to define the breadth and depth of Benin works in their different forms, or to determine the reasons for iconographic similarities and stylistic peculiarities.[105]

Tableaux: The Queen Mother with Her Retinue

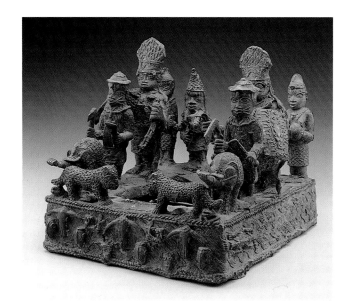

In the *Altar with Eight Figures* (fig. 77), the Queen Mother (Iyoba) is depicted accompanied by high dignitaries : a messenger from Ife (?)—with typical clothing, insignia (stone axe), and scarification marks—and musicians. In the foreground are two leopards and two elephants, whose trunks end in a hand (the hand possesses the strength of the elephant). The sides of the pedestal are decorated with guilloche patterns and depictions of skulls of cattle and motifs of the hand. Kola nuts and other sacrificial offerings were placed into the depression in the middle of the pedestal. It was probably an ancestral altar commemorating a deceased Queen Mother. Her high position in Benin is reflected in her splendid garments and jewelry, as well as in the costumes of her entourage. A similar altar (fig. 78), however, has two semicircular handles on the sides. On the front are three female figures, and on each side two female figures. Several of them are carrying leather fans (see fig. 79). Here, too, one can see again the arm with a human hand. The central figure, the Queen Mother, is supported by two female attendants, both of whom are holding a fan in their other hand. A few figures, now missing, have been broken off. The figures on both altars are solid castings, while the pedestal is half hollow.

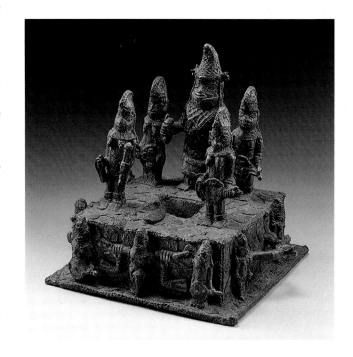

Altars to the Hand

The cult of the hand can be found not only in Benin, but also in many parts of southern Nigeria, where it symbolizes both achieved and potential success. This cult is often linked with graphic representations, which usually use the male hand as a symbol for aggressiveness, the art of war and hunting. During Ewuare's rule, contacts with many of these neighboring peoples during their wars of conquest may have led to altars to the hand signifying symbols of success in the royal cult.[106] They had their heyday during the reign of Akenzua I at the beginning of the eighteenth century, and they have been linked with his military victories against Iyase ne Ode, the powerful rebel leader of the Town Chiefs, thus making them symbols of his own personal success. Sacrifices at these altars (*ikegobo*) are performed privately to the exclusion of the public.

Only high-ranking personalities, such as warriors, noblemen, and chiefs—in addition to the Oba and Queen Mother— were allowed to own an altar to the hand. The Oba, Queen Mother, and the Ezomo—the leader of the Palace Chiefs— whose ancestor helped Akenzua I quash the rebellion led by the Iyase, were permitted to possess altars cast in brass. All others

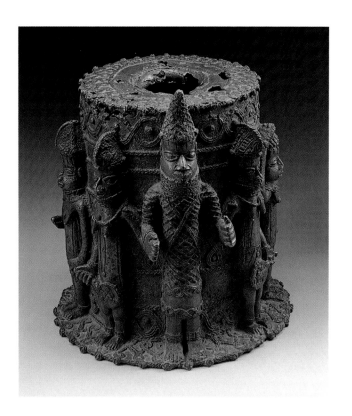

80 Altar to the
Hand (Queen
Mother and Atten-
dants). Late 18th
century. Brass.
(Cat. 65)

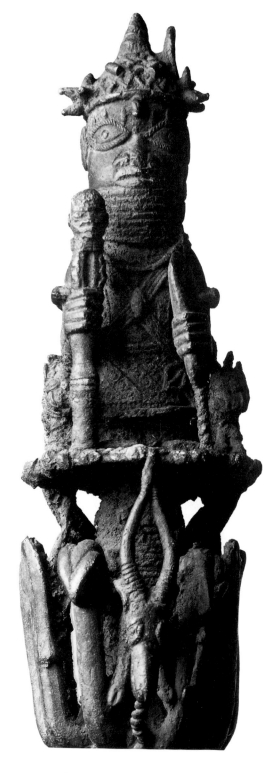

were carved from wood (see fig. 13, p. 22).[107] The altar to the
hand symbolized the power that its owner had cultivated, rather
than those powers inherited through birth.

Cast brass altars have an opening in the middle, which
make it possible to fasten a support for an ivory tusk; on wooden
ones there is a spike for a tusk or, as an alternative, the horn of
an antelope. The Queen Mother's altar (fig. 80) can be distin-
guished by the female figure's pointed headdress made of a
beaded latticework net, her beaded net dress, and the lavish jew-
elry on her neck. Six scantily clad women from her court hold-
ing fans accompany her. She is supported by two others.[108]

The wooden altar to the hand reflects the authority of its
owner, whose high position is mirrored in all his regalia and
insignia, such as his *eben* (ceremonial sword). The hands are
noticeably enlarged, and one of them holds the hand of a com-
panion to express his superiority. On the upper base of the altar
lie two mudfish, symbols of sacrifices to be brought to the altar
and of the safeguarding and enhancement of the owner's social
position and personal prosperity.

81 Staff with a
Seated Oba. Late
18th/19th century.
Brass. (Cat. 69)

Staffs

The Royal Staff

The design of this brass staff (fig. 82) indicates it was probably
both an insignia for the prestige and authority of the ruler, and
a link with the world of spirits. The many snakes also suggest a
close relationship with Olokun. The lower male kneeling figure
holds a sacrificial offering in his hand, a container with kola
nuts. The upper figure holds a stone axe, which is considered a
source of magical powers (cf. fig. 81).

The staff, whose top section has been broken off, was incor-
rectly described by von Luschan as a "family tree," but even he
used the term with reservation as he had noticed "an absence of
any native tradition for this piece."[109] It is an extremely rare
piece, of which only nine are known. Two are in Vienna (see
also fig. 81, where the lower section has been broken off). With
one exception, the richly clad figures are holding in one hand a
ukhurhe (rattle staff), suggesting a connection with the ancestor
cult, and in the left a stone axe (thunder stone), an allusion to
the holy kingdom. The kneeling figure holds in its hand a con-
tainer, probably with a sacrificial offering (kola nuts).

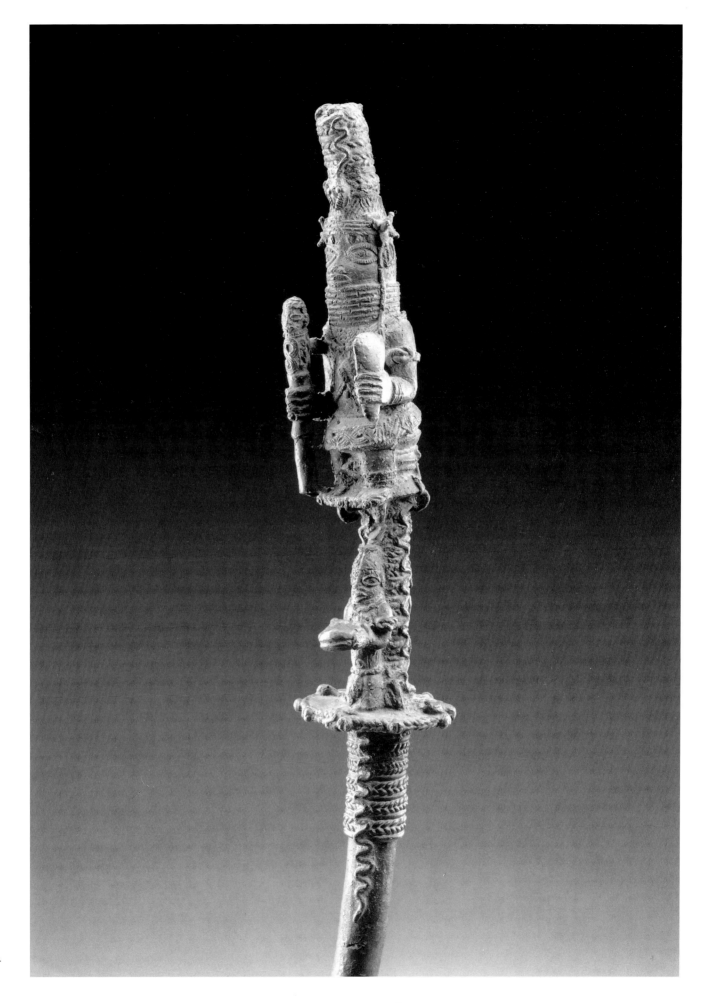

82 *Staff with a Seated Oba.* Late 18th/19th century. Brass. (Cat. 68)

The upper section of such a staff—as with that shown in fig. 81—reinforces the belief that these objects are an essential part of sacrificial acts. Along with both figures are leopards, and below the upper figure appear the heads of cattle, which are also precious sacrificial offerings.

The presence of snakes and chameleons—symbolizing a magical ability to transform oneself to serve as messengers of the nocturnal world—emphasizes the function of these staffs as magical and cult objects. The pointed end of such staffs seems to indicate their being set either in the ground or leaned or placed on another surface, as, for example, on an ancestral altar. The rich costumes and regalia of the figures suggest that these staffs were related inherently to the Oba and his cult practices.

The Medicine Staff

This *osun ematon* (medicine staff) (fig. 83), the only large object that was cast in iron and covered with a brass alloy, refers to Osun, an impersonal force found in certain leaves and herbs of the forest that is transformed by a kind of magician (*obo*) into magical and medicinal ingredients. The *ebo* (pl. of obo) use these preparations to treat troublemakers and as protection against feared witches, the rulers of the night. Witches transform themselves into nightbirds, descend on their victims, and rob them of their life force while changing them into defenseless animals, such as sheep or antelope, to then be devoured. The priest of Osun, who possesses the same powers as the witches, uses them, however, for good purposes. The center of his power can be found in this iron staff ruled by a bird, around which gather other birds and animals like snakes, leopards, chameleons, and antelope. Osun magicians are bound through their use of iron to Ogun, the tutelary god of craftsmen, warriors, and hunters. Ogun is the inherent mystical force in metal and is linked with flames, blazing anger, and war. The staff resembles the licking of flames, a symbol of the effectiveness of the remedies, and gives its user the power to transform himself into an animal in order to avoid danger or escape. Finally, it enables one to fight sinister witches, who become active through transforming themselves. The gathered birds on the staff symbolize the antagonistic, threatening world of evil magic. They are dominated by their leader, the gray heron—king of the nightbirds—with his huge, asymmetrical, repulsive-looking head and pointed beak that symbolizes his aggressiveness. The crawling chameleon is thought to be a scout or spy; because of his ability to transform himself, he is intrinsically connected to the shaman or magician priest. Through his uncertain gait, similar to that of an old and wise man, the chameleon symbolizes wisdom, but also cunning, because he can adapt to any situation through his ability to transform himself. The snakes depicted here are warriors of the night, dispatched by Osun—the god of medicine—to kill any attacker. All of these hostile animals and nightbirds share a common trait: they violate the Edo canon of aesthetics and harmony. As can be seen in the animals into which they transform themselves, witches are like monsters carving up the universal order.[110]

83 *Medicine Staff.* Late 18th century. Iron and brass alloy. (Cat. 70)

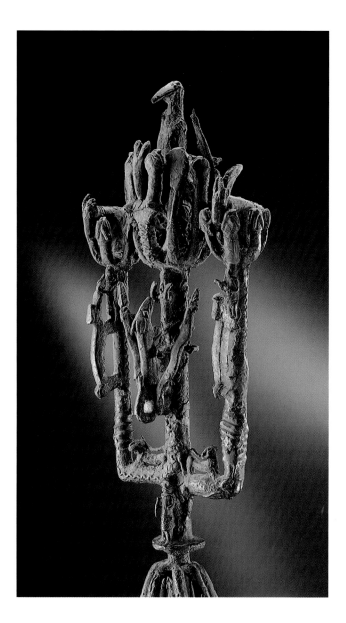

Rattle Staffs

Most rattle staffs (*ukhurhe*) are made of wood and have a carved head or figure at the end and a rectangular slit opening into a cavity, which holds a small cylindrical rod (figs. 84, 87, 88). The rattling sound is caused by the staff being shaken up and down. The staffs themselves—several of which were placed on an ancestral altar—are partially carved to imitate a bamboo cane. They are connected to the collective authority of the ancestors, be they kings or other important personages. Staffs are often seen—especially on plaques and figures on staffs (fig. 81)—in the hand of an Oba, suggesting that he has inherited the power of his father and royal ancestors. The thunder stone held in the other hand refers to his supernatural power.[111]

Several staffs of this type were used in village cults of Olokun. They functioned not only as an insignia of authority, but also, by being tapped on the ground, served as a link with the world of spirits. Shaking the staff was supposed to direct people's attention simultaneously to its user, who had the authority to make declarations, or to pronounce blessings and curses.[112]

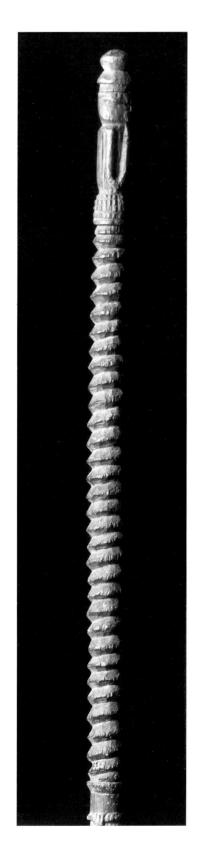

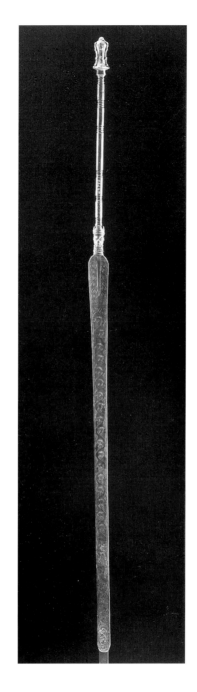

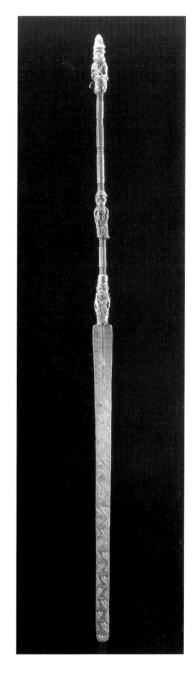

84 *Rattle Staff.*
19th century.
Wood. (Cat. 75)

85 *Staff of Office
of a Royal Purchaser.*
18th/19th century.
Copper. (Cat. 72)

86 *Staff of Office
of a Royal Purchaser.*
18th/19th century.
Copper. (Cat. 71)

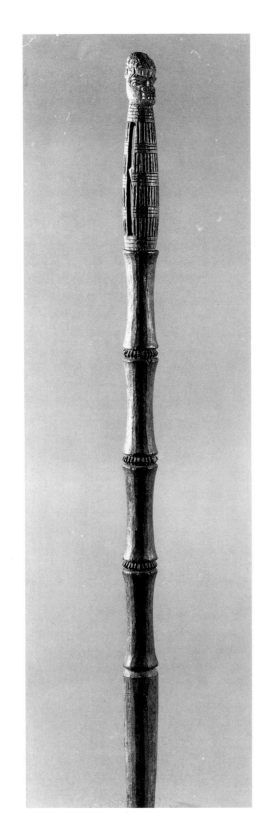

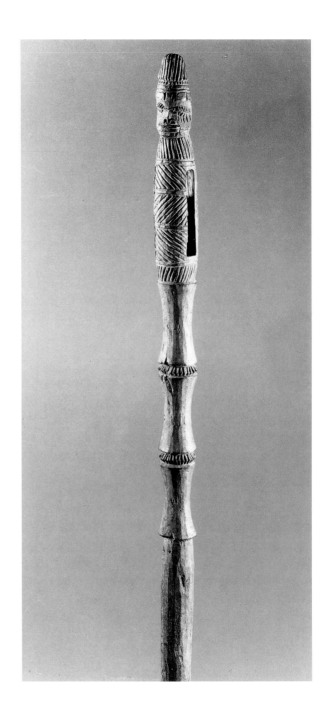

87 *Rattle Staff.*
19th Century.
Wood. (Cat. 74)

88 *Rattle Staff.*
19th century.
Wood. (Cat. 73)

Ivory Tusks

The works discussed here are usually large ivory tusks covered completely from tip to base with carved human and animal figures. They are arrayed in distinct groups that, in turn, form self-contained rows encircling the tusk. On each tusk the last row has been embellished with a braided pattern—with one exception where it is missing, or has been destroyed.

As a symbol, each tusk is extremely "charged." Tusks were once displayed on brass heads by placing them over wooden spikes in openings at the crown. They commemorated deceased kings and were thought to possess a spiritual power; only male dignitaries could touch them without harm.[113] Their whiteness linked them with kaolin (*orhue*) used in rituals to exemplify joy, purity, peace, and prosperity. Purity was observed in the custom of cleaning the tusks of blood and food remains after every sacrifice.

Coming from an elephant, the tusk possesses this animal's physical power. Although the elephant often symbolizes powerful and rebellious chiefs,[114] it also has the traits of a royal animal: leadership qualities, wisdom, and a long life—qualities one also attributes to the Oba. The tusk, with its many meanings, is a material whose hardness and durability makes it suitable for portraying historical reminders and symbols of royalty. Ivory and regalia made from this material were reserved for the Oba and his immediate circle at court. The Oba was the primary patron and customer for ivory works.

As in the case with many other precious materials, the figures on the tusks are related to the court of Olokun, the Oba's counterpart in the world of spirits, who is a symbol of wealth, fertility, and the forces in water. All figures are united in a single purpose: to increase the ruler's power. Although each tusk usually has its own combination of motifs, most figures depict themes that situate them in the sixteenth-century dynasty of the Warrior Kings, especially Ozolua and Esigie. These historical motifs are continually combined and interwoven with figures from the region of the spirits and magic, which are bound inseparably to the history and superiority of Benin's kings. As with so many other objects of Benin art, they, too, are instruments in the service of the Obas and their kingdom.

"Reading" these tusks is neither simple nor possible in every case. Only chiefs in the service of the royal altars and carvers from the Iwebo palace association—who were given custody of the regalia and royal insignia—could, after their initiation in ritual knowledge, completely fathom and interpret these symbols. Consequently, only a small circle of insiders could decipher the many figures and motifs on the tusks, even though many people could view the tusks at palace ceremonies.

Some repeating motifs, however, do not change on brass, leather, wood, and ivory objects. Yet one must not forget that some motifs are merely reminders—evocations of long and complicated oral traditions—or pantomimic depictions of rhythms, dances, and songs, or accompaniments to ritual cult practices.[115]

Equally, one must remember that the interpretations of many motifs were neither absolute nor unchangeable.[116] Contemporary interpretations, although not necessarily wrong, need not correspond identically to the original idea of the person who did the actual carving. Furthermore, in the course of time Benin, too, changed—a change that may have been erratic rather than gradual. Thus a plastic depiction may often evolve in meaning and use, although its form remains constant for longer periods of time.

Motifs are only valid, and of value, to the degree that they contribute to the political and social stability of the kingdom. Carvers belonged to the *Igbesanmwan* guild, which had been founded by Ere, the second Ogiso ruler.[117] Their name means "they who write (carve on) ivory." They were called to the palace whenever the king needed their services. Their leader received his directions and assigned various carvers specific tasks based on their abilities. Some were assigned the task of carving the outlines of the figures on a tusk, while some worked on the band motifs; others held the piece of ivory still for the carvers or sharpened their tools. The most accomplished carvers were responsible for the detailed carving and "finishing touches."

The reddish color of the tusks was probably caused by the very fine laterite dust from the roof of the palace, which, in the course of time, settled on the rough surface of the tusks. Plaques, brass figures, and especially ivory figures in the Museum für Völkerkunde have also assumed a reddish color in certain areas, such as the upward-facing parts of heads, shoulders, upper chests, and forefeet. One can therefore assume that the tusks were placed always under the roof and not in an open area, since then other sections of these objects would have been affected.

The dark discoloring on the tusks, about 24 to 28 inches in length, could be the result of sacrificial blood having been smeared on them, despite their having been washed afterwards.[118] The fact that the raised sections of the tusks look especially dark while the depressions appear lighter could indicate that the discoloration was caused by hands holding the tusks to raise them.

All four richly carved tusks (figs. 89–96) display similar ornamentation in relief. The figures are organized in rows and usually in groups. The most important figure is placed in the middle of a row. The concave back is normally occupied by animal figures. A human head wearing a tall pointed headdress with a scalelike pattern in the back is near the tip of all the tusks. Three of them have a guilloche bordering. Based on style and figures it is, however, possible to divide them into two distinct groups.

Many similarities shared by the first two of the above-mentioned tusks (group one; figs. 89–94) are not found on the other two, whose common traits permit them to be classified as group two (figs. 95, 96). For example, the emphasis on, and clear demarcation between, individual rows distinguish group one from group two. Isolated individual figures, or groups of figures, stand out clearly on the tusks of the first group, whereas this is

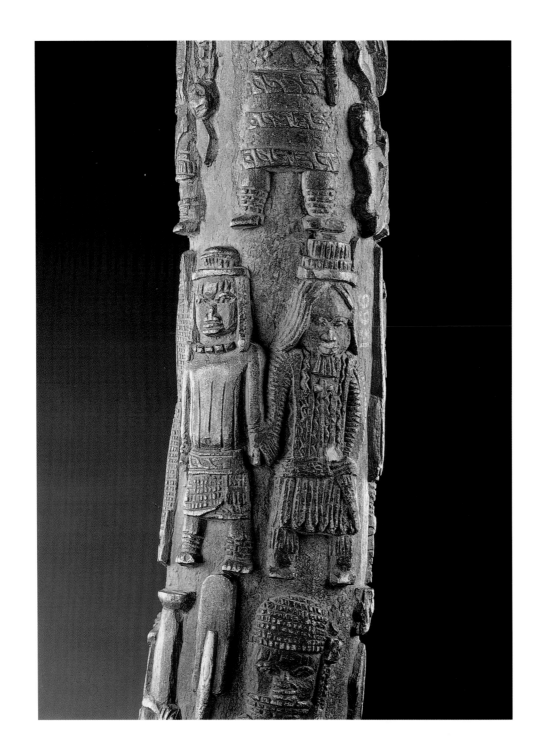

89 *Tusk with
Eleven Rows of
Carved Figures,*
detail. Ca.
1820–50. Ivory.
(Cat. 79)

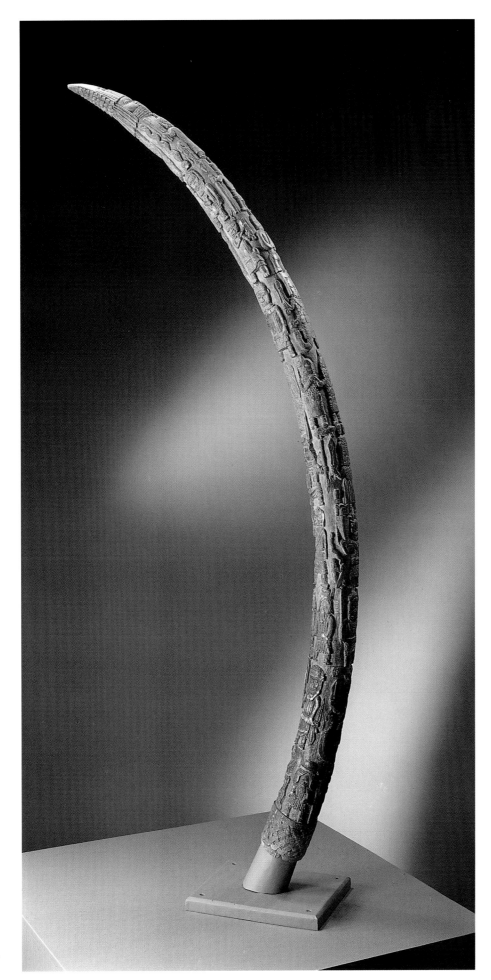

90 *Tusk with
Eleven Rows of
Carved Figures.*
Ca. 1820–50. Ivory.
(Cat. 79)

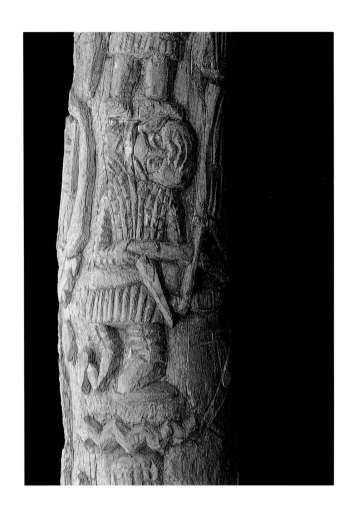

91–94 *Tusk with
Relief Carving.*
Ca. 1750–1850.
Ivory (Cat. 82)

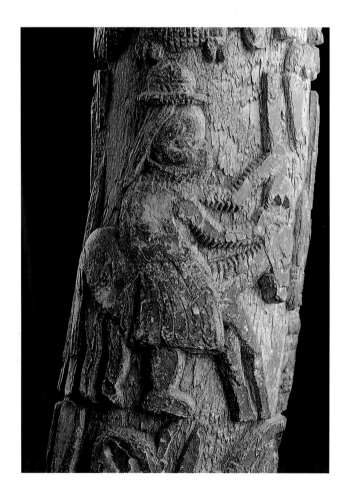

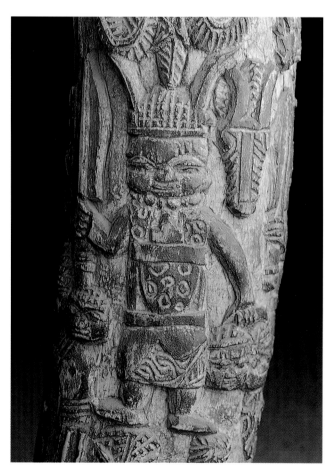

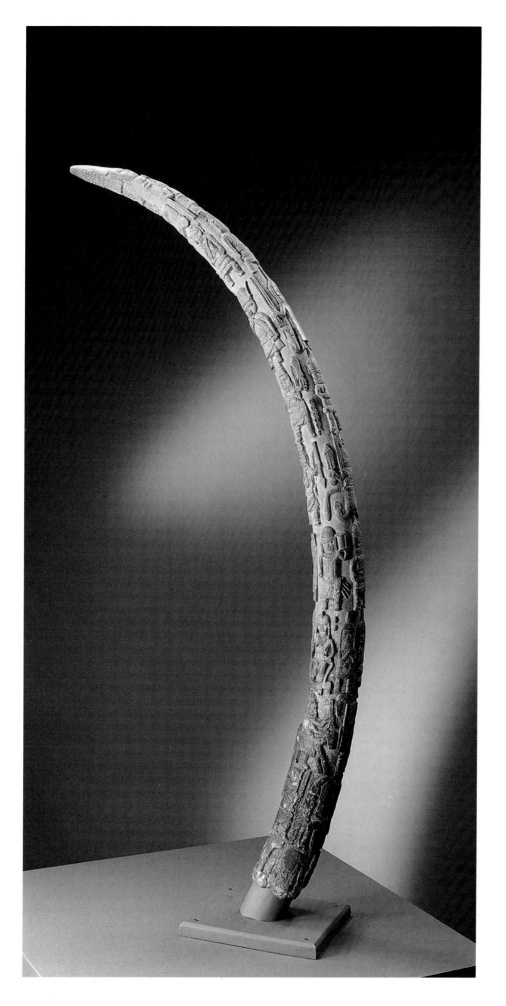

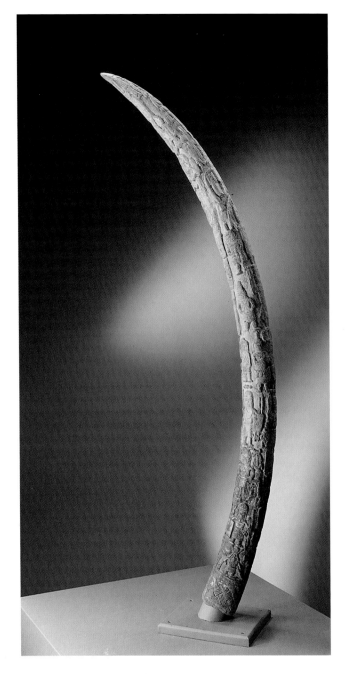

95 *Tusk with Relief Carving.*
Ca. 1820–50. Ivory.
(Cat. 84)

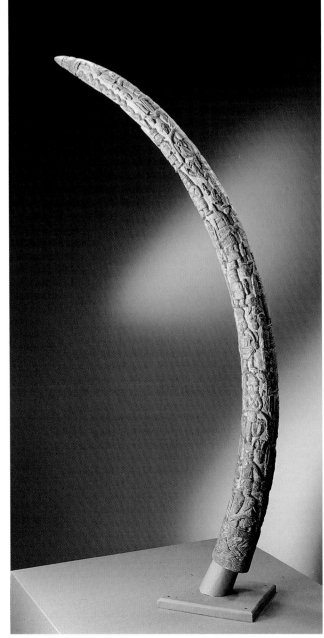

96 *Tusk with Relief Carving.*
Ca. 1750–1850.
Ivory. (Cat. 83)

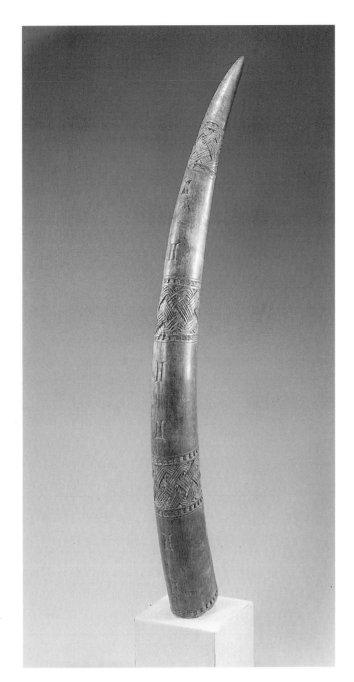

97 *Tusk with Relief
Carving.* 18th/19th
century. Ivory.
(Cat. 80)

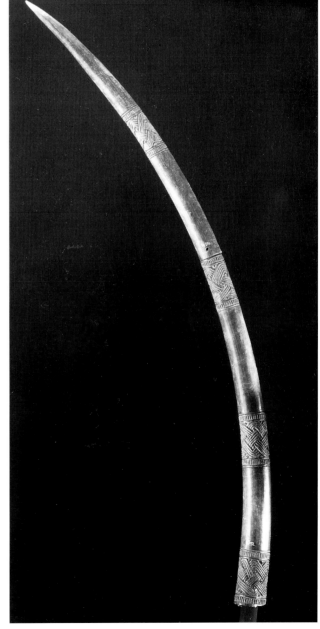

98 *Tusk with Relief
Carving.* 19th cen-
tury. Ivory.
(Cat. 81)

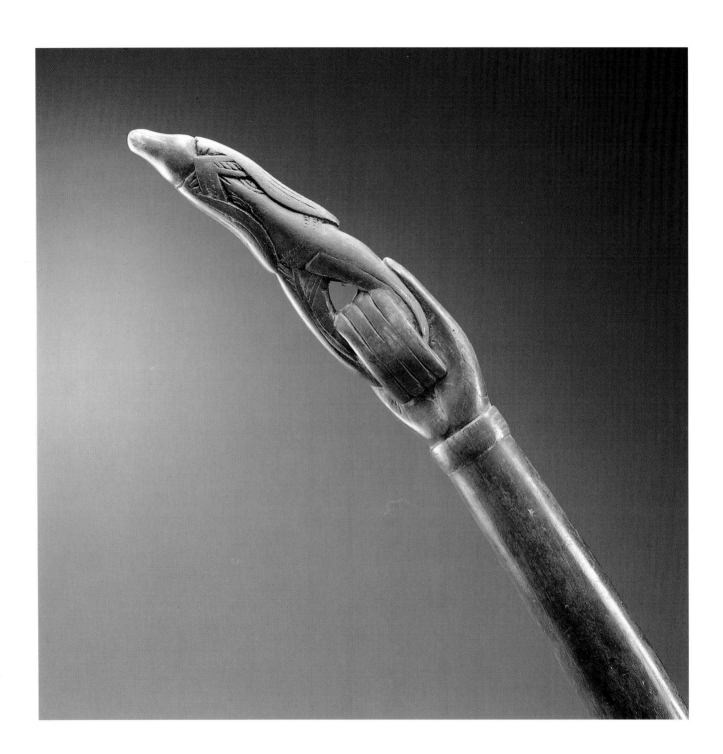

99 *Tusk with a
Hand Grasping a
Fish.* 18th/19th
century. Ivory.
(Cat. 85)

only rarely so in group two. Figures in group one are identical in size; variations in size are readily apparent in the second group.

In group one the motif of the elephant's trunk ending in a hand appears repeatedly. In group two the motif is missing. The differences in the way warriors, weapons, shields, and Europeans are portrayed support the assumption that the first group dates from a different stylistic period.

According to Barbara W. Blackmun,[119] the tusks shown in figs. 94 and 96 are both typical of a group of sixteen similar figural ivories that she has designated Set II.[120] Determining their origins is difficult. Blackmun proposes two possibilities: either they were commissioned by Oba Akengbuda to commemorate his father Eresonyen or another deceased ancestral ruler, sometime between 1753 and the 1780s; or they were carved at a later time to match or resemble the earlier tusks, sometime in the early nineteenth century.[121]

Blackmun informed me that in either case, these tusks, together with a tusk in the Musée de l'Homme, Paris (no. 32.15.13), form a rare subset of her designated Set II tusks. "Because the Igbesanmwan artists habitually work as a group in a type of 'assembly line' approach, it is difficult to match details of carving from one ivory to another. Yet these three examples share many of the same motifs, carved by the same hands."[122]

The tusks illustrated in figs. 90 and 95, according to Blackmun, both belong to another matched group, made up of eleven rather idiosyncratic ivories. The motifs seem to celebrate traditions related to the Ezomo and other chiefs rather than the Oba. The style of carving places the group after 1819 and before 1850. Nevertheless Professor Blackmun is still not certain whether they were commissioned by the Ezomo.[123]

The symbolic significance of human and animal figures has already been extensively described in the course of this work. The other ivory tusks in the collection (see figs. 97, 98) are adorned with guilloche motifs. On the tip of one tusk (fig. 99) is the figure of a human hand holding a fish similar to those found on some ukhurhe staffs. It is a reference to the proverb "He who holds the fish can also let it loose."[124] Most tusks bear the royal insignia ")(".

Other Objects in Ivory

Other ivory works in the collection are a bell, bracelets, leopard heads, and side-blown trumpets. According to Blackmun, the beautiful ivory trumpet (fig. 102) serves as a metaphor for asserting royal power and may also refer to a link between the Benin and Yoruba dynasties of kings. The bat or bird form with outstretched wings is an emblem shared with broader-based Yoruba traditions in southwestern Nigeria. She continues: "Thus the motif of the elephant as a symbol of opposition to Benin's Yoruba kingship reaches back to the original imposition of Oranmiyan's rule over the autochthonous Ogiso dynasty. When the Oba is represented astride the elephant, he personifies the Oranmiyan line asserting royal control over the Ogiso, over the chiefs, and over any challenge to his authority. The birdlike form with outstretched wings that appears below the mounted Oba on the elephant . . . is one of a vocabulary of images shared by Benin and ancient Yorubaland."[125]

The ivory figure illustrated in fig. 104, a hand-held clapper with an Oba, wears a coral-bead cap, headband, collar, anklets, bracelets, and a wrapped skirt with a lattice pattern. A single large bead at the intersection of crossed bandoliers identifies the figure as the Oba himself. The hands are broken. But in comparison with similar hand-held ivory clappers, this item must be used as a clapper. The beating of the clapper depicted the "bird of prophecy" and emphasized the Oba's domination of the bird's horrible powers.

The ivory statuettes depicting a female, perhaps the Queen Mother (figs. 106, 107), as well as a dignitary with shield-shaped pendants, were likely placed in the immediate vicinity of the palace.[126] Little is known about the statuettes, which were probably part of a larger group. The pieces, whose workmanship is somewhat careless, are probably later works, perhaps from the nineteenth century.[127]

Fig. 105 illustrates a kind of staff that was reserved for the Oba. It shows him standing victorious atop a leopard: the king rises above the leopard, the king of beasts, and above the Europeans, who were increasingly pushed aside.

It must be admitted that in one's efforts to contemplate Benin art, as well as to understand its subject matter and symbolism, one frequently uses concepts employed in the criticism of European art that may be more or less irrelevant, ambiguous, or even misleading. Accordingly, a clear line between the "pure" and "applied" arts of Benin and other African art forms, with regard to the essence of their original creation, cannot be drawn. The line between the sacred and profane becomes blurred when dealing with utensils—including those serving a purely representative function for a sacred ruler, such as the Oba in Benin—at least as long as the special religio-political concepts that he embodies remain intact.

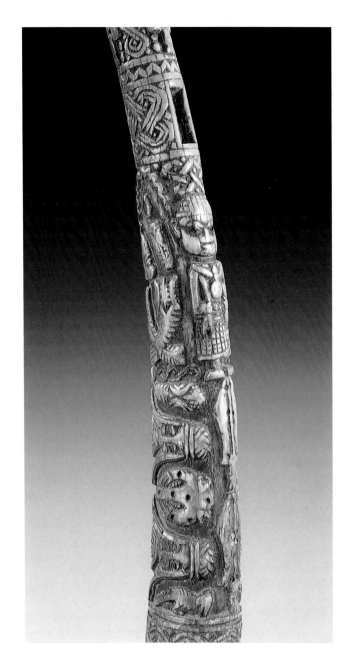

100, 101 *Horn*
with Relief Carving.
17th century. Ivory.
(Cat. 87)

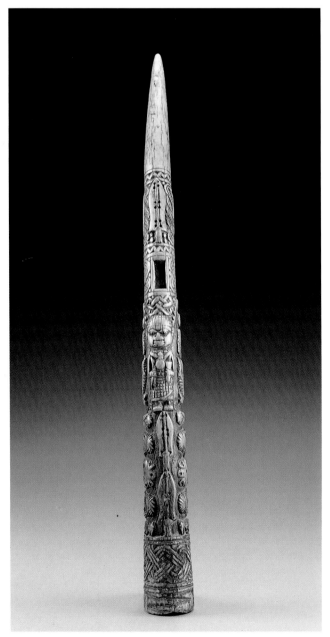

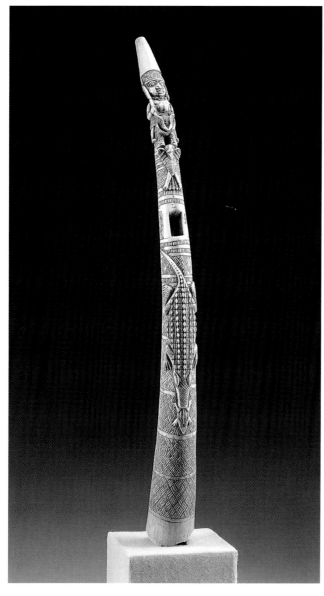

102 *Horn with a Crocodile.* 16th century. Ivory. (Cat. 86)

103 *Horn with a European Head.* 18th century. Ivory. (Cat. 88)

99

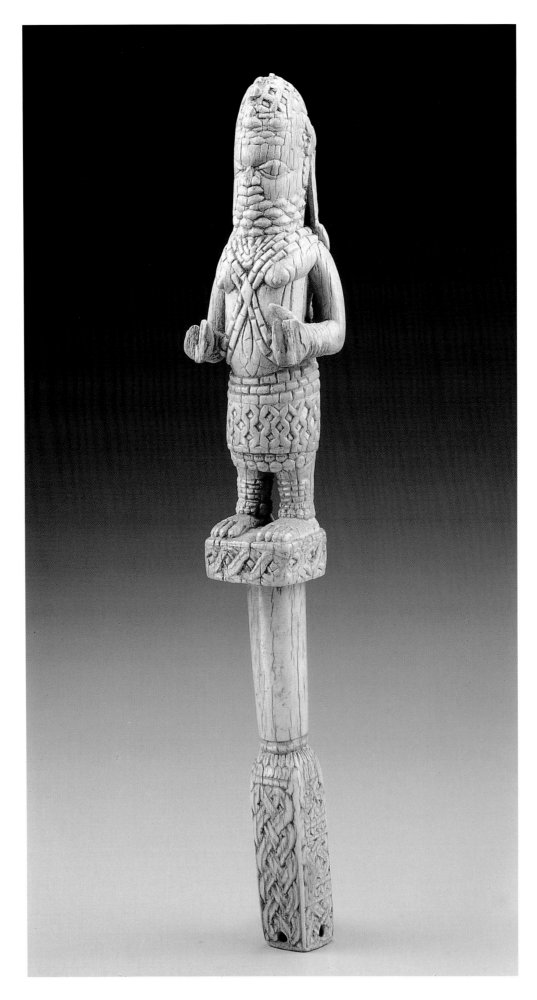

104 *Hand-held Clapper with an Oba.* 18th century. Ivory. (Cat. 78)

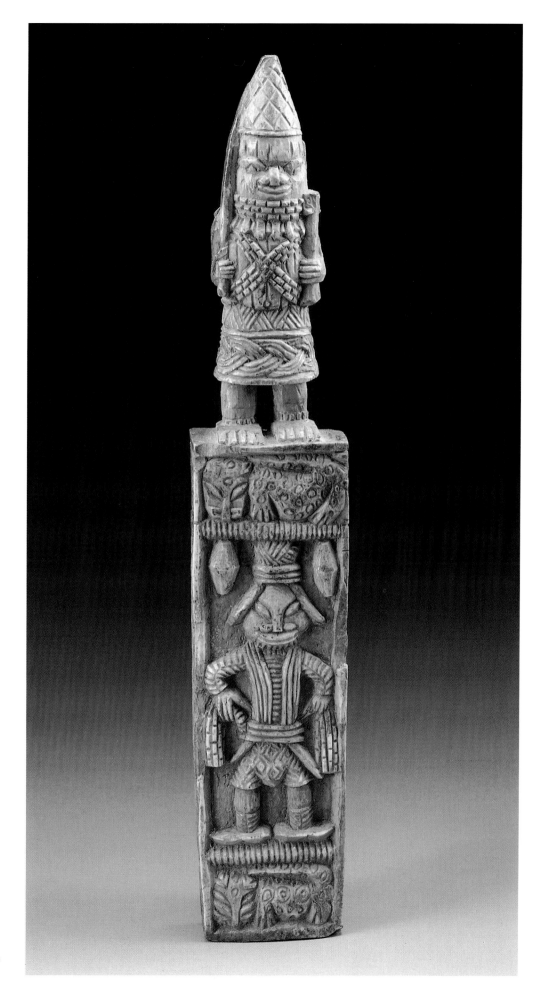

105 *Carved Slab with an Oba, European, and Leopards.* 18th century. Ivory. (Cat. 13)

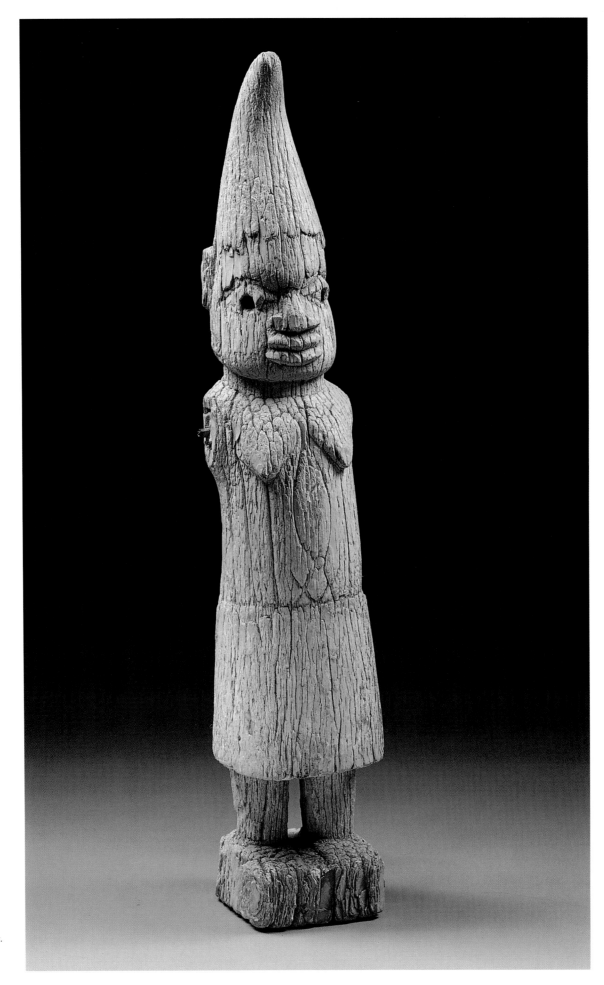

106 *Queen Mother.*
18th/19th century.
Ivory. (Cat. 12)

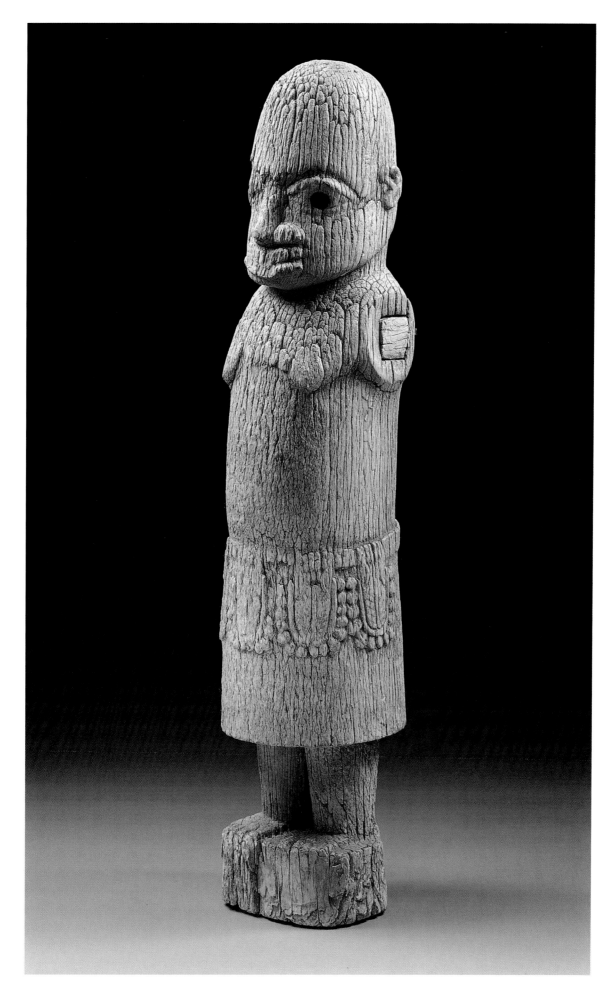

107 *Dignitary.*
18th/19th century.
Ivory. (Cat. 11)

108 Announcing the King's Entrance at Igue, ca. 1985.
Photograph by Joseph Nevadomsky

The History of the Benin Collection in Vienna

Only in the last hundred years has it become customary for ethnographic collections to be displayed openly to the general public. In Austria credit for this goes to Emperor Franz I, who in 1806 acquired parts of the collection that the explorer Captain James Cook had bought at an auction in London. Even then a major problem lay in where to store and display the increasing number of ethnographic objects. Until the founding of the Naturhistorisches Hofmuseum in 1876, which included a department of anthropology and ethnography, ethnographic objects were periodically put on display in the Lower Belvedere or Harrach Palace.[1] Franz Heger (1853–1931), the first curator of the newly established department, worked enthusiastically on building up his inventory systematically. The following statistics illustrate this point. Upon taking office in 1877 Heger found 4,737 objects in the inventory; upon retiring forty-three years later in 1919 there were 94,637 objects, representing an increase of 89,900 items.[2]

The arrival of the first ivory carvings and brass castings in Europe, which followed the destruction of Benin City in the summer of 1897, not only caused a sensation in circles of flabbergasted experts, but also caught the interest of museum representatives and private collectors. Heger was so impressed by both the beauty of these objects and by their significance for West African cultural history that he set about acquiring several pieces for the ethnographic department in Vienna.[3] The piece that would form the cornerstone of Vienna's Benin Collection was a carved elephant's tusk, which Heger bought for 500 marks during a trip to Berlin and the ethnographic museum there. It was thanks to the intervention of Professor Felix von Luschan, the Austrian-born curator of the museum's department of Africana and Oceania, that the purchase was made before the end of 1897.[4]

A variety of problems prevented the further acquisitions that were necessary to build a representative collection of Benin antiquities. On the one hand, the financial means of the Hofmuseum were rather modest (a fate curators still share today), and with the purchase of the elephant's tusk the department's annual budget was nearly exhausted; on the other hand, as a result of the intense interest and demand for these antiquities, it was necessary to act quickly. Heger's ability to obtain more objects can no doubt be attributed to his initiative, energy, and self-sacrifice. It certainly did not hurt that Heger, who came from Bohemia's bourgeois class, knew how to benefit from his contacts with the well-to-do bourgeoisie and aristocracy. By holding out the prospect of orders and medals, he began to secure the necessary funds. As he himself once wrote, the vast majority of all Benin purchases was "owed to the willingness of a number of men to make sacrifices."[5] His most important patron was undoubtedly Georg Karl Augustin Haas (1841–1914) from Schlaggenwald in Bohemia, an industrialist and landowner who, from 1892 on, donated several prehistoric and ethnographic collections. For this he was awarded the Knight's Cross of the Franz Josef Order.[6] Haas's interest in Benin antiquities had been awakened by the Court Councilor and lawyer, Dr. Johann Frank (1840–1904).

At that time, antiquities consisting primarily of ivory carvings and brass castings could be bought either on the coast of West Africa or at auctions in London, or from an English dealer in ethnographica, W. D. Webster of Bicester, Oxfordshire. Webster, a "Collector of Ethnological Specimens, European Arms and Armour," published an illustrated catalogue—initially containing beautiful drawings and later with photographs—that was sent to museums. Heger, too, used it for making purchases. The seventy-five pieces (inventory nos. 64.659–64.733) donated to the Naturhistorisches Hofmuseum by Haas in 1898 came mostly from Webster's warehouse and cost £440, equalling 5,302 gulden. The first piece—again a carved elephant's tusk, assigned number 120 in catalogue 15—was purchased for £80 (fig. 94).[7]

Webster was obviously a good businessman. Not only did he strive continually to secure optimal proceeds from his transactions, but he also personally wrote Heger in an effort to make a sale.[8] Thus in a letter dated 17 October 1898 he offered Heger more new objects. He wanted to send them for inspection, as well as to offer him a line of credit, as he did not doubt that Heger would certainly wish to buy the pieces (he was indeed well informed about the financial and administrative problems of the Hofmuseum). Furthermore he suggested the existence of a new source of purchases: "I know a few other specimens in officers' hands [possibly members of the Punitive Expedition] that I hope to purchase."[9] Finally, he mentioned that the ethnological museum in Berlin possessed the greatest number of Benin

objects: "at the present time I would give double for what I sold Benin specimens for when they first came over." Aside from the sales strategy that Webster employed, it is clear that the demand for antiquities from Benin was greater than the supply, which naturally resulted in an increase in prices.

The shipment that Webster sent in 1898 contained several brass heads, a snake's head, two large panther figures, a statue of a cock, relief plaques, a sword, a scepter, brass and ivory bracelets, bells, and wooden staffs. With this shipment Georg Haas donated two large carved elephant's tusks obtained through Gustav Spiess in Hamburg, which he bought for 1,900 marks (figs. 95, 96).[10] In the following year, a collection consisting of ninety items (inventory nos. 64.743–64.832; figs. 109–120)[11] was purchased for £995, or 12,060 gulden, by direct subscription from Lagos through the efforts of an intermediary, Captain Albert Maschmann. More will be said about him later. Haas was also involved in the subscription, contributing 5,490 gulden. He contributed a total of 14,690 gulden for the Benin Collection. The magnitude of his generosity can be appreciated especially when compared to Heger's salary in 1897, which in that year had reached 3,000 gulden![12] If one adds Haas's Benin endowments to his donations of 60,000 gulden made before 1897, one has the impressive sum of 75,290 gulden (endowments for scientific publications not included). In a report dated 8 February 1898 from the director of the Naturhistorisches Museum to the office of the Obersthofmeisteramt, it is stated that the collections donated by Haas "form together the most important acquisition this department has registered in the more than twenty-one years of its existence. . . . This deed cannot be overestimated as the still young collection is otherwise deprived of every opportunity for making large-scale purchases."[13] Haas, however, was not only a benefactor of the Hofmuseum's collections. His concern for the welfare of his employees in his porcelain and stoneware factory (Firma Haas und Czijak) in Bohemia was exemplary, as can be seen by his establishment of social institutions for them, such as pensions and widow's and orphan's annuities into which he made annual payments. Once again a proposal was sent to the office of the Chamberlain asking that Haas be awarded the highest decoration and/or elevated to the nobility. The request was granted in 1899 with a generous "disregard of the taxes."[14] Although donations to the Hofmuseum ceased once Haas was elevated to the nobility, the institution's inventory had been enriched by a large number of the most varied objects.

Other well-known, aristocratic patrons, whose lives and beneficence were well publicized, also contributed to the subscription. Johannes II, Prince von und zu Liechtenstein (1840–1929), belonged to this circle and enjoyed an excellent reputation as a connoisseur and patron of the arts. He collected paintings, sculptures, and curios, carried out historically accu-

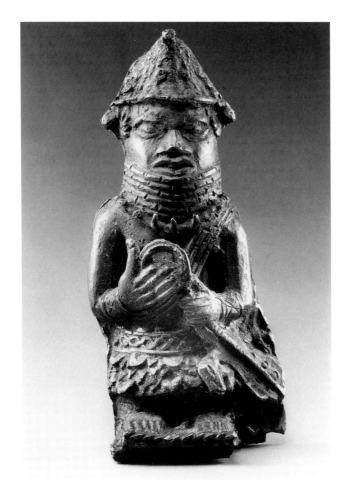 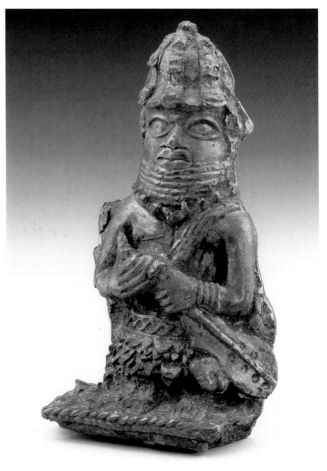

109 *Dignitary.*
19th century. Brass.
(Cat. 6)

110 *Dignitary.*
19th century. Brass.
(Cat. 7)

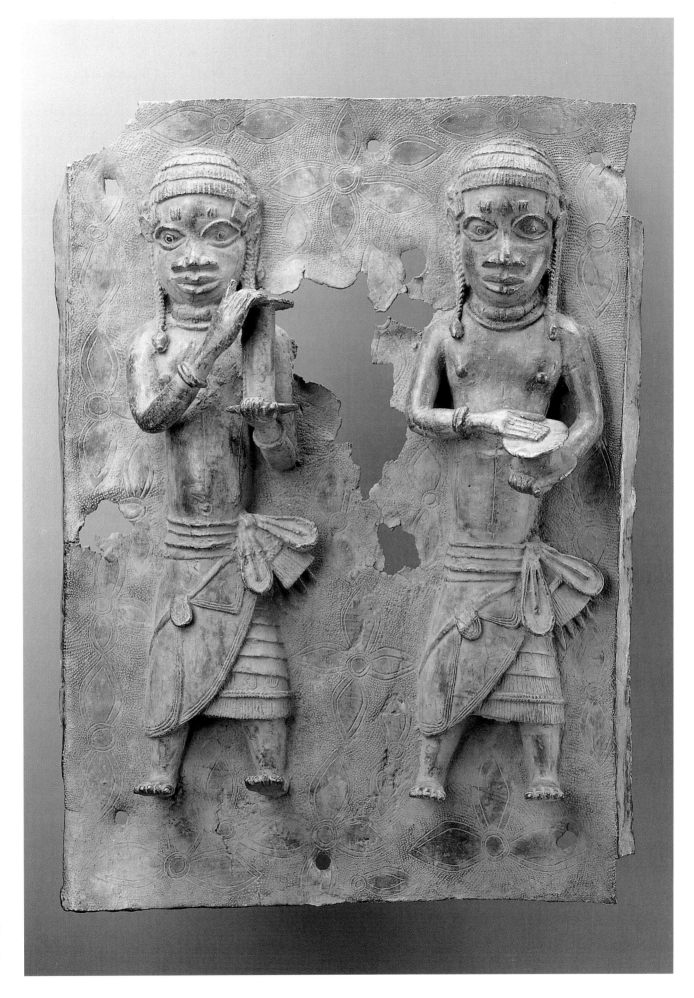

111 *Plaque with
Two Figures Holding
Containers.*
17th century. Brass.
(Cat. 39)

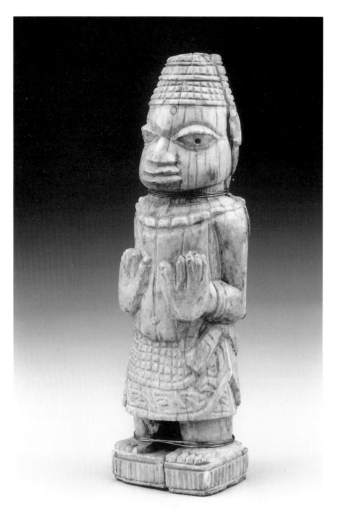

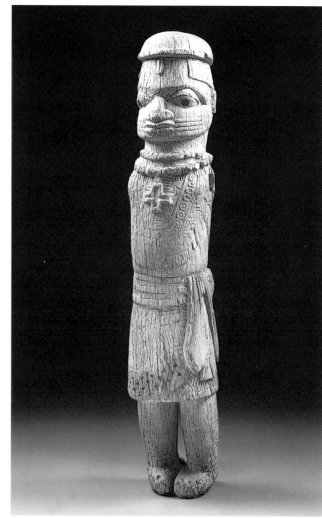

112 *Dignitary.*
18th century. Ivory.
(Cat. 9)

113 *Messenger* or
(Court Official).
18th century. Ivory.
(Cat. 10)

rate restorations of castles belonging to the Liechtensteins, was responsible for the construction of churches, secular buildings and gardens, founded one of the oldest horticultural schools in the monarchy, and donated sizeable collections to scientific institutes and numerous museums.[15] For £200 he purchased the three most famous brass figures in the museum's Department of Anthropology and Ethnography (figs. 67–71, pp. 74–77). In the catalogue included by the above-mentioned Albert Maschmann during the sales negotiations, the dwarfs (figs. 67–70) were said to be "the only perfect pair that were found in the City." The industrialist and politician Nikolaus Dumba (1830–1900), another generous patron of the arts, also contributed 200 gulden. His predilection, however, was music, in particular the works of Franz Schubert. He possessed the vast majority of the composer's manuscripts and donated them eventually to the Gesellschaft der Musikfreunde and the Viennese Library. Dumba was a friend of Johannes Brahms, Johann Strauss, and Richard Wagner; he also supported the fine arts, primarily works by Hans Makart, Gustav Klimt, Carl Kundmann, and Kaspar Zumbusch.[16] Margrave Alexander Pallavicini (1852–1933), Court Chamberlain and Privy Councilor,[17] donated 1,000 gulden. The bankers Nathaniel Freiherr von Rothschild (1836–1905)[18] and Philip Ritter von Schoeller (1864–1906),

partners in the banking house Schoeller in Bohemia and Moravia,[19] contributed 1,000 gulden and £100. Very little is known about the above-mentioned Dr. Johann Frank, Court Councilor and lawyer, who gave 700 gulden to the fund for Benin antiquities. In an application sent to the director of the Naturhistorisches Hofmuseum, Heger requested that Frank be awarded a medal for his services in the negotiations between Haas and the Hofmuseum, which he performed in a "most unselfish manner ... and discreet fashion." Carrying out the "often difficult transactions" would not have been possible without his "working assistance," and the fact that he "unfailingly kept the interests of the Hofmuseum in view."[20] The application was forwarded to the office of the Oberstkämmereramt, where it was approved, and Frank was awarded the Knight's Cross of the Franz Josef Order in May 1901.[21] Frank's wife, Maria, was, by birth, the Baroness von Felder in Bohemia,[22] which explains the good contacts with Haas. Frank appears once more in 1901, when he donated 3,000 marks to purchase the Säuberlich Collection from East Africa.[23] The author knows of no later references concerning him.

The collection for which this subscription had been organized came directly from Lagos, on the West African coast. Captain Albert Maschmann of Hamburg wrote in a letter dated 7

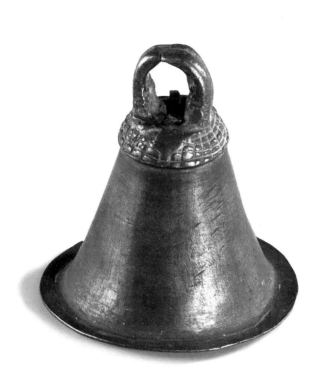

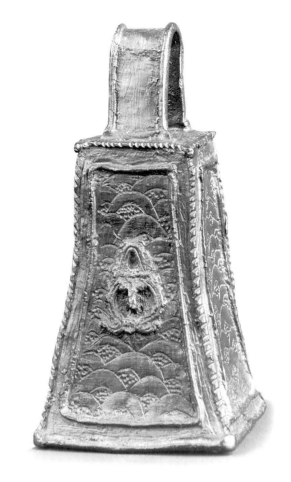

114 *Altar Bell without Clapper.* 19th century. Copper. (Cat. 93)

115 *Bell with Clapper.* 19th century. Brass and iron. (Cat. 94)

116 *Bell with Janus-headed Clapper.* 18th century. Ivory. (Cat. 95)

117 *Bracelet with Human Heads and Leopards.* 18th century. Ivory. (Cat. 92)

118 *Bead Neck-lace*. 18th cen-tury (?). Coral and stone. (Cat. 102)

119 *Necklace with Amulets Containing Magical Substances*. 19th century. Cop-per chain, leather, cowry shells, coral, brass, cloth, and animal tooth. (Cat. 104)

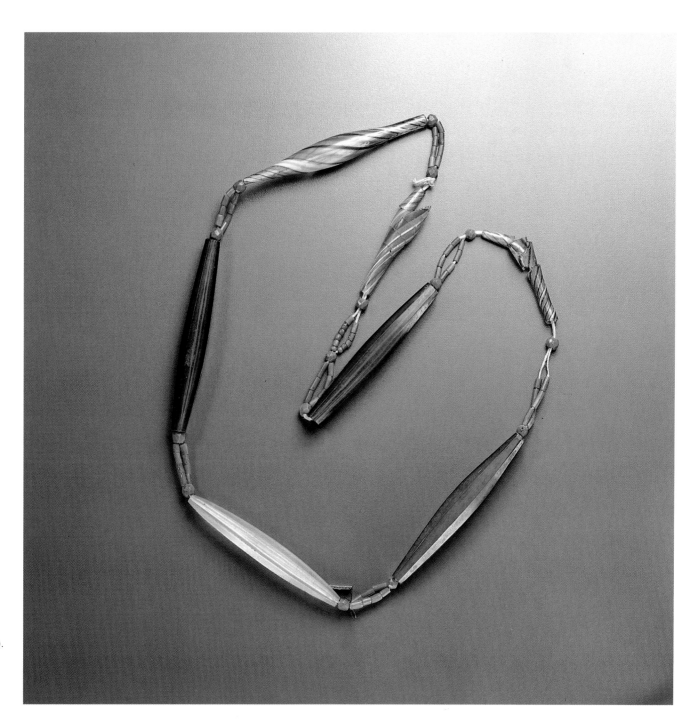

120 *Bead Neck-lace.* 18th century(?). Glass beads of European origin and coral. (Cat. 103)

January 1899 that he regretted having already sold the brass objects, but he had heard nothing from Heger.[24] He did, though, know about a "very valuable and beautiful collection, which belongs to an agent out in Africa whom I have known for years. However, since one has heard about the value of these bronzes even out there, the gentleman has not been able to decide whether to part with them." Maschmann offered to see what could be done. In his next letters he wrote about contacting the gentleman, sent a photograph (which, unfortunately, has been lost), and asked Heger to exercise "utmost discretion . . . so that this photograph for the time being does not become known to [other] museums; I do not wish the sale to be frustrated, since it is the last of its kind."[25] On 23 June 1899, Maschmann quoted from a letter from his agent: "there is none at all to be got after this latest expedition after the King of Benin's chief fighting man (Ologbo shera), which took place a fortnight ago. . . . I sent a man up to the Benin country, but he came back empty handed, having seen nothing at all after the expedition returned." In his next letters he informed Heger that the collection was already on its way to Europe.[26] On 22 August he wrote: "It is becoming even more clear that these bronzes are not meant for me, and that their owner wishes to back out. . . . In a less than friendly letter could be read, for example, 'Come personally, convince

yourself of the value and correctness of the collection, but bring money, otherwise there is no reason for your trip.'" The terms for purchasing the "bronzes" were virtually unacceptable: under no condition was Maschmann to be allowed to inspect them first. On the contrary, the entire sales price had to be paid in cash immediately, otherwise the seller would hand them over to other "prospective buyers." No one had anticipated such difficulties: "I would certainly not have gotten them [the bronzes] . . . because for the owner it was just a business deal, by which earning money was the decisive factor for the Englishman." Maschmann, "in great embarrassment,"[27] had borrowed money against his property and from his father-in-law and had used his property as collateral for other loans; he asked Heger repeatedly to reimburse at least a part of the amount that he had advanced, as "there was only one choice: get the money and buy—or forget it."[28] Through the donations to the subscription, Heger was able to meet his payments to Maschmann and acquire the collection for the Naturhistorisches Hofmuseum, later to be transferred to the present-day Museum für Völkerkunde.

In the same year, nine pieces from the Wilson Collection—once again through the intercession of Professor Felix von Luschan of the Völkerkunde Museum in Berlin—were purchased for 866 gulden and became part of the inventory of the

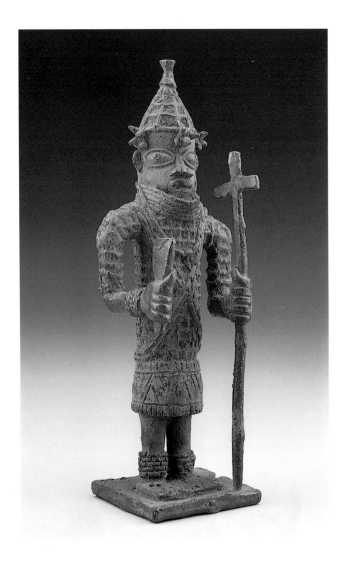

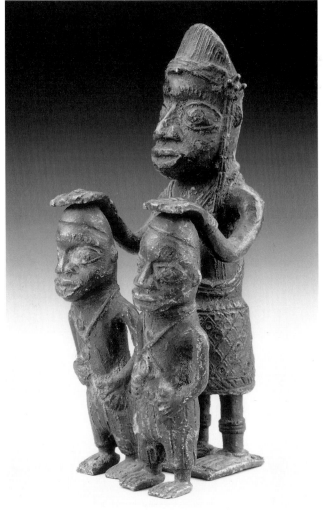

121 *Dignitary Holding a Gong and a Cross.* 19th century. Brass. (Cat. 5)

122 *Oba with Two Dignitaries.* 19th century. Brass. (Cat. 4)

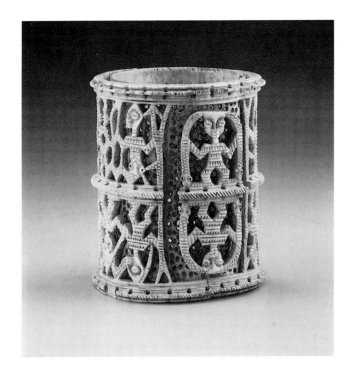

The Vienna Collection of Benin Art will soon mark its centennial. Acquired largely through donations rather than through purchases, it has been open to the public in the Museum für Völkerkunde since the founding of the museum in 1929. Major exhibitions presented not only in the Benin Room, but occupying most of the Africa Halls, too, have made it possible to show this collection in a number of cities, such as Zurich, Paris, Leiden, Brussels, Bologna, and Rottenburg on the Neckar, and now four cities in the United States. The timeless cultural value of the collection cannot hide the fact that its formation derived from the destruction of a civilization. Just as the museum preserves these great objects from Benin, so too does it serve as a reminder of this tragic event in Benin history.

Department of Anthropology and Ethnography (inventory nos. 64.734–64.742).[29] The Hofmuseum bought a relief plaque (fig. 48, p. 61) from Kurt Schembara of Breslau for 95 gulden in 1899.[30] In the following years individual pieces were acquired through funds of the Hofmuseum, thus increasing the number of Benin antiquities in the collection. By this method a saucer, which was assigned number 125 in catalogue 21 from the ethnographic dealer W. D. Webster and cost 733 gulden,[31] and a bracelet (fig. 123) priced at £17 10s entered the collection in the years 1901 and 1905. The acquisition of a part of the collection of Dr. Hans Meyer (1858–1929), explorer and scholar, marked the Benin Collection's completion: in 1918 fourteen objects, such as an elephant's tusk (fig. 90, p. 91), a brass tableau (fig. 77, p. 83), various brass heads and plaques (fig. 37, p. 51; fig. 124), brass figures (figs. 121, 122; fig. 73, p. 80), a bird staff (fig. 63, p. 71)), a ceremonial sword, a bracelet, and a small brass leopard (fig. 58, p. 68), entered the museum's collection at a cost of 6,950 marks.[32] Professor Meyer is best known for his publications based on his expeditions and study tours, which led him to East Africa in the years 1882–83, 1886–87, and 1888–89. In 1889 he was also the first to climb Mount Kilimanjaro. From 1910 to 1914, he was a professor of colonial geography in Berlin and from 1915 on, he taught in Leipzig, where he founded the Bibliographisches Institut and was a member of the Colonial Council.[33] His collection of African art consisted of strikingly beautiful pieces.

The passing of the monarchy marked the end of the age of art patrons who, not least through their donations of additional items to the Benin Collection, had been able to receive personal decorations and prestige. In more recent times only three other purchases have been registered—in 1959, 1991, and 1992. These are a plaque of a flute player (fig. 49, p. 62), a rattle staff, and a ceremonial sword (fig. 21, p. 33).[34]

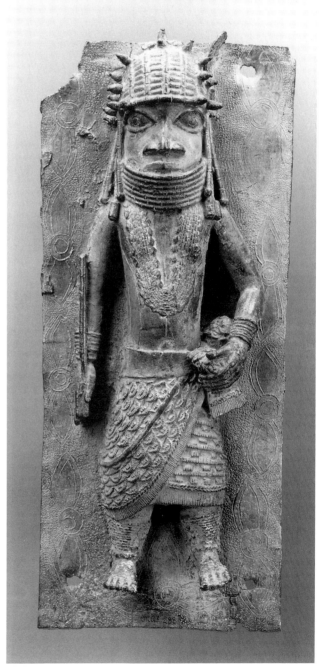

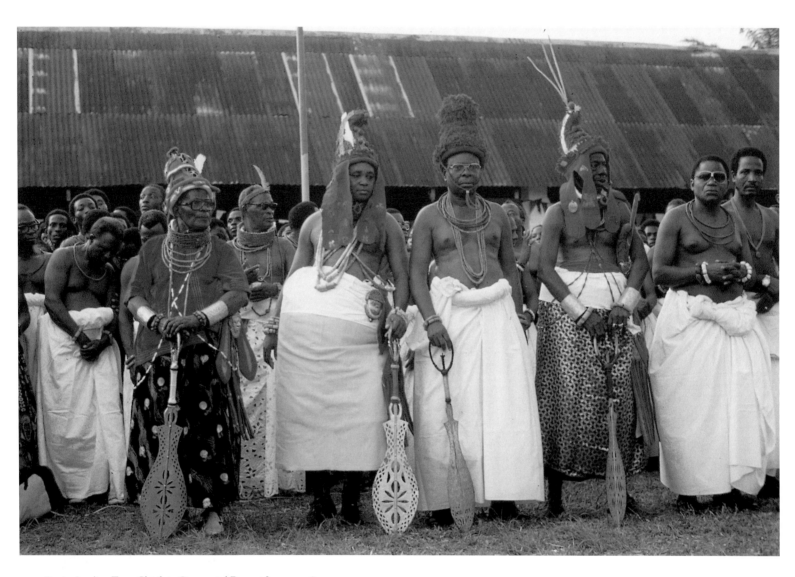

125 Benin: Leading Town Chiefs in Ceremonial Dress at Igue, ca.1985.
Photograph by Joseph Nevadomsky

Notes

Abbreviations used in the Notes:

HHStA: Records of the Haus-, Hof- und Staatsarchiv in Vienna relating to the Naturhistorisches Museum.

IB: Inventory Books of the Museum für Völkerkunde, Vienna.

INahiM: Records and accounts from the Office of the Director of the Naturhistorisches Museum from the years 1890–1905.

NDB: *Neue Deutsche Biographie*.

NÖB: *Neues Österreichisches Biographisches Lexikon*.

ÖBL: *Österreichisches Biographisches Lexikon*.

The History of the Kingdom of Benin

1 Cf. Graham Connah, "Archaeological Research in Benin City 1961–1964," *Journal of the Historical Society of Nigeria* 2, no. 4 (1963): 456–77; *The Archaeology of Benin: Excavations and Other Researches in and around Benin City, Nigeria* (Oxford, 1975).

2 Jacob U. Egharevba, *The Origin of Benin* (Benin City, 1954); *A Short History of Benin*, 4th ed. (Ibadan, 1968).

3 Cf. G. A. Akinola, "The Origin of the Eweka Dynasty of Benin: A Study in the Use and Abuse of Oral Traditions," *Journal of the Historical Society of Nigeria* 8, no. 3 (1976); Paula Ben-Amos, *The Art of Benin* (London, 1980); Mechthildis Jungwirth, *Benin in den Jahren 1485–1700: Ein Kultur- und Geschichtsbild* (Vienna, 1968).

4 "Many, many years ago, the Binis came all the way from Egypt to found a more secure shelter in this part of the world after a short stay in the Sudan and at Ile Ife . . . ," Egharevba, *Short History of Benin*, 1; Ade Obayemi, "The Yoruba and Edo-Speaking Peoples and their Neighbors before 1600," in *History of West Africa*, vol. 1, 2d ed., edited by J. F. A. Ajayi and Michael Crowder (New York, 1976), 241–42.

5 P. Dittel, "Die Besiedlung Südnigeriens von den Anfängen bis zur Britischen Kolonisation," *Wissenschaftliche Veröffentlichung des D. Museums für Länderkunde zu Leipzig*, n.s., 3 (1936): 71–116; R. E. Bradbury, *The Benin Kingdom and the Edo-Speaking Peoples of the South-Western Nigeria*. Ethnographic Survey of Africa: Western Africa, pt. 13 (London, 1957), 116.

6 Connah, *Polished Stone Axes in Benin* (Apapa, 1964), 7 et seq.

7 Egharevba, *Origin of Benin* and *Short History of Benin*, 1.

8 Bradbury, *Benin Kingdom*, 19.

9 Philip Aigbona Igbafe, "Benin in the Pre-Colonial Era," *Tarikh* 5, no. 1 (London, 1974): 5.

10 Egharevba, *Short History of Benin*, 1–3.

11 Igbafe, "Benin in the Pre-Colonial Era," 5.

12 Ibid., 6.

13 Ibid. See also Egharevba, *Short History of Benin*, 1.

14 Ben-Amos, *Art of Benin*, 15.

15 Egharevba, *Short History of Benin*, 1; Connah, *Archaeology of Benin*.

16 Egharevba, *Short History of Benin*, 3.

17 Peter M. Roese, "Das Königreich Benin—von den Anfängen bis 1485," *Anthropos* 79 (1984): 200.

18 Ben-Amos, *Art of Benin*, 15.

19 Bradbury believes that it is not possible to determine the date of the beginning of the kingdom of Benin as creation myths equate the time of the first war with the birth of the earth's population. See *Benin Studies* (London, 1973), 7.

20 Philip J. C. Dark, *An Introduction to Benin Art and Technology* (Oxford, 1973), 8; Ben-Amos, *Art of Benin*, 15.

21 Egharevba, *Short History of Benin*, 5.

22 Ekpo Eyo and Frank Willett (eds.), *Treasures of Ancient Nigeria*, London (1982), 26; cf. Egharevba, *Short History of Benin*, 6; Bradbury, *Benin Studies*, 8.

23 Akinola, "The Origin of the Eweka Dynasty," 35; cf. also A. F. C. Ryder, "A Reconsideration of the Ife-Benin Relationship," *Journal of African History* 6, no. 1 (1965): 25–37. Ryder describes an opposition directed towards Oranmiyan in his new land: "Oranmiyan grew tired of the opposition he constantly met from the chiefs of Benin and decided to return to Ife."

24 Bradbury, *Benin Studies*, 8.

25 Egharevba, *Short History of Benin*, 9; Ryder, *Benin and the Europeans, 1485–1897* (London, 1969), 5.

26 Cf. Bradbury, *Benin Studies*, 44–45.

27 Ben-Amos, *Art of Benin*, 18.

28 Egharevba, *Short History of Benin*, 13.

29 Ibid., 14.

30 Jungwirth, *Benin in den Jahren 1485–1700*, 217.

31 Ryder, *Benin and the Europeans*, 11.

32 Roese, "Das Königreich Benin," 215, and "Erdwälle und Gräben im ehemaligen Königreich von Benin," *Anthropos* 76 (1981): 174–75; Egharevba, *Short History of Benin*, 14; Connah, "New Light on the Benin City Walls," *Journal of the Historical Society of Nigeria* 3 (1967), no. 4: 593–609.

33 Egharevba, *Short History of Benin*, 17; Ryder, *Benin and the Europeans*, 8–9; Bradbury, *Benin Studies*, 34–139.

34 Egharevba, *Short History of Benin*, 76; Ryder, *Benin and the Europeans*, 10–11; Bradbury, *Benin Studies*, 138.

35 Ben-Amos, *Art of Benin*, 20.

36 Bradbury, *Benin Studies*, 133, 270; Roese, "Die Hierarchie des ehemaligen Königreiches Benin aus der Sicht zeitgenössischer europäischer Beobachter," *Ethnographisch-Archäologische Zeitschrift* 29 (1988), 58–59; Roese, "Neues Material im Zusammenhang mit dem möglichen Ursprung der Akori-Perlen, die als Handelsartikel aus Benin bekannt waren," *Wiener Völkerkundliche Mitteilungen*, n.s., 32 (1990): 75–81.

37 Bradbury, *Benin Studies*, 278.

38 Antonio Galvão, *Tradado dos Descobrimentos* (1555), Porto, 1944; English ed., C. B. Bethune, ed., *The Discoveries of the World . . . 1555 by Antonio Galvano* (London, 1862), 75.

39 Egharevba, *Short History of Benin*, 23.

40 Duarte Pacheco Pereira, *Esmeraldo de Situ Orbis* (1505), ed. Raymond Mauny (Bissau, 1956), 134.

41 João de Barros, *De Ásia* (1552), 6th ed., Lisbon, 1944, decade 1, bk. 3, chap. 3, 88 and chap. 4, 90; Ruy de Pina, *Chronica del Rey Dom João II* (Lisbon, 1712), chap. 24.

42 de Pina, *Chronica*, chap. 24. English translation in John William Blake, *Europeans in West Africa, 1450–1560* (London, 1941), 78–79.

43 Akinola, "Origin of the Eweka Dynasty," 232, 305 n. 27.

44 Samuel Johnson, *The History of the Yorubas: From the Earliest Times to the Beginning of the British Protectorate* (London, 1921), 18.

45 Ryder, *Benin and the Europeans*, 35.
46 Pereira, *Esmeraldo de Situ Orbis*, 124.
47 Blake, *Europeans in West Africa*, 89.
48 Ibid., 106.
49 Pereira, *Esmeraldo de Situ Orbis*, chap. 8.
50 Ibid.; Ryder, *Benin and the Europeans*, 37; cf. Leo Frobenius, *Und Afrika sprach . . .* (Berlin, 1912); Frank Willett, "Ife and Its Archaeology," *Journal of African History* 1, no. 2 (1960); Milan Kalous, "A Contribution to the Problem of Akori Beads," *Journal of African History* 7, no. 1 (1966).
51 Joseph Marquart, *Die Benin-Sammlung des Reichsmuseums für Völkerkunde in Leiden . . .* (Leiden, 1913), 186; Ryder, *Benin and the Europeans*, 37; Roese, "Neues Material," 81.
52 Jungwirth, *Benin in den Jahren 1485–1700*, 238.
53 Ryder, *Benin and the Europeans*, 40; Olfert Dapper, *Naukeurige beschrijvinge der Afrikaensche Gewesten* (Amsterdam, 1668), 127. German ed.: *Umbständliche und Eigentliche Beschreibung von Africa* (Amsterdam, 1670), 490.
54 Egharevba, *Short History of Benin*, 29.
55 Roese, "Das Königreich Benin," 59.
56 de Barros, *De Ásia*, decade 1, bk. 3, chap. 3, 88 and chap. 4, 90; Avelino Teixeira da Mota, "Novos Elementos sobre a acção dos Portugeses e Franceses em Benin na primeira metade do século XVI," *Proceedings of the Third International West African Conference* (1949), 246.
57 Ryder, *Benin and the Europeans*, 46.
58 Letter from King Manuel II to the King of Benin, 21 November 1514, quoted in Ryder, *Benin and the Europeans*, 47.
59 Letter from Duarte Pires to King Manuel II, 20 October 1516, quoted in Blake, *Europeans in West Africa*, 123–24; António Brásio, *Monumenta Missionária Africana* 1 (Lisbon, 1952): 367–70; Egharevba, *Short History of Benin*, 20.
60 Jungwirth, *Benin in den Jahren 1485–1700*, 244; Ryder, *Benin and the Europeans*, 49–50; R. E. Bradbury, "Chronological Problems in the Study of Benin History," *Journal of the Historical Society of Nigeria* 1, no. 4 (1959): 279.
61 Brásio, "Politica do espirito no Ultramar Português," *Portugal em Afrika*, 2nd ser., nos. 5, 6 (1949), 20–29.
62 Jungwirth, *Benin in den Jahren 1485–1700*, 253.
63 de Barros, *De Ásia*, decade 1, bk. 3, chap. 4.
64 Walter Hirschberg, *Die Kulturen Afrikas* (Frankfurt, 1974), 253–54.
65 Ben-Amos, *Art of Benin*, 28–29.
66 Letter from the missionaries in Benin to King John III of Portugal, 30 August 1539, in Brásio, *Monumenta Missionária Africana* 2 (Lisbon, 1954), 79–82.
67 Ryder, *Benin and the Europeans*, 70–72; cf. Ryder, "The Benin Missions," *Journal of the Historical Society of Nigeria* (1961) 2, no. 2, 237–40.
68 Jungwirth, *Benin in den Jahren 1485–1700*, 258.
69 Ben-Amos, *Art of Benin*, 28.
70 In 1596 various Afro-Portuguese works of ivory, such as hunting horns and salt containers, were entered in the inventory of Schloss Ambras in Tirol. Today the majority of them are located in the Museum für Völkerkunde, Vienna. See Franz Heger, "Alte Elfenbeinarbeiten aus Afrika in den Wiener Sammlungen," *Mitteilungen der Anthropologischen Gesellschaft in Wien* 29 (1899): 101–9.
71 Armand Duchâteau, "Konfrontation und Akkulturation: Das Bild der Weissen in früheren afrikanischen Mythen und Legenden," in *Europäisierung der Erde?*, Wiener Beiträge zur Geschichte der Neuzeit 7 (Vienna, 1981): 55–72.
72 Ben-Amos, *Art of Benin*, 28.
73 Blake, *European Beginnings in West Africa* (London, 1937), chap. 6.
74 Ryder, *Benin and the Europeans*, 68–69.
75 Blake, *Europeans in West Africa* 2, 283–84.
76 This unfortunate enterprise was reported by Richard Eder (1521?–76), who was known as a translator of travel literature. His account was based on information supplied by seamen who had taken part in the trip. He published his report in his work *Decades of the New World* (1544), which was used in the Hakluyt collection of travel accounts, *The Principal Navigations* (London, 1599). See also Blake, *Europeans in West Africa* 2: 314–20; Ryder, *Benin and the Europeans*, 76–78; Jungwirth, *Benin in den Jahren 1485–1700*, 25–28, 257–60.
77 Ryder, *Benin and the Europeans*, 88.
78 D. R.'s account is quoted in Pieter de Marees, *Beschryvinge ende historische verhael vant Gout Koninckrijck van Gunea anders de Gout-custe de Mina* (Amsterdam, 1602), 115a–21a. English. ed.: Albert van Dantzig and Adam Jones (eds. and trans.), *Description and Historical Account of the Gold Kingdom of Guinea* (1602) (Cambridge, 1987), 226–34.
79 These ditches were already mentioned by Pereira in 1505, *Esmeraldo de Situ Orbis*, 137; cf. Egharevba, *Short History of Benin*, 11–12; Roese, "Das Königreich Benin," 208–9; Marees, *Beschryvinge*, 115a (trans. by van Dantzig and Jones, 226).
80 Marees, *Beschryvinge*, 115b (trans. by van Dantzig and Jones, 227).
81 Ibid., 116a (trans. by van Dantzig and Jones, 228).
82 Ryder, *Benin and the Europeans*, 86.
83 Marees, *Beschryvinge*, 116a–b (trans. by van Dantzig and Jones, 228–29).
84 Cf. Pereira, *Esmeraldo de Situ Orbis*, 135, 137; James Welsh, account in Richard Hakluyt, *The Principal Navigations*, 126–33.
85 Pereira, *Esmeraldo de Situ Orbis*, 137.
86 Jungwirth, *Benin in den Jahren 1485-1700*, 202–4, 279–80.
87 Egharevba, *Short History of Benin*, 33.
88 Jungwirth, *Benin in den Jahren 1485–1700*, 280.
89 Egharevba, *Short History of Benin*, 33–34.
90 Jungwirth, *Benin in den Jahren 1485–1700*, 204, 254.
91 Dapper, *Umbständliche*, 493–94.
92 Ibid., 491, 493.
93 Ibid., 486.
94 Egharevba, *Short History of Benin*, 34.
95 Ibid., 33.
96 William Bosman, *A New and Accurate Description of the Coast of Guinea* (London, 1705): 435; reprint ed. by J. R. Willis, J. D. Fagg, and R. E. Bradbury, 1967. Originally published as *Neuwkeurige Beschreyvinghe van de Guinese Goud-Tand-en Slave-kust* (Utrecht, 1704).
97 Ryder, *Benin and the Europeans*, 17–18; Egharevba, *Short History of Benin*, 34.
98 Ryder, *Benin and the Europeans*, 114.
99 Jean Barbot, *A Description of the Coast of North and South Guinea*, vol. 5 in *A Collection of Voyages and Travels*, edited by Awnsham Churchill (London 1732), 361.
100 Ryder, *Benin and the Europeans*, 143.
101 Ibid., 20–21, 145, 150; Egharevba, *Short History of Benin*, 39–40; Ben-Amos, *Art of Benin*, 32, pl. 33.
102 Sir Richard Burton, "My Wanderings in West Africa," Pt. 2, "The Renowned City of Benin," *Fraser's Magazine* 67 (March, 1863): 273–89.
103 *Royal Coast Gazette* 1, nos. 21, 25 (March, 1823), quoted in Ben-Amos, *Art of Benin*, 39–42.
104 Egharevba, *Short History of Benin*, 51–53.
105 Burton, "My Wanderings in West Africa"; Ambroise Palisot, Baron de Beauvois, "Notice sur le peuple de Bénin," *La Décade philosophique, littéraire et politique* 9, no. 12 (1801), 141–51; Ryder, *Benin and the Europeans*, 247, 249.
106 Egharevba, *Short History of Benin*, 51.
107 Ryder, *Benin and the Europeans*, 271. For text of treatise, see Egharevba, *Short History of Benin*, 86–88.
108 J. O. E. Sagay, *Benin Kingdom and the British Invasions*, 1970, pp. 16–18.
109 Ryder, *Benin and the Europeans*, 273–74.
110 Quoted in Ryder, *Benin and the Europeans*, 284.
111 Telegram from Lord Salisbury, Prime Minister and Foreign Secretary, to Phillips, 8 January 1897. Quoted in Ryder, *Benin and the Europeans*, 285.
112 For details about this incident see the British White Paper "Papers Relating to the Massacre of British Officials near Benin and the Consequent Punitive Expedition," *Africa* 6 (London, 1897); Sagay, *Benin Kingdom*, 18–22; A. M. Boisragon, *The Benin Massacre* (London, 1897).
113 R. H. S. Bacon, *Benin, the City of Blood* (London, 1897).
114 "Papers Relating to the Massacre," 45 et seq.
115 The fire was started by native porters, probably Itsekiri, who had been playing with gunpowder. Contrary to the widespread belief, it was not laid by the British expedition corps. The first source of the fire was in the immediate vicinity of the British hospital, from which the sick and injured had to be hastily removed. For more accurate background information concerning the Benin fire and the capture of the city, see William Fagg, "Benin: The Sack That Never Was," in *Images of Power: Art of the Royal Court of Benin*, ed. Flora S. Kaplan (New York, 1981), 20–21.
116 Sagay, *Benin Kingdom*, 31.
117 Henry Ling Roth, *Great Benin: Its Customs, Art and Horrors* (Halifax, 1903), app. 3, xiii; Egharevba, *Short History of Benin*, 51–52.
118 Moor to the Foreign Office, 18 October 1897, quoted in Ryder, *Benin and the Europeans*, 293.
119 Sagay, *Benin Kingdom*, 34–35; Roth, *Great Benin*, app. 3, xvii–xviii; Egharevba, *Short History of Benin*, 57–59.
120 "Papers Relating to the Massacre," 45–47.
121 Ibid., 46.
122 Felix von Luschan, *Die Altertümer von Benin* (Berlin, 1919), 14.

The Court Hierarchy

1 Bradbury, *Benin Studies*, 75.
2 Ibid.
3 Ibid.; Ryder, *Benin and the Europeans*, 16.
4 Thomas Hodgkin, ed., *Nigerian Perspectives: An Historical Anthology* (London, 1960), 101; Bradbury, *Benin Studies*, 74.
5 Dapper, *Umbständliche*, 492.
6 Bradbury, *Benin Studies*, 216.
7 Pereira, *Esmeraldo de Situ Orbis*, 134–35; D. R. in Marees, *Beschryvinge*, 116a–b (trans. by van Dantzig and Jones, 228).
8 Dapper, *Umbständliche*, 486.
9 D. R. in Marees, *Beschryvinge*, 116b (trans. by van Dantzig and Jones, 228).
10 David van Nyendael, "A Description of the Rio Formosa, or, The River of Benin," in Bosman, *A New and Accurate Description*: 453.
11 Ben-Amos, *Art of Benin*, 64.
12 Egharevba, *Short History of Benin*; Roth, *Great Benin*.
13 Ben-Amos, *Art of Benin*, 68.
14 Ibid., 75.
15 van Nyendael, "A Description of the Rio Formosa," in Bosman, *A New and Accurate Description*: 436–37; Marquart, *Die Benin-Sammlung*, 25–26.
16 Ben-Amos, *Art of Benin*, 85–88.
17 Dapper, *Umbständliche*, 492.
18 Ben-Amos, "In Honor of Queen Mothers," in *The Art of Power, The Power of Art: Studies in Benin Iconography*, eds. Paula Ben-Amos and Arnold Rubin (Los Angeles: Fowler Museum of Cultural History, UCLA, 1983), 79; Dark, *An Introduction to Benin Art*, 12.
19 Ryder, *Benin and the Europeans*, 106, 309–10.
20 Ben-Amos, *Art of Benin*, 25 (caption to pl. 23).
21 von Luschan, *Die Altertümer von Benin*, 350–53; Kate Ezra, *Royal Art of Benin: The Perls Collection in the Metropolitan Museum of Art* (New York, 1992), 41. The importance of the Queen Mother can be seen in the fact that only she, the Oba, and the Ezomo (the Oba's chief military commander) were allowed to wear the coral-bead crown.
22 Ben-Amos, "In Honour of Queen Mothers," in *The Art of Power*, 82; Egharevba, *Short History of Benin*, 75.

23 Ben-Amos, "In Honour of Queen Mothers," in *The Art of Power*, 82.
24 Bradbury, *Benin Studies*, 52.
25 Roese, "Die Hierarchie," 51–52.
26 Egharevba, *Short History of Benin*, 9.
27 Ibid.; Bradbury, *Benin Studies*, 11 et seq.
28 Hans Melzian, "Zum Festkalender von Benin," in J. Lukas (ed.), *Afrikanische Studien* 26 (Berlin, 1955): 90 et seq.; Bradbury, Benin Studies, 13; Jungwirth, *Benin in den Jahren 1485–1700*, 116; Roese, "Die Hierarchie," 55 et seq.
29 Roese, "Die Hierarchie," 60; Egharevba, *Short History of Benin*, 77.
30 Melzian, "Zum Festkalender von Benin," 91.

The Art of Brasscasting

1 Copper alloys known today are classified according to their percentage of tin (bronze or, more accurately, tin bronze) or zinc (brass). Benin castings, too, were often referred to as bronze or brass. Strictly speaking, neither term (bronze or brass) encompasses all castings found in Benin, as not all Benin alloys contained tin or zinc, at least not to a degree that could justify the precise use of the word. Nevertheless, several authors believe that the general term "brass" can be used in its more general meaning of any copper alloy capable of being cast (see Siegfried Wolf, "Neue Analysen von Benin-Legierungen in vergleichender Betrachtung," *Abhandlungen und Berichte des Staatlichen Museums für Völkerkunde Dresden* 28 [Dresden, 1968]: 95–96). Thus, the designation "brass" is used not only with alloys of copper and zinc, but also with alloys of several metals that, in addition, contain tin or lead (ibid., 97). The particular copper alloy chosen depended on its use. While the upper limit for the amount of zinc in relief plaques was about 20 percent, heads and statues usually had substantially more. Plaques sometimes had especially high levels of lead (8.5–13 percent), while with heads the upper value was approximately 8.5 percent. The tin content in plaques was generally less than 5 percent, and in heads less than 4 percent. In plaques the tin content decreased inversely to increases in zinc content and normally was never greater than the amount of lead (ibid., 106).
2 Frobenius, *Die atlantische Götterlehre* (Jena, 1926), 16.
3 Frobenius, *Das unbekannte Afrika* (Munich, 1923), 172; Frobenius, "Terrakotten von Ife," *Feuer* 3 (Wiesbaden, 1921–22), 26.
4 Raymond Mauny, "A Possible Source of Copper for the Oldest Brass Heads of Ife," *Journal of the Historical Society of Nigeria* 2, no. 3 (1962): 393–95; Mauny, "Essai sur l'histoire des métaux en Afrique Occidentale," *Bulletin de l'IFAN* 14, no. 2 (1952): 545–95.
5 Heinz Sölken, "Innerafrikanische Wege nach Benin," *Anthropos* 49 (1954): 825–26.
6 Ivor Wilks, "A Medieval Trade-Route from Niger to the Gulf of Guinea," *Journal of African History* 3, no. 2 (1962): 337–41.
7 Jacques Berthot and Raymond Mauny, "Archéologie des Pays Yoruba et du Bas-Niger," *Notes Africaines* 56 (1952): 113.
8 Thurston Shaw, "Those Igbo-Ukwu Radiocarbon Dates: Facts, Fictions and Probabilities," *Journal of African History* 16, no. 4 (1975): 513.
9 Eustache de La Fosse, who traveled the coast of Guinea in 1479–80, already mentioned bartering for bracelets and kettles. See Raymond Mauny, "Eustache de la Fosse: Voyage dans l'Afrique occidentale (1479–80)," in *Boletim Cultural da Guiné Português* 44 (1949): 186; cf. Pereira, *Esmeraldo de Situ Orbis*, 77, 81, 85, 95.
10 R. Braamcamp, *Archivo Histórico Português*, vol. 2 (Porto, 1898); Blake, *Europeans in West Africa*, 111.
11 Pereira, *Esmeraldo de Situ Orbis*, 131, 135, 147, 149.

12 Blake, *Europeans in West Africa*, 111–12.
13 von Luschan, *Die Altertümer von Benin*, 507–8.
14 Irwin Leonard Tunis, "Origins, Chronology and Metallurgy of the Benin Wall Bas-Reliefs" (Ph. D. diss., University of London, 1979), vol. 1.
15 Jakob Strieder, "Negerkunst von Benin und deutsches Metallexportgewerbe im 15. und 16. Jahrhundert," *Zeitschrift für Ethnologie* 64 (1932): 251–52.
16 Thurston Shaw, "Spectrographic Analyses of the Igbo and Other Nigerian Bronzes," *Archaeometry* 8 (1965), 95.
17 Walter Buchanan Cline, *Mining and Metallurgy in Negro Africa*. General Series in Anthropology 5 (Menasha, Wisconsin, 1937): 79.
18 Wilhelm Peter Bauer, "Zusammensetzung und Gefügestruktur dreier Flachkappenköpfe aus Benin," *Abhandlungen und Berichte des Staatlichen Museums für Völkerkunde Dresden* 34 (Dresden, 1975): 37. This analysis is based on research by Bauer, 31–39.
19 Ben-Amos, *Art of Benin*, 17–18; cf. Connah, *Archaeology of Benin*.
20 Ben-Amos, *Art of Benin*, 17; cf. Egharevba, *Short History of Benin*, 11.
21 J. F. Landolphe, *Mémoires du Capitaine Landolphe*, vol. 1, ed. Jacques Salbigoton Quesne (Paris, 1823), 12.
22 Cf. Egharevba, *Short History of Benin*, 11. In this source, however, it is not clear whether one has the original introduction of the process, or only of specific characteristics, or only of a clan of casters' guilds in the palace of Benin. Cf. Ben-Amos, *Art of Benin*, 17–18; Bradbury, *Benin Studies*, 42; Fagg, "The Sack That Never Was," 64. Egharevba and Fagg are of the opinion that this event occurred about 1290, whereas Bradbury dates it about 1390.
23 Dark, *Benin Art* (London, 1965), 16; Wolf, "Elfenbein und Bronze: Vergleich zwischen Benin-Arbeiten verschiedenen Materials," *Abhandlungen und Berichte des Staatlichen Museums für Völkerkunde Dresden* 30 (Dresden, 1970): 173.
24 Frank Willett, *Ife in the History of the West African Sculpture* (London and New York, 1967), 163; Dark, "Cire-Perdue Casting: Some Technological and Aesthetical Considerations," *Ethnologica*, n.s., 3 (1966): 226.
25 Wolf, "Elfenbein und Bronze," 177–78.
26 Wolf, *Benin* (Die Schatzkammer, vol. 28) (Leipzig, 1972), 13.
27 Bradbury, *Benin Studies*, 43.
28 Ibid., 43.
29 de Barros, *De Ásia*, decade 1, bk. 3, chap. 4, 90.
30 Wolf, "Elfenbein und Bronze," 155.
31 Fagg, *Nigeria: 2000 Jahre Plastik* (Basel, 1962), 19; Fagg, *Nigerian Images* (London, 1963), 23.
32 Ben-Amos, "Symbolism in Olokun Mud Art," *African Arts* 6, no. 4 (1973): 28–31.
33 Fagg, *Nigerian Images*, 23.
34 Dark, "Benin Bronze Heads: Styles and Chronology," *African Images: Essays in African Iconology*, eds. Daniel F. McCall and Edna G. Bay, Boston University Papers on Africa, vol. 6 (New York, 1975), 61.
35 Joseph Nevadomsky, "The Benin Bronze Horseman as the Ata of Idah," *African Arts* 19, no. 4 (1986): 42–43; Bryna Freyer, *Royal Benin Art in the Collection of the National Museum of African Art* (Washington, D.C.: Smithsonian Institution Press, 1987), 19; Ezra, *Royal Art of Benin*, 32–33.
36 Dark, "Benin Bronze Heads," 38–48; cf. Dark, *Introduction to Benin Art and Technology*, 9–11.
37 The very exact studies of Irwin Leonard Tunis, in particular, were used here. Cf. Tunis, "The Benin Chronologies," *African Arts* 14, no. 2 (1981): 86–87; Tunis, "A Note on Benin Plaque Termination Dates," *Tribus* 32 (1982): 45–53.
38 Dapper, *Umbständliche*, 486.
39 Charles Hercules Read and Ormonde Maddock Dalton, *Antiquities from the City of Benin and from Other Parts of West Africa in the British Museum* (London, 1899), 4–6; Marquart, *Die Benin-Sammlung*, 42–43; Tunis, "Origins, Chronology and Metallurgy," 68–69.
40 Roth, *Great Benin*, 229.
41 von Luschan, *Die Altertümer von Berlin*, 22.

42 Bernhard Struck, "Chronologie der Benin Altertümer," *Zeitschrift für Ethnologie* 55 (1923): 141.
43 Strieder, "Negerkunst," 256; Ben-Amos, *Art of Benin*, 28.
44 von Luschan, *Die Altertümer von Berlin*, 23.
45 Werner Forman, Bedřich Forman, and Philip J. C. Dark, *Benin Art* (London, 1960), 21–22; cf. Dark, *Introduction to Benin Art*, 3 et seq.
46 Forman and Dark, *Benin Art*, 24.
47 Freyer, *Royal Benin Art*, 43; Tunis, "Origins, Chronology and Metallurgy," 69.
48 Forman and Dark, *Benin Art*, 21–22.
49 Cf. Ryder, "A Reconsideration of the Ife-Benin Relationship," 25–37.

The Art of Benin and Its Symbolism

1 Ben-Amos, "Introduction: History and Art in Benin," in *The Art of Power*, 15.
2 Bradbury, *Benin Studies*, 263.
3 Fagg, *Divine Kingship in Africa* (London, 1970), 4, 18.
4 Ben-Amos, *Art of Benin*, 18.
5 Fagg, *Nigerian Images*, 23; Stacy Schaefer, "Benin Commemorative Heads," in *The Art of Power*, 75; Ben-Amos, *Art of Benin*, 18; Ezra, in *Royal Art of Benin*, 38, places one head, which stylistically—according to Fagg — belongs to the first period, in the fifteenth to nineteenth century.
6 Ben-Amos, *Art of Benin*, 18.
7 Fagg, *Nigerian Images*, 23.
8 Schaefer, "Benin Commemorative Heads," 71–72.
9 See figs. 24, 25, 26.
10 Ibid.
11 Schaefer, "Benin Commemorative Heads," 75.
12 Ibid., 77; cf. Jack Gallagher, "Between Realms: The Iconography of Kingship in Benin," in *The Art of Power*, 23.
13 Cf. John Adams, *Remarks on the Country from Cape Palmas to the River Congo* (London, 1823), 111; Roth, *Great Benin*, 76.
14 Dark, *Introduction to Benin Art*, 95; cf. Wolf ("Neue Analysen," 136), who assumes that such heads were cast early in the eighteenth century; Fagg, *Nigerian Images*, 27, shares this opinion.
15 Nevadomsky, "The Iconography of Benin Brass Rings," *Tribus* 38 (1989): 66.
16 Ezra, *Royal Art of Benin*, 123.
17 Ben-Amos, *Art of Benin*, 28–29.
18 Heger, "Drei merkwürdige Metallfiguren von Benin," *Mitteilungen der Anthropologischen Gesellschaft in Wien* 46 (1916): 150; von Luschan, *Die Altertümer von Berlin*, 198–99.
19 von Luschan, *Die Altertümer von Berlin*, 199.
20 Forman and Dark, *Benin Art*, 4–48, figs. 57, 58, 59.
21 Fagg, *Nigerian Images*, fig. 30.
22 Egharevba, *Short History of Benin*, 32; Tunis, "Origins, Chronology and Metallurgy," 391.
23 Peter Karpinski, "A Benin Bronze Horseman at the Merseyside County Museum," *African Arts* 17, no. 2 (1984): 59–60.
24 von Luschan, *Die Altertümer von Berlin*, 38–39; Read and Dalton, *Antiquities from the City of Benin* pl. XII, fig. 2; Forman and Dark, *Benin Art*, 43, fig. 44.
25 Adams, *Remarks on the Country*, 115; von Luschan, *Die Altertümer von Berlin*, 183–84.
26 Roth, *Great Benin*, 153–54.
27 von Luschan, *Die Altertümer von Berlin*, 192.
28 Bradbury, *Benin Studies*, 192.
29 Annemarie Schweeger-Hefel, *Afrikanische Bronzen* (Vienna, 1948), 29.
30 Barbara Winston Blackmun, "Wall Plaque of a Junior Titleholder Carrying an *Ekpokin*," in *The Art of Power*, 86; cf. Ben-Amos, *Art of Benin*, 84, 85.
31 von Luschan, *Die Altertümer von Berlin*, 186–87.
32 Ibid., 188.
33 Roese, "Die Hierarchie," 60.

34 George Nelson Preston, "Reading the Art of Benin," in *Images of Power*, ed. Flora S. Kaplan (New York, 1981), 63.

35 Blackmun, "The Iconography of Carved Altar Tusks from Benin, Nigeria" (Ann Arbor, Mich., 1984), 309–10; Ezra, *Royal Art of Benin*, 126.

36 Dark, "A Benin Bronze Plaque of a Single Figure with Leopard," in *The Art of Power*, 87–88.

37 Heger, "Drei merkwürdige Metallfiguren von Benin," 138.

38 von Luschan, *Die Altertümer von Berlin*, 218–19; Dark, "A Benin Bronze Plaque," 87.

39 Dapper, *Umbständliche*, 488; Roth, *Great Benin*, 7.

40 von Luschan, *Die Altertümer von Berlin*, 195; Roth, *Great Benin*, 195.

41 Ben-Amos, "Men and Animals in Benin Art," *Man*, n.s. 2, no. 2 (1976): 243, 247; Gallagher, "Between Realms," 21, 36.

42 Lee Chambers, "Crocodiles," in *The Art of Power*, 94.

43 Ibid.

44 Ben-Amos, "Men and Animals in Benin Art," 247–48.

45 Ben-Amos, *Art of Benin*, 46.

46 Bradbury, quoted in Blackmun, "Iconography of Carved Altar Tusks," 406.

47 Boniface I. Obichere, "Benin City and the Royal Patronage of the Arts," in *Images of Power*, 51.

48 E. Nii Quarcoopome, "Pendant Plaques," in *The Art of Power*, 96.

49 Blackmun, "Reading a Royal Altar Tusk," in *The Art of Power*, 64.

50 Ben-Amos, "Men and Animals in Benin Art," 246–47.

51 Blackmun, "Iconography of Carved Altar Tusks," 396.

52 Ben-Amos, "The Powers of Kings: Symbolism of a Benin Ceremonial Stool," in *The Art of Power*, 51.

53 Ibid.; Bradbury, *Benin Studies*, 75.

54 van Nyendael, "A Description of the Rio Formosa," in Bosman, *A New and Accurate Description*: 53A.

55 Gallagher, "Between Realms," 22–25.

56 von Luschan, *Die Altertümer von Berlin*, 269.

57 E. Schüz, "Der problematische Ibis der Benin-Bronzen," *Tribus* 18 (1969), 73–81.

58 Fagg, *Divine Kingship*, 28; Ben-Amos, *Art of Benin*, 23. In a slight variance of the above-mentioned sources, Nevadomsky asserts that accompanying Portuguese soldiers killed the "bird that calls disaster" on the king's command ("Benin Bronze Horseman," 42–44, and "Iconography of Benin Brass Rings," 76–78).

59 Gallagher, "Between Realms," 28.

60 von Luschan, *Die Altertümer von Berlin*, 273.

61 Ibid.

62 Ibid.

63 Ibid., 274–75; Tunis, "Origins, Chronology and Metallurgy," 143–45.

64 Ben-Amos, "Men and Animals in Benin Art," 245.

65 Gallagher, "Between Realms," 21–22.

66 Jacques Blache, *Les Poissons du Bassin du Tchad et du Bassin Adjacent du Myo Kelbi* (Paris, 1964), 210–11. Dapper mentioned a "quivering fish," which would vibrate when touched; and Barbot wrote in 1732 "it causes a quivering in the arm of any person that does but lay one finger on it," in *A Description*, 356.

67 Egharevba, *Short History of Benin*, 12–13; Ben-Amos writes that Oba Ohen's paralysis was his punishment by the spirits for having committed adultery. Ewuare, who wanted to honor his ancestor, had his legs portrayed as mudfish to hide his paralysis. Ben-Amos, *Art of Benin*, 20 (caption to pl. 20).

68 Bradbury, quoted by Blackmun, "Reading a Royal Altar Tusk," 64.

69 Blackmun, "Iconography of Carved Altar Tusks," 252.

70 Gallagher, "Between Realms," 22; Blackmun, "Reading a Royal Altar Tusk," 64; Blackmun, "Iconography of Carved Altar Tusks," 251.

71 Blackmun, "Iconography of Carved Altar Tusks," 248; cf. 249–56.

72 Cf. von Luschan, *Die Altertümer von Berlin* 2: 27, fig. C., 188, 281–82.

73 See discussion on plaques with messengers (p. 62).

74 Roth, *Great Benin*, 218–19.

75 Dapper, *Umbständliche*, 492; fig. between 486 and 487.

76 These tests were made in June 1985 by the Rathgen Forschungslabor in Berlin with the following results excerpted here: "The gamma dose was 1.15 mGy/a; the Sn/S ratio remained in reasonable limits of about 10:1."

77 Dark believes (*Introduction to Benin Art*, 97) that the first dwarf (fig. 67) is younger, after Esigie (15th–16th century), than the other (figs. 68–70): "the more corpulent dwarf does seem a very particular piece of portraiture and is probably earlier in time."

78 Schweeger-Hefel, *Afrikanische Bronzen*, 20.

79 von Luschan, *Die Altertümer von Berlin*, 299.

80 Fagg, *Nigerian Images*, 24; cf. Wolf, "Neue Analysen," 129–30.

81 Dark, *Introduction to Benin Art*, 97.

82 Jungwirth, *Benin in den Jahren 1485–1700*, 134, 228.

83 von Luschan, *Die Altertümer von Berlin*, 290.

84 Schweeger-Hefel, *Afrikanische Bronzen*, 21.

85 Ben-Amos, *Art of Benin*, 40.

86 Schweeger-Hefel, *Afrikanische Bronzen*, 21.

87 Wolf, "Neue Analysen," 131.

88 Fagg, *Nigerian Images*, 32; Ben-Amos, *Art of Benin*, 40; Dark, *Introduction to Benin Art*, 99.

89 Jungwirth, *Benin in den Jahren 1485–1700*, 251.

90 Ezra, *Royal Art of Benin*, 67; Ben-Amos, *Art of Benin*, 40.

91 Ezra, *Royal Art of Benin*, 68.

92 Blackmun, "From Trader to Priest in Two Hundred Years: The Transformation of a Foreign Figure on Benin Ivories," *Art Journal* 47, no. 2 (Summer 1988): 131–32; Ezra, *Royal Art of Benin*, 68.

93 Bradbury, *Benin Kingdom*, 55; Dark, *Introduction to Benin Art*, 36.

94 Joseph Nevadomsky, "Brass Cocks and Wooden Hens in Benin Art," *Baessler-Archiv*, n.s. 35, no. 1 (1987): 225, n. 6.

95 Ibid., 213–29.

96 Ezra, *Royal Art of Benin*, 86.

97 Ibid., 131.

98 Bradbury, *Benin Studies*, 254–55; P. Amaury Talbot, *The Peoples of Southern Nigeria* 1 (London, 1926): 254–55; Blackmun, "Iconography of Carved Altar Tusks," 273–76; Freyer, *Royal Benin Art*, 26–27.

99 Blackmun, "Iconography of Carved Altar Tusks," 275.

100 Ibid.

101 Cf. Freyer, *Royal Benin Art*, 27; von Luschan, *Die Altertümer von Berlin*, 389.

102 Flora S. Kaplan, ed., *Images of Power: Art of the Royal Court of Benin* (New York, 1981), 60–61; cf. Preston, *Images of Power*, 63; Ben-Amos, *Art of Benin*, 49; Blackmun, "Iconography of Carved Altar Tusks," 411–13.

103 Wolf, "Neue Analysen," 134.

104 Fagg, *Nigerian Images*, 29–30.

105 Cf. Wolf, "Neue Analysen," 134–35; Kenneth Crosthwaite Murray, "Benin Art," *Nigeria Magazine* 71 (1961): 378.

106 Cf. Bradbury, *Benin Studies*, 257–70; Carolyn Dean, "The Individual and the Ancestral: *Ikegobo* and *Ukhurhe*," in *The Art of Power*, 33.

107 Bradbury, *Benin Studies*, 268.

108 Cf. Read and Dalton, *Antiquities from the City of Benin*, pl. IX, figs. 1, 2; Bradbury, *Benin Studies*, 253.

109 von Luschan, *Die Altertümer von Berlin*, 446–48.

110 Ben-Amos, "Men and Animals in Benin Art," 248–50; Ben-Amos, *Art of Benin*, 52; Eckart von Sydow, "Ancient and Modern Art in Benin City," *Africa* 11, no. 1 (1938): 55–62.

111 Susan Mullin Vogel, "Art and Politics: A Staff from the Court of Benin, West Africa," *Metropolitan Museum Journal* 13 (1978): 87–93.

112 Cf. Ben-Amos, *Art of Benin*, 52–57; Dean, "The Individual and the Ancestral," 37–40.

113 Blackmun, "Iconography of Carved Altar Tusks," 31.

114 Ben-Amos, "Men and Animals in Benin Art," *Man*, n.s. 2, no. 2 (1976): 247. Blackmun, "Iconography of Carved Altar Tusks," 31–32; Vogel, "Art and Politics," 93–94.

115 Blackmun, "Iconography of Carved Altar Tusks," 31–33; Melzian, "Zum Festkalender von Benin," 41, 71, 84; Melzian, *A Concise Dictionary of the Bini Language of Southern Nigeria* (London, 1937).

116 Wolf, "Neue Analysen," 165.

117 Egharevba, *Short History of Benin*, 1.

118 Annemarie Schweeger-Hefel, "Zur Thematik und Ikonographie der geschnitzten Elfenbeinzähne aus Benin im Museum für Völkerkunde in Wien," *Archiv für Völkerkunde* 12 (Vienna, 1957): 186.

119 I would like to thank Professor Barbara W. Blackmun for her personal communications in a letter of 17 December 1992. They are the best current estimates, based upon her fourteen years of work with these carvings.

120 Blackmun, "Who Commissioned the Queen Mother Tusks? A Problem in the Chronology of Benin Ivories," *African Arts* 24, no. 2 (April 1991): 57.

121 For more information see Blackmun, "From Trader to Priest," 130–32.

122 The characteristics of Set II are thoroughly described as "Type L" in Blackmun, "Iconography of Carved Altar Tusks," vol. 1, 71–84.

123 Blackmun, "Who Commissioned the Queen Mother Tusks?," 64–65.

124 Wolf, "Elfenbein und Bronze," 195.

125 Blackmun, "The Elephant and Its Ivory in Benin," in *Elephant: The Animal and Its Ivory in African Culture*, ed. Doran H. Ross (Los Angeles: Fowler Museum of Cultural History, UCLA, 1992), 167–68.

126 Cf. Ben-Amos, *Art of Benin*, 67, fig. 71.

127 Wolf, "Elfenbein und Bronze," 189–90; cf. Augustus Henry Lane-Fox Pitt-Rivers, *Antique Works of Art from Benin* (London, 1900), fig. 342.

The History of the Benin Collection in Vienna

1 Christian F. Feest, "Kurzer Abriss der Geschichte der Wiener völkerkundlichen Sammlungen vor 1928," *Archiv für Völkerkunde* 32 (Vienna, 1978): 3; Irmgard Moschner, "Die Wiener Cook-Sammlung, Südsee-Teil," *Archiv für Völkerkunde* 10 (Vienna, 1955): 136 et seq.; Alois Primisser, *Übersicht der k.k. Ambraser Sammlung* (Vienna, 1825).

2 Alfred Janata, "Franz Heger und die Sammlungen 'Kaukasische Altertümer' in Wien," *Archiv für Völkerkunde* 32 (Vienna 1978): 127.

3 Heger, "Merkwürdige Altertümer aus Benin in West-Afrika," *Mitteilungen der Geographischen Gesellschaft Wien* 64 (1921): 104 et seq.

4 IB (1897); INahiM (1897) Z 550, Z 578, Z 641; Actenjournal Franz Heger (1897), 18.

5 Heger, "Drei merkwürdige Metallfiguren von Benin," 132.

6 HHStA (1984); INahiM (1987) Z 585; Actenjournal Franz Heger (1897), 19.

7 IB Post XVII (1899).

8 Webster to Heger, 17 October 1897, 18 March 1898, 26 March 1898, 18 May 1898, 27 May 1898, and also from the years 1899 to 1905.

9 Ibid., 17 October 1898.

10 IB Post XVII (1899).

11 IB Post XIX (1899).

12 Andreas Grigorowicz, "Zufall und Notwendigkeit bei der Entstehung ethnographischer Sammlungen," *Archiv für Völkerkunde* 32 (Vienna, 1978), 112.

13 HHStA (1898) OMeAr 50/7/9.

14 HHStA letter dated 27 January 1899 from Dr. Johann Frank, OkäA Reihe C Naturhistorisches Hofmuseum 1899, Cah. A; *Gothaisch genealogisches Taschenbuch der Freiherrlichen Häuser* (Vienna, 1941). In November 1908 Haas was granted the title of Baron; see INahiM (1897) Z 587 for first petition to the nobility.

15 NDB XIV; NÖB VII; ÖBL.
16 NDB IV; ÖBL; The City of Vienna awarded Dumba an honorary citizenship and later gave him a tomb of honor.
17 *Gothaisch genealogisches Taschenbuch.*
18 Virginia Cowles, *Die Rothschilds 1763–1973: Die Geschichte einer Familie* (Würzburg, 1974), 156, 187, 189 et seq.
19 Bibliographische Sammelmappe W 7676 der Genealogisch-Heraldischen Gesellschaft in Vienna.

20 INahiM (1900) Z 213 ; Actenjournal Franz Heger (1900), 21
21 HHStA (1901).
22 Bibliographische Sammelmappe W 7676 der Genealogisch-Heraldischen Gesellschaft in Vienna.
23 IB Post 1 (1901).
24 Maschmann to Heger, 7 January 1899.
25 Ibid., 26 January 1899.
26 Ibid., 7 August 1899.
27 Ibid., 22 August 1899.

28 Ibid., 18 December 1899.
29 IB Post XVIII (1899); Actenjournal Franz Heger (1898), 34a.
30 IB Post XXI (1899).
31 IB Post VIII (1901); IB Post XVI (1905), Varia.
32 IB Post I (1918).
33 Cornelia Essner, *Deutsche Afrikareisende im 19. Jahrhundert Zur Sozialgeschichte des Reisens* (Stuttgart, 1985).
34 IB (1959).

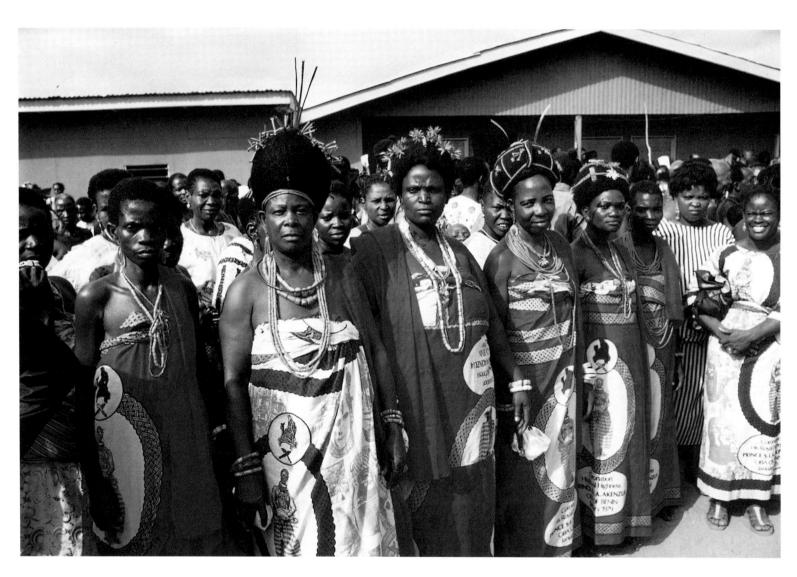

126 Benin: Leading Town Women at the King's Coronation, ca. 1978. Photograph by Joseph Nevadomsky

Glossary

Ada: Ceremonial sword; one of the objects found on ancestral altars symbolizing the ancestors' power to influence the course of events in the kingdom.

Agba: Rectangular royal throne.

Ahammangiwa: Brasscaster, who in one legend was the first to manufacture brass plaques.

Coris: Glass beads, primarily blue in color.

Eben: A wide-bladed ceremonial sword used by dignitaries.

Edaiken: Title of crown prince of Benin.

Edionwere: Benin village elders outside of Benin City.

Edo: Name of the original Benin population, capital city, and language.

Efa: Palace association with the ritual responsibility for purifying breaches of taboos.

Eghaevbo n'Ogbe: Palace Chiefs in town association (*Ogbe* = palace precinct)

Eghaevbo n'Ore: Town Chiefs (*Ore* = town).

Ekiti: Ethnic groups northwest of kingdom of Benin.

Enigie: Chiefs of large towns and important areas in kingdom of Benin.

Eribo: Chief in *Iwebo* palace association. The Eribo was responsible for conducting trade with Europeans.

Esere: Leader of the *Iweguae*, one of the three palace associations.

Ezomo: Title of one of two supreme military commanders and, from the eighteenth century on, the most important man after the king. Leader of the Palace Chiefs.

Fiador: Intermediary, chosen by the king, between king and Europeans (from Portuguese).

Gwato (or *Ughoton*): Port town on Benin River.

Ibiwe: One of the three main palace associations; responsible for the Benin ruler's wives, children, and slaves.

Igala: Ethnic groups northeast of the kingdom of Benin.

Igbesanmwan: Carvers' guild at the Court of Benin.

Igbirra: Ethnic groups north of the kingdom of Benin.

Igbo: Ethnic groups east of the kingdom of Benin.

Igue: Festival ensuring renewal of the powers of the king of Benin.

Igueghae: Leader of brasscasters, who came from Ife and was awarded the title of *Ineh n'Igun* by the Benin King Oguola.

Ihaza: Chief in *Iwebo* palace association.

Ihogbe: Palace association of the court chroniclers.

Ikegobo: Altar to the hand.

Ilorin: A Yoruba town northwest of Benin.

Ineh: Leader of the *Ibiwe* palace association.

Ineh n'Igun Eronmwon: Highest dignitary of brasscasters.

Itsekiri: Ethnic groups located primarily along the coast and in the swamps south of Benin (center: Ode Itsekiri).

Iwaranmwen: Palace association that performed animal sacrifices and was subordinate to the *Iwebo*.

Iwebo: One of the three main palace associations at the Court of the Benin ruler; responsible for the clothing of the ruler and for the safekeeping of the royal insignia.

Iweguae: One of the three main palace associations; responsible for the personal needs of the king, such as household, servants, and storage rooms.

Iyase: Title of one of two supreme military commanders, and leader of the Town Chiefs (*Eghaevbo n'Ore*).

Iyase ne Ode: Rebellious leader of the Town Chiefs in the eighteenth century.

Iyoba (*Iye Oba*): Queen Mother.

Manilla (from the Portuguese word *manilha* = bangle): Copper or brass horseshoe-shaped rings. First mentioned by Duarte Pacheco Pereira (1505), they were introduced into West Africa as "large money."

Oba: Title of the ruler of Benin.

Obo (pl. *Ebo*): Magician, *Osun* specialist.

Ofoe: Sinister messenger of the *Ogiuwu* spirit.

Ogane: Priest-king who, according to an oral tradition, sent messengers to Benin.

Ogie: Title of rulers of the *Ogiso* dynasty.

Ogiso: Name for the kings of the *Ogiso* dynasty (predecessor of the *Oba* dynasty) of the ancient kingdom of Benin.

Ogiuwu: God (spirit) of death.

Ogun: God of iron and guardian of craftsmen, warriors, and hunters.

Ohen n'Ughoton: Chief of the port town *Ughoton.*

Ohen Olokun: Chief and priest from Igo, a village between Benin and *Ughoton.*

Oliha: Leader of the *Uzama* (King Makers).

Olokun: God of the waters and wealth.

Oloton: Member of the *Uzama* palace group, who alone was allowed to stay within the palace walls.

Oni (Oghene): Title of the ruler of Ife, the "cosmic center" of the Western Yoruba peoples, which was held by them to be the origin of Divine Kingship.

Oranmiyan: Son of the Yoruba ruler from Ife and founder of the *Oba* dynasty, the second and current dynasty of Benin.

Orhue: Kaolin for ritual use.

Osa: One of the high priests.

Osanobua: Creator god of the *Edo.*

Osuan: One of the high priests.

Osun: God (priest) of medicine and healing power.

Osun ematon: Medicine staff (or *Osun* staff).

Oyo: Yoruba kingdom, northwest of Benin.

Ugha-Ebo: Residence in the city district of the *Iwebo* reserved for European merchants.

Ughoron: Royal chroniclers, who commemorated individual rulers by reciting their dates of death and important events during their reigns.

Ughoton: Port on Benin River, also known by the name Gwato.

Ugie Erha Oba: Annual ceremony honoring the royal ancestors.

Ugie Ivie: Bead festival.

Ukhurhe: Rattle staff.

Uwangue: Chief in *Iwebo* palace association.

Uzama (Uzama n'Ihinron): King Makers. As "keepers of tradition," they had an important position in the kingdom, especially at royal coronations.

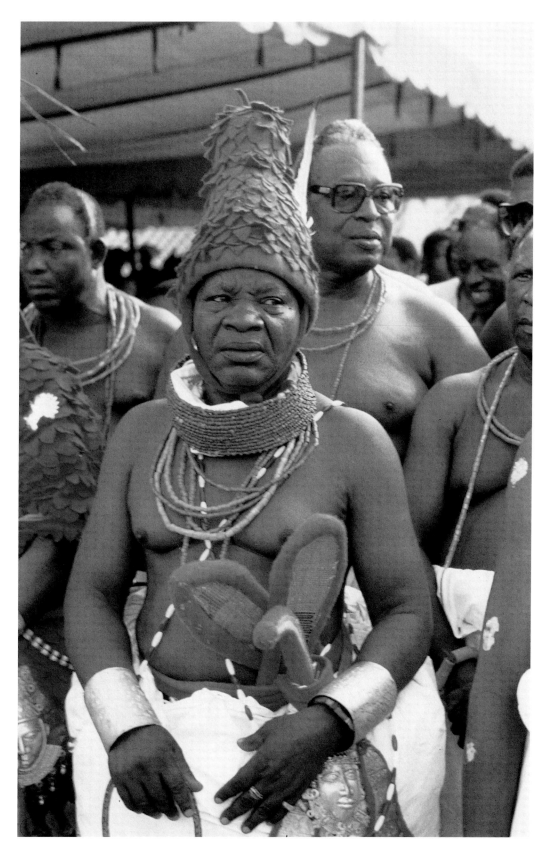

127 Benin: One of the Senior Chiefs in Ceremonial Dress, ca. 1984. Photograph by Joseph Nevadomsky

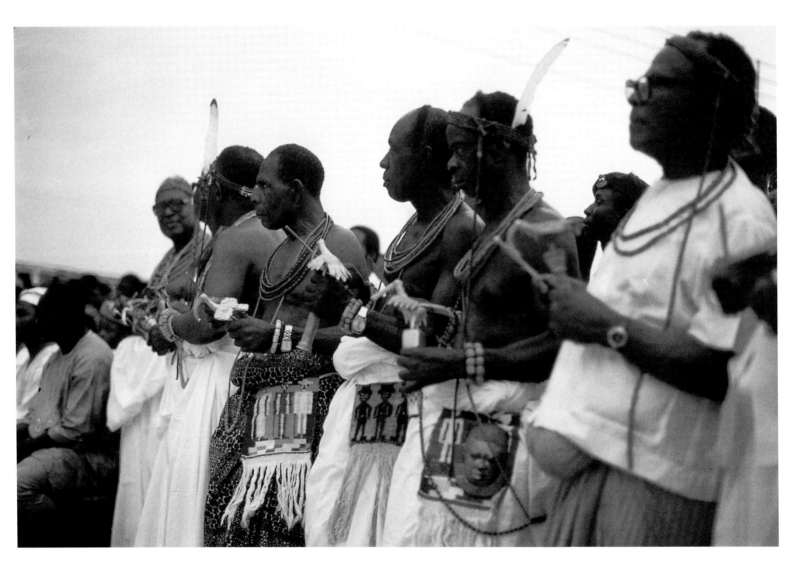

128 Benin Chiefs at Ugie-Oro Clack the Bird of Prophecy, ca. 1987. Photograph by Joseph Nevadomsky

Catalogue

Figural Representations

Humans

1

Court Dwarf
Late 14th/early 15th century
Brass
H. 23 ½ in. (59.5 cm)
Collection A. Maschmann, 1899
Donation Prince Johannes II von und zu
Liechtenstein.
64.745

2

Court Dwarf
Late 14th/15th century
Brass
H. 23 ¼ in. (59 cm)
Collection A. Maschmann, 1899
Donation Prince Johannes II von und zu
Liechtenstein.
64.743

3

Messenger (or *Court Official*)
Late 16th/17th century
Brass
H. 23¼ in. (60 cm)
Collection A. Maschmann, 1899
Donation Prince Johannes II von und zu
Liechtenstein.
64.747

4

Oba with Two Dignitaries
19th century
Brass
H. 9 in. (23 cm)
Collection H. Meyer, 1918
98.163

5

Dignitary Holding a Gong and a Cross
19th century
Brass
H. 10 ½ in. (26.5 cm)
Collection H. Meyer, 1918
98.164

6

Dignitary
19th century
Brass
H. 7 in. (18 cm)
Collection A. Maschmann, 1899
64.787

7

Dignitary
19th century
Brass
H. 7 ½ in. (19 cm)
Collection A. Maschmann, 1899
64.788

8

Queen Mother
Late 18th century
Brass
H. 11¼ in. (30 cm)
Collection G. Haas, 1899
64.700

9

Dignitary
18th century
Ivory
H. 7 in. (17.5 cm), H. 7 in. (18 cm)
Collection A. Maschmann, 1899
64.761, 64.702

10

Messenger (or *Court Official*)
18th/19th century
Ivory
H. 21 in. (53 cm)
Collection A. Maschmann, 1899
64.784

11

Dignitary
18th/19th century
Ivory
H. 21 in. (53 cm)
Collection G. Haas, 1899
64.701

12

Queen Mother
18th/19th century
Ivory
H. 18¼ in. (46.5 cm)
Collection G. Haas, 1899
64.725

13

*Carved Slab with an Oba, European, and
Leopards*
18th/19th century
Ivory
H. 13¼ in. (35 cm)
Collection A. Maschmann, 1899
64.781

Animals

14

Cock
17th century
Brass
H. 21 in. (53 cm)
Collection G. Haas, 1899
64.723

15

Head of a Snake

17th century
Brass
L. 20 in. (51 cm)
Collection Wilson, 1899
64.739

16

Head of a Snake

17th century
Brass
L. 20½ in. (52 cm)
Collection A. Maschmann, 1899
64.746

17

Leopard

18th century
Brass
L. 8¼ in. (21 cm), H. 6 in. (15 cm)
Collection H. Meyer, 1918
98.166

18

Turtle Shell

19th century
Brass
H. 2¾ in. (7 cm), D. 6¼ in. (15.6 cm),
W. 3¾ in. (9.3 cm)
Collection G. Haas, 1899
64.675

19

Head of a Leopard

17th century
Ivory, brass tack, and iron nails
L. 6¼ in. (16 cm)
Collection A. Maschmann, 1899
64.760

Commemorative Heads

20

Head of an Oba

Late 16th century
Brass
H. 10½ in. (26.5 cm), Diam. 6¼ in. (16 cm)
Collection A. Maschmann, 1899
64.748

21

Head of an Oba

Late 16th century
Brass
H. 9¾ in. (25 cm), D. 7¼ in. (18.5 cm)
Collection G. Haas, 1899
64.696

22

Head of an Oba

Late 16th/early 17th century
Brass
H. 9½ in. (24 cm), Diam. 7½ in. (19 cm)
Collection A. Maschmann, 1899
64.749

23

Head of an Oba (with Flange)

17th/18th century
Brass
H. 9¾ in. (25 cm), Diam. 9 in. (23 cm)
Collection H. Meyer, 1918
98.160

24

Head of an Oba

19th century
Brass
H. 17¼ in. (44 cm), Diam. 10¾ in. (27 cm)
Collection H. Meyer, 1918
98.158

25

Head of an Oba (with Flange and Wings)

19th century
Brass
H. 16 in. (40.5 cm), Diam. 10¾ in. (27 cm)
Collection A. Maschmann, 1899
64.804

26

Head of an Oba (with Flange and Wings)

19th century
Brass
H. 17¾ in. (45 cm), Diam. 11¾ in. (30 cm)
Collection G. Haas, 1899
64.699

24

27

Head of a Queen Mother (with Flange)

19th century
Brass
H. 21¼ in. (54 cm), Diam. 9½ in. (24 cm)
Collection G. Haas, 1899
64.698

28

Head of a Queen Mother (with Flange)

19th century
Brass
H. 19¼ in. (49 cm), Diam. 10¾ in. (27 cm)
Collection H. Meyer, 1918
98.159

18

Palace Plaques

Court Dignitaries

29
Plaque with an Oba, Dignitaries, and Musicians
17th century
Brass
H. 15¼ in. (38.5 cm), W. 15¼ in. (39 cm)
Collection G. Haas, 1899
64.717

30
Plaque with a Dignitary Holding a Ceremonial Sword
17th century
Brass
H. 16¼ in. (41.5 cm), W. 12½ in (31.5 cm)
Collection G. Haas, 1899
64.662

31
Plaque with a Dignitary Holding a Ceremonial Sword
17th century
Brass
H. 14½ in. (37 cm), W. 7 in. (18 cm)
Collection G. Haas, 1899
64.663

32
Plaque with a Dignitary Holding a Ceremonial Sword
17th century
Brass
H. 11¾ in. (30 cm), W. 6¾ in. (17 cm)
Collection G. Haas, 1899
64.664

33
Plaque with a Dignitary Holding a Ceremonial Sword
17th century
Brass
H. 16½ in. (42 cm), W. 7 in. (17.5 cm)
Collection G. Haas, 1899
64.691

34
Plaque with a Dignitary Holding a Shield
17th century
Brass
H. 11¾ in. (30 cm), W. 7 in. (17.5 cm)
Collection Wilson, 1899
64.734

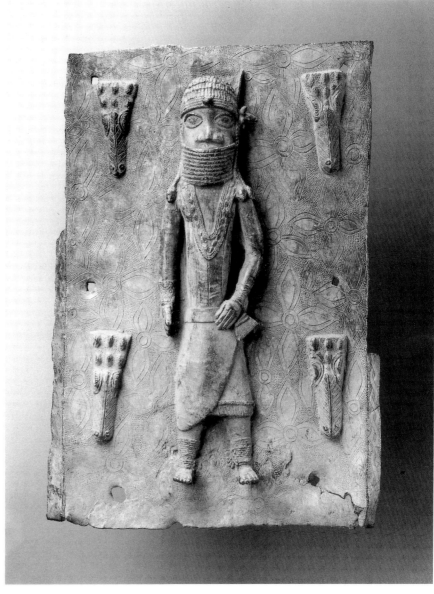

37

35
Plaque with a Dignitary Holding a Staff
17th century
Brass
H. 15¾ in. (40 cm), W. 6¾ in. (17 cm)
Collection G. Haas, 1899
64.683

36
Plaque with Two Dignitaries
17th century
Brass
H. 16¼ in. (41 cm), W. 12½ in. (32 cm)
Collection G. Haas, 1899
64.716

37
Plaque with a Dignitary and Four Crocodile Heads
17th century
Brass
H. 17½ in. (44.5 cm), W. 12¼ in. (31 cm)
Collection G. Haas, 1899
64.682

38
Plaque with a Dignitary Holding a Staff
18th century
Brass
H. 17 in. (43 cm), W. 7½ in. (19 cm)
Collection H. Meyer, 1918
98.157

Other Court Attendants

39

Plaque with Two Figures Holding Containers
17th century
Brass
H. 17½ in. (44.5 cm), W. 12¼ in. (31 cm)
Collection A. Maschmann, 1899
64.798

40

Plaque with Two Musicians Holding Gourd Rattles
17th century
Brass
H. 20 in. (51 cm), W. 12¼ in. (31 cm)
Collection K. Schembara, 1899
65.064

41

Plaque with a Flute Player
17th century
Brass
H. 13¾ in. (35 cm), W. 7½ in. (19 cm)
Collection Knize Jr., 1959
139.554

42

Plaque with a Messenger Holding a Leopard-Skin Pouch
17th century
Brass
H. 16½ in. (41.7 cm), W. 7¼ in. (18.5 cm)
Collection G. Haas, 1899
64.679

43

Plaque with a Horse and Rider
17th century
Brass
H. 13¾ in. (35 cm), W. 11½ in. (29 cm)
Collection A. Maschmann, 1899
64.796

Europeans

44

Plaque with a European and Five Manillas
17th century
Brass
H. 18 in. (46 cm), W. 13½ in. (34 cm)
Collection A. Maschmann, 1899
64.799

45

Plaque with a European Carrying Manillas
17th century
Brass
H. 18¾ in. (47.5 cm), W. 11½ in. (29.5 cm)
Collection Wilson, 1899
64.735

46

Plaque with the Top Half of a European
Early 17th century
Brass
H. 13¼ in. (33.5 cm), W. 11 in. (28 cm)
Collection G. Haas, 1899
64.697

47

Plaque with the Bottom Half of a European
Late 16th century
Brass
H. 15½ in. (39.5 cm), W. 14½ in. (36.5 cm)
Collection G. Haas, 1899
64.718

Animals

48

Plaque with a Leopard
17th century
Brass
H. 11¼ in. (28.5 cm), W. 18 in. (46 cm)
Collection G. Haas 1899
64.719

49

Plaque with a Crocodile
17th century
Brass
H. 15¾ in. (40 cm), W. 7¾ in. (19.5 cm)
Collection A. Maschmann, 1899
64.797

50

Plaque with a Crocodile Head
Late 16th century
Brass
H. 16½ in. (42 cm), W. 6¾ in. (17 cm)
Collection G. Haas, 1899
64.666

51

Plaque with a Crocodile Head
Late 16th/17th century
Brass
H. 15¼ in. (38.5 cm), W. 6½ in. (16.5 cm)
Collection G. Haas, 1899
64.692

52

Plaque with a Snake
17th century
Brass
H. 16½ in. (42 cm), W. 6¼ in. (16 cm)
Collection G. Haas, 1899
64.667

53

Plaque with a Bird of Prophecy
17th century
Brass
H. 16¼ in. (41 cm), W. 6¾ in. (17 cm)
Collection Wilson, 1899
64.737

54

Plaque with a Mudfish
Late 16th/17th century
Brass
H. 17¾ in. (45 cm), W. 6¾ in. (17 cm)
Collection G. Haas, 1899
64.694

55

Plaque with a Mudfish
17th century
Brass
H. 16¼ in. (41 cm), W. 7 in. (17.5 cm)
Collection G. Haas, 1899
64.695

56

Plaque with a Fish
17th century
Brass
H. 15¾ in. (40 cm), W. 7 in. (18 cm)
Collection G. Haas, 1899
64.693

Other

57

Plaque with a Nude Boy
Late 17th century
Brass
H. 15 in. (38 cm), W. 7 in. (17.5 cm)
Collection G. Haas, 1899
64.715

58

Plaque with a Leopard-Skin Pouch
17th century
Brass
H. 18 in. (46 cm), W. 11½ in. (29 cm)
Collection G. Haas, 1899
64.720

Pendants

59
Pendant with an Oba and Two Dignitaries
18th century
Brass
H. 6 in. (15.5 cm)
Collection G. Haas, 1899
64.721

60
Pendant with an Oba and Two Dignitaries
18th century
Brass
H. 5¾ in. (14.5 cm)
Collection H. Meyer, 1918
98.161

61
Hip Ornament: Human Face
19th century
Brass
H. 8 in. (20 cm)
Collection G. Haas, 1899
64.722

62
Pendant with a Frog
Late 17th century
Brass
H. 5 in. (12.5 cm)
Collection G. Haas, 1899
64.669

63
Pendant with a Leopard Head
17th/18th century
Ivory and iron nails
L. 7¼ in. (18.5 cm)
Collection G. Haas, 1899
64.704

Altars

64
Altar with Eight Figures
Late 18th century
Brass
H. 10¾ in. (27 cm), D. 13 in. (33 cm),
W. 11 in. (28 cm)
Collection H. Meyer, 1918
98.155

65
Altar to the Hand (Queen Mother and Attendants)
Late 18th century
Brass
H. 10 in. (25.5 cm), D. 6¾ in. (17.2 cm)
Collection W. D. Webster, 1901
68.699

66
Altar with Queen Mother and Attendants
Late 18th century
Brass
H. 6 in. (15.5 cm), D. 8¾ in. (22 cm)
Collection A. Maschmann, 1899
64.782

67
Altar to the Hand
19th century
Wood
H. 7 in. (18 cm), D. 8 in. (20 cm)
Collection A. Maschmann, 1899
64.755

Staffs and Clappers

68
Staff with a Seated Oba
Late 18th/19th century
Brass
L. 26¾ in. (68 cm)
Collection G. Haas, 1899
64.724

69
Staff with a Seated Oba
Late 18th/19th century
Brass
L. 26¾ in. (68 cm)
Collection G. Haas, 1899
64.668

70
Medicine Staff
Late 18th century
Iron and brass alloy
H. 56¼ in. (143 cm), W. 14¼ in. (36 cm)
Collection Wilson, 1899
64.742

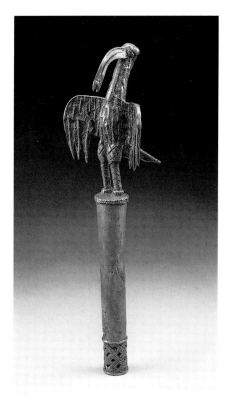

76

71
Staff of Office of a Royal Purchaser
18th/19th century
Copper
L. 22¼ in. (56.5 cm)
Collection A. Maschmann, 1899
64.795

72
Staff of Office of a Royal Purchaser
18th/19th century
Copper
L. 31¾ in. (80.5 cm)
Collection A. Maschmann, 1899
64.676

73
Rattle Staff
19th century
Wood
L. 33 in. (84 cm)
Collection A. Maschmann, 1899
64.812

74
Rattle Staff
19th Century
Wood
L. 43 in. (109 cm)
Collection A. Maschmann, 1899
64.813

75
Rattle Staff
19th century
Wood
L. 36¼ in. (92 cm)
Collection A. Maschmann, 1899
64.763

76
Clapper with a Bird of Prophecy
18th/19th century
Brass
L. 12½ in. (32 cm)
Collection H. Meyer, 1918
98.162

77
Clapper with a Bird of Prophecy
18th/19th century
Brass
L. 11¼ in. (30 cm)
Collection G. Haas, 1899
64.673

78
Hand-held
Clapper with Oba
18th century
Ivory
L. 13 in. (33 cm)
Collection G. Haas, 1899
64.726

Royal Altar Tusks

79
Tusk with Eleven Rows of Carved Figures
CA. 1820–50
Ivory
L. 91¾ in. (233 cm)
Collection H. Meyer, 1918
98.154

80
Tusk with Relief Carving
18th/19th century
Ivory
L. 59 in. (150 cm)
Collection A. Maschmann, 1899
64.750

81
Tusk with Relief Carving
19th century
Ivory
L. 43½ in. (110.5 cm)
Collection A. Maschmann, 1899
64.751

82
Tusk with Relief Carving
Ca. 1750–1850
Ivory
L. 89¾ in. (228 cm)
Collection G. Haas, 1899
64.659

83
Tusk with Relief Carving
Ca. 1750–1850
Ivory
L. 88¼ in. (224 cm)
Collection G. Haas, 1899
64.732

84
Tusk with Relief Carving
Ca. 1820–50 century
Ivory
L. 86½ in. (220 cm)
Collection G. Haas, 1899
64.733

85
Tusk with a Hand Grasping a Fish
18th/19th century
Ivory
L. 42¾ in. (106 cm)
Collection A. Maschmann, 1899
64.780

Horns

86
Horn with a Crocodile
16th century
Ivory
L. 21½ in. (54.5 cm)
Imperial Collection of Arms
91.916

87
Horn with Relief Carving
17th century
Ivory
L. 19 in. (48 cm)
Collection G. Haas, 1899
64.727

88
Horn with a European Head
18th century
Ivory
L. 16¼ in. (41 cm)
Collection A. Maschmann, 1899
64.756

Bracelets

89
Bracelet with Pierced Strapwork
19th century
Brass
H. 4¾ in. (12.2 cm), Diam. 3¼ in. (8.3 cm)
Collection G. Haas, 1899
64.670

90
Bracelet with Pierced Strapwork
19th century
Brass
H. 5¼ in. (13.5 cm), Diam. 3¼ in. (8.3 cm)
Collection G. Haas, 1899
64.672

91
Bracelet with Stylized Male Figures (Owo Style)
18th century
Ivory
H. 4½ in. (11.3 cm), Diam. 3¼ in. (9.5 cm)
Collection W. D. Webster, 1905
74.017

92
Bracelet with Human Heads and Leopards
18th century
Ivory
H. 5 in. (13 cm), D. 3 in. (7.9 cm)
Collection A. Maschmann, 1899
64.759

Bells

93
Altar Bell without Clapper
19th century
Copper
H. 3¼ in. (8 cm), Diam. 2½ in. (6.5 cm)
Collection A. Maschmann, 1899
64.823

94
Bell with Clapper
19th century
Brass and iron
H. 5 in. (13 cm)
Collection A. Maschmann, 1899
64.808

95
Bell with Janus-headed Clapper
18th century
Ivory
H. 5½ in. (14 cm), Diam. 3 in. (7.5 cm)
Clapper: Diam. 3 in. (7.5 cm)
Collection A. Maschmann, 1899
64.807

Miscellany

96
Jar with Snakes and Frogs
18th century
Brass
H. 6¼ in. (17 cm), Diam. 4½ in. (11.5 cm)
Collection A. Maschmann, 1899
64.758

97
Imperial Orb
Late 18th century (?)
Copper alloy
H. 6½ in. (16.5 cm), Diam. 4¼ in. (11 cm),
Collection G. Haas, 1899
64.674

98
Ceremonial Sword
19th century
Iron with zinc plates
L. 38½ in. (97.5 cm), W. 9 in. (23 cm),
D. 35½ in. (90 cm)
Collection W. Klein, 1992
173.697

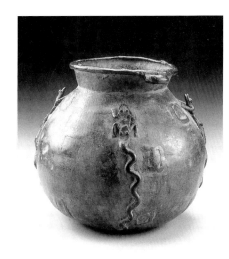

96

99
Manilla of European Origin
17th century (?)
Copper
L. 9¾ in. (25 cm), thickness 1¾ in. (4.5 cm)
Collection A. Maschmann, 1899
64.801

100
Hip Insignia with a European Head
18th century
Brocaded cotton
H. 9¾ in. (25 cm) (without fringe), W. 8¼ in.
(21 cm)
Collection A. Maschmann, 1899
64.811

101
Fan
19th century (?)
Hide, leather, and cloth
L. 13¼ in. (34.5 cm), W. 9¼ in. (23.5 cm)
Collection G. Haas, 1899
64.713

102
Bead Necklace
18th century (?)
Coral and stone
L. 54¼ in. (138 cm)
Collection A. Maschmann, 1899
64.762

103
Bead Necklace
18th century (?)
Glass beads of European origin and coral
L. 28 in. (71 cm)
Collection A. Maschmann, 1899
64.832

104
*Necklace with Amulets Containing Magical
Substances*
19th century
Copper chain, leather, cowry shells, coral,
brass, cloth, and animal tooth
L. 32¼ in. (83 cm)
Collection A. Maschmann, 1899
64.810

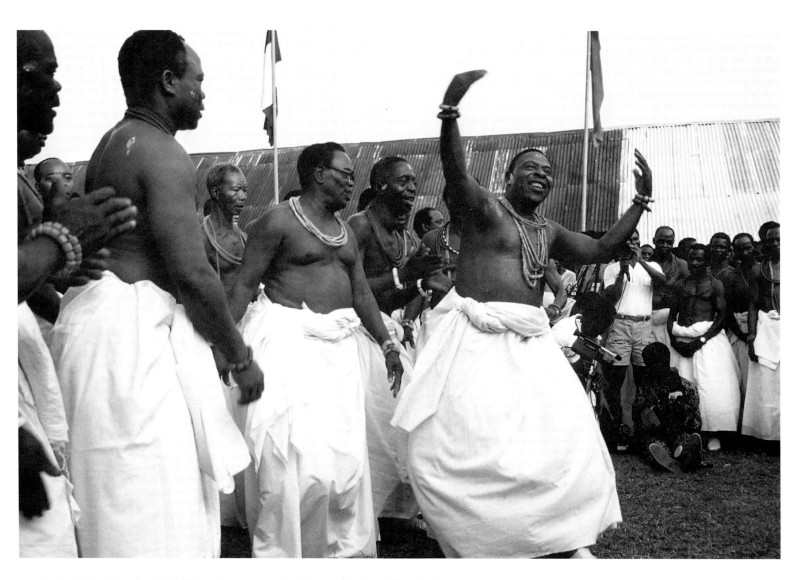

133 Benin: A Newly Confirmed Chief Dances Joyously, ca. 1987. Photograph by Joseph Nevadomsky

Bibliography

Actenjournal Franz Heger in the archives of the Museum für Völkerkunde, Vienna.

Adams, Captain John. *Remarks on the Country from Cape Palmas to the River Congo*. London, 1823.

Akinola, G. A. "The Origin of the Eweka Dynasty of Benin: A Study in the Use and Abuse of Oral Traditions." *Journal of the Historical Society of Nigeria* 8, no. 3 (1976): 21–36.

Bacon, Reginald Hugh Spencer. *Benin, the City of Blood*. London, 1897.

Barbot, Jean. *A Description of the Coast of North and South Guinea*. Vol. 5 in *A Collection of Voyages and Travels*. Edited by Awnsham Churchill. London, 1732.

Barros, João. de. *De Ásia*. 1552. 6th ed. Lisbon, 1944.

Bassani, Ezio, and William Butler Fagg. *Africa in the Renaissance: Art in Ivory*. New York: The Center for African Art, and Munich: Prestel-Verlag, 1988.

Bauer, Wilhelm Peter. "Zusammensetzung und Gefügestruktur dreier Flachkappenköpfe aus Benin." *Abhandlungen und Berichte des Staatlichen Museums für Völkerkunde Dresden* 34 (Dresden 1975): 31–39.

Beauvois, Ambroise Palisot, Baron de. See Palisot.

Ben-Amos, Paula. *Bibliography of Benin Art*. Primitive Art Bibliographies, 6. New York, 1968.

—. "Symbolism in Olokun Mud Art." *African Arts* 6, no.4 (1973): 28–31, 95.

—. "Professionals and Amateurs in Benin Court Carving." In *African Images: Essays in African Iconology*, edited by Daniel F. McCall and Edna G. Bay. New York: Africana Pub. Co., for the African Studies Center, Boston University, 1975.

—. "Men and Animals in Benin Art." *Man*, n.s. 2, no. 2 (1976): 243–52.

—. *The Art of Benin*. London, 1980.

—. "The Powers of Kings: Symbolism of a Benin Ceremonial Stool." In *The Art of Power*, edited by Paula Ben-Amos and Arnold Rubin. Los Angeles: Fowler Museum of Cultural History, UCLA, 1983.

—. "In Honour of Queen Mothers." In *The Art of Power*, edited by Paula Ben-Amos and Arnold Rubin. Los Angeles: Fowler Museum of Cultural History, UCLA, 1983.

Ben-Amos, Paula, and Arnold Rubin, eds. *The Art of Power, The Power of Art: Studies in Benin Iconography*. Los Angeles: Fowler Museum of Cultural History, UCLA, 1983.

Berthot, Jacques, and Raymond Mauny. "Archéologie des Pays Yoruba et du Bas-Niger." *Notes Africaines* 56, 1952: 97–115.

Bethune, C. B. See Galvão.

Bibliographische Sammelmappe W 7676 der Genealogisch-Heraldischen Gesellschaft in Vienna.

Blache, Jacques. *Les Poissons du Bassin du Tchad et du Bassin Adjacent du Myo Kelbi*. Paris, 1964.

Blackmun, Barbara Winston. "Wall Plaque of a Junior Titleholder Carrying an *Ekpokin*." In *The Art of Power*, edited by Paula Ben-Amos and Arnold Rubin. Los Angeles: Fowler Museum of Cultural History, UCLA, 1983.

—. "Reading a Royal Altar Tusk." In *The Art of Power*, edited by Paula Ben-Amos and Arnold Rubin. Los Angeles: Fowler Museum of Cultural History, UCLA, 1983.

—. *Art as Statecraft: A King's Justification in Ivory. A Carved Tusk from Benin*. Monographies Musée Barbier-Müller. Geneva, 1984.

—. "The Iconography of Carved Altar Tusks from Benin, Nigeria." Vols. 1–3 in 2 vols. Ann Arbor, Mich: University Microfilms, 1984.

—. "From Trader to Priest in Two Hundred Years: The Transformation of a Foreign Figure on Benin Ivories." *Art Journal* 47, no. 2 (Summer 1988): 128–37.

—. "Who Commissioned the Queen Mother Tusks? A Problem in the Chronology of Benin Ivories." *African Arts* 24, no. 2 (April 1991): 54–65, 90, 91.

—. "The Elephant and Its Ivory in Benin." In *Elephant: The Animal and Its Ivory in African Culture*, edited by Doran H. Ross, 163–83. Los Angeles: Fowler Museum of Cultural History, UCLA, 1992.

Blake, John William. *European Beginnings in West Africa*. London, 1937.

—. *Europeans in West Africa, 1450–1560*. 2 vols. Hakluyt Society, 2d ser., vol. 86, London, 1941; vol. 87, London, 1942.

Boisragon, Captain Alan M. *The Benin Massacre*. London, 1897.

Bosman, William. *Neuwkeurige Beschreyvinghe van de Guinese Goud-Tand-en Slave-kust*. Utrecht, 1704. English ed.: *A New and Accurate Description of the Coast of Guinea*. London, 1705; reprint edited by J. R. Willis, J. D. Fagg and R. E. Bradbury (London 1967).

Braamcamp, R. *Archivo Histórico Português*. 2 vols. Porto, 1898.

Bradbury, R. E., "Some Aspects of the Political Organization of the Benin Kingdom." In *Procedures of the Annual Conference of the West African Institute of Social and Economic Research*, vol. 1, Ibadan, 1952.

—. *The Benin Kingdom and the Edo-Speaking Peoples of South-Western Nigeria*. Ethnographic Survey of Africa: Western Africa, pt. 13. London, 1957.

—. "Chronological Problems in the Study of Benin History." *Journal of the Historical Society of Nigeria* 1, no.4 (1959), 263–87.

—. "Ezomo's 'Ikegobo' and the Benin Cult of the Hand." *Man* 61, no. 165 (1961): 129–38.

—. *Benin Studies*. London, 1973.

Brásio, António. "Politica do espirito no Ultramar Português." *Portugal em Africa*, 2d ser., no. 6 (1949) 6: 20–29.

—. *Monumenta Missionária Africana*. Lisbon. Vol. 1, 1952; vol. 2, 1954.

Buchner, Max. "Benin und die Portugiesen." *Zeitschrift für Ethnologie* 40 (1908): 981–92.

[Burton, Sir Richard.] An F.R.G.S. "My Wanderings in West Africa: A Visit to the Renowned Cities of Wari and Benin." Pt. 1, "The Renowned City of Wari." *Fraser's Magazine*, vol. 67, February 1863: 135–57. Pt. 2, "The Renowned City of Benin," ibid., March 1863: 273–89; cont., ibid., April 1963: 407–22.

Chambers, Lee. "Crocodiles." In *The Art of Power*, edited by Paula Ben-Amos and Arnold Rubin. Los Angeles: Fowler Museum of Cultural History, UCLA, 1983.

Churchill, Awnsham. *A Collection of Voyages and Travels.* 6 vols. London, 1732.

Cline, Walter Buchanan. *Mining and Metallurgy in Negro Africa.* General Series in Anthropology 5. Menasha, Wisconsin: George Banta Publishing Company, 1937.

Connah, Graham. "Archaeological Research in Benin City 1961–1964." *Journal of the Historical Society of Nigeria* 2, no. 4 (1963): 465–77.

—. *Polished Stone Axes in Benin.* Apapa, 1964.

—. "New Light on the Benin City Walls." *Journal of the Historical Society of Nigeria* 3, no. 4 (1967): 593–609.

—. *The Archaeology of Benin: Excavations and Other Researches in and around Benin City, Nigeria.* Oxford, 1975.

Cowles, Virginia. *Die Rothschilds 1763–1973: Die Geschichte einer Familie.* Würzburg, 1974.

Curnow, Kathy. "The Afro-Portuguese Ivories: Classification and Stylistic Analysis of a Hybrid Art Form." Ann Arbor, Mich.: University Microfilms, 1983.

Dantzig, Albert van, and Adam Jones (eds. and trans.). Pieter de Marees, *Description and Historical Account of the Gold Kingdom of Guinea* (1602). Union Académique Internationale Fontes Historicae Africanae, Series Varia V. Cambridge, 1987.

Dapper, Olfert. *Naukeurige Beschrijvinge der Afrikaensche Gewesten.* Amsterdam, 1668. (German ed.: *Umbständliche und Eigentliche Beschreibung von Africa.* Amsterdam, 1670. French ed.: *Description de l' Afrique.* Amsterdam 1686.)

Dark, Philip. J.C. *The Art of Benin: A Catalogue of an Exhibition of the A.W.F. Fuller and Chicago Natural History Museum Collections of Antiquities from Benin, Nigeria.* Chicago, 1962.

—. *Benin Art.* London, 1965.

—. "Cire-Perdue Casting: Some Technological and Aesthetical Considerations." *Ethnologica,* n.s. 3 (1966): 222–30.

—. *An Introduction to Benin Art and Technology.* Oxford: Clarendon Press, 1973.

—. "Benin Bronze Heads: Styles and Chronology." In *African Images: Essays in African Iconology,* edited by Daniel F. McCall and Edna G. Bay. New York: Africana Pub. Co., for the African Studies Center, Boston University, 1975.

—. *An Illustrated Catalogue of Benin Art.* Boston: G. K. Hall, 1982.

—. "A Benin Bronze Plaque of a Single Figure with Leopard." *The Art of Power,* edited by Paula Ben-Amos and Arnold Rubin. Los Angeles: Fowler Museum of Cultural History, UCLA, 1983.

Dark, Philip J.C., Werner Forman, and Bedřich Forman. *Benin Art.* London, 1960.

Dean, Carolyn. "The Individual and the Ancestral: *Ikegobo* and *Ukhurhe.*" In *The Art of Power,* edited by Paula Ben-Amos and Arnold Rubin. Los Angeles: Fowler Museum of Cultural History, UCLA, 1983.

Dittel, P. "Die Besiedlung Südnigeriens von den Anfängen bis zur britischen Kolonisation." *Wissenschaftliche Veröffentlichung des D. Museums für Länderkunde zu Leipzig.* n.s. 3 (1936): 71–116.

Duchâteau, Armand. "Konfrontation und Akkulturation: Das Bild der Weissen in früheren afrikanischen Mythen und Legenden." In *Europäisierung der Erde?,* Wiener Beiträge zur Geschichte der Neuzeit, vol. 7. Vienna, 1981.

Egharevba, Jacob U. *The Origin of Benin.* Benin City, 1954.

—. *A Short History of Benin.* 4th ed. Ibadan, 1968.

Essner, Cornelia. *Deutsche Afrikareisende im 19. Jahrhundert Zur Sozialgeschichte des Reisens.* Stuttgart, 1985.

Eyo, Ekpo. *Two Thousand Years of Nigerian Art.* Lagos, 1974.

Eyo, Ekpo, and Frank Willett, eds. *Treasures of Ancient Nigeria.* London, 1982.

Ezra, Kate. *Royal Art of Benin: The Perls Collection in The Metropolitan Museum of Art.* New York: The Metropolitan Museum of Art and Henry N. Abrams, Inc., 1992.

Fagg, William. *Nigeria: 2000 Jahre Plastik.* Basel, 1962.

—. *Nigerian Images.* London, 1963.

—. *Divine Kingship in Africa.* London, 1970.

—. "Benin: The Sack That Never Was." In *Images of Power: Art of the Royal Court of Benin,* edited by Flora S. Kaplan. New York: New York University, 1981.

Feest, Christian F. "Kurzer Abriss der Geschichte der Wiener völkerkundlichen Sammlungen vor 1928." *Archiv für Völkerkunde* 32 (Vienna, 1978): 3–7.

Forman, Werner, Bedřich Forman, and Philip J. C. Dark. *Benin Art.* London, 1960.

Freyer, Bryna. *Royal Benin Art in the Collection of the National Museum of African Art.* Washington, D.C.: Smithsonian Institution Press, 1987.

Frobenius, Leo. *Und Afrika sprach . . .* Berlin, 1912.

—. "Terrakotten von Ife." *Feuer* 3 (Wiesbaden, 1921–22): 18–31.

—. *Das unbekannte Afrika.* Munich, 1923.

—. *Die atlantische Götterlehre.* Jena, 1926.

Gallagher, Jack. "Between Realms: The Iconography of Kingship in Benin." In *The Art of Power,* edited by Paula Ben-Amos and Arnold Rubin. Los Angeles: Fowler Museum of Cultural History, UCLA, 1983.

Galvão, Antonio. *Tratado dos Descobrimentos* (1555). Porto, 1944. English ed.: C. B. Bethune, *The Discoveries of the World from the First Original into the Year of Our Lord 1555 by Antonio Galvano.* Hakluyt Society, vol. 30. London, 1862.

Gothaisch geneologisches Taschenbuch der Freiherrlichen Häuser. Vienna, 1941.

Grigorowicz, Andreas. "Zufall und Notwendigkeit bei der Entstehung ethnographischer Sammlungen." *Archiv für Völkerkunde* 32 (Vienna, 1978): 101–26.

Hakluyt, Richard. *The Principal Navigations, Voyages, Traffiques and Discoveries of the English Nation.* 3 vols. London, 1599.

Heger, Franz. "Alte Elfenbeinarbeiten aus Afrika in den Wiener Sammlungen." *Mitteilungen der Anthropologischen Gesellschaft in Wien* 29 (Vienna, 1899): 101–9.

—. "Benin und seine Altertümer." *Mitteilungen der Anthropologischen Gesellschaft in Wien* 29 (Sitzungsberichte) (Vienna, 1899): 2–6.

—. Correspondence between Maschmann and Webster in the archives of the Museum für Völkerkunde, Vienna.

—. "Die Altertümer von Benin." *Mitteilungen der k. k. Geographischen Gesellschaft Wien* 44 (Vienna, 1901): 9–28.

—. "Drei merkwürdige Metallfiguren von Benin." *Mitteilungen der Anthropologischen Gesellschaft in Wien* 46 (Vienna, 1916): 132–77.

—. "Merkwürdige Altertümer aus Benin in West-Afrika." *Mitteilungen der Geographischen Gesellschaft Wien* 64 (Vienna, 1921): 104–19.

Hein, Wilhelm. "Reliefplatte von Benin (Reiter)." *Mitteilungen der Anthropologischen Gesellschaft in Wien* 31 (Vienna, 1901): 129–30.

Hirschberg, Walter. *Die Kulturen Afrikas.* Frankfurt, 1974.

Hodgkin, Thomas, ed., *Nigerian Perspectives: An Historical Anthology.* London, 1960.

Hof- und. Staatshandbuch der Österreichisch-Ungarischen Monarchie. Vienna, 1905.

Home, Robert. *City of Blood Revisited: A New Look at the Benin Expedition of 1897.* London, 1982.

Igbafe, Philip Aigbona. "Benin in the Pre-Colonial Era." *Tarikh* 5, no. 1 (London, 1974): 1–16.

—. *Benin Under British Administration: The Impact of Colonial Rule on an African Kingdom 1897–1938.* London, 1979.

Inventory Books (IB) of the Museum für Völkerkunde, Vienna.

Janata, Alfred. "Franz Heger und die Sammlungen 'Kaukasische Altertümer' in Wien." *Archiv für Völkerkunde* 32 (Vienna, 1978): 127–42.

Jeffreys, Mervyn David Waldegrave. "The Origins of the Benin Bronzes." *African Studies* 10, no. 2 (Johannesburg, 1951): 87–92.

Jong, A. de. *Benin*. Amsterdam, 1986.

Joyce, Thomas Athol. "Note on the Relationship of the Bronze Heads to the Carved Tusks, Benin City." *Man* 8, no. 2 (1908): 2–4.

Jungwirth, Mechthildis. *Benin in den Jahren 1485–1700: Ein Kultur- und Geschichtsbild*. Vienna, 1968.

Kalous, Milan. "A Contribution to the Problem of Akori Beads." *Journal of African History* 7, no. 1 (1966): 61–66.

Kaplan, Flora S., ed. *Images of Power: Art of the Royal Court of Benin*. New York: New York University, 1981.

Karpinski, Peter. "A Benin Bronze Horseman at the Merseyside County Museum." *African Arts* 17, no. 2 (1984): 54–62, 88–89.

Landolphe, Captain J. F. *Mémoires du Capitaine Landolphe*, 2 vols., ed. Jacques Salbigoton Quesne, Paris, 1823.

Linden-Museum. *Kongo und Benin: Höhepunkt afrikanischer Kunst*. Stuttgart, 1961.

Luschan, Felix von. *Die Karl Knorr'sche Sammlung von Benin-Altertümern im Museum für Länder- und Völkerkunde in Stuttgart*. Stuttgart, 1901.

——. *Die Altertümer von Benin*. Veröffentlingum aus dem Museum für Völkerkunde Berlin, vols. 8, 9, 10. Berlin: Museum für Völkerkunde, 1919.

McClelland, Elizabeth M. *The Kingdom of Benin in the Sixteenth Century*. London: Oxford University Press, 1971.

Marees, Pieter de. *Beschryvinge ende historische verhael vant Gout Koninck-rijck van Gunea anders de Gout-custe de Mina*. Amsterdam, 1602. Reprint, edited by Samuel Pierre l' Honoré Naber (Linschoten Vereeniging, The Hague, 1909). English ed.: see Dantzig and Jones.

Marquart, Joseph. *Die Benin-Sammlung des Reichsmuseums für Völkerkunde in Leiden beschrieben und mit ausführlichen Prolegomena zur Geschichte der Handelswege und Völkerbewegungen in Nordafrika*. Leiden, 1913.

Mauny, Raymond. "Eustache de la Fosse: Voyage dans l' Afrique Occidentale (1479–80)." *Boletim Cultural da Guiné Português* 44 (1949): 181–95.

——. "Essai sur l' histoire des métaux en Afrique occidentale." *Bulletin de l' IFAN* 14, no. 2 (1952): 545–95.

——. "A Possible Source of Copper for the Oldest Brass Heads of Ife." *Journal of the Historical Society of Nigeria*, 2, no. 3 (1962): 393–95.

Melzian, Hans. *A Concise Dictionary of the Bini Language of Southern Nigeria*. London, 1937.

——. "Zum Festkalender von Benin." *Afrikanische Studien*, edited by J. Lukas. Deutsche Akademie der Wissen zu Berlin, Institut für Orientforschung 26 (Berlin, 1955): 87–107.

Moschner, Irmgard. "Die Wiener Cook-Sammlung, Südsee Teil." *Archiv für Völkerkunde* 10 (Vienna, 1955): 136–253.

Murray, Kenneth Crosthwaite. "Benin Art." *Nigeria Magazine* 71 (1961): 370–78.

Museum of Fine Arts, Houston. *Benin*. Houston, 1968.

Neue Deutsche Biographie (NDB).

Neues Österreichisches Biographisches Lexikon (NÖB).

Nevadomsky, Joseph. "The Benin Bronze Horseman as the Ata of Idah." *African Arts* 19, no. 4 (1986): 40–47, 85.

——. "Brass Cocks and Wooden Hens in Benin Art." *Baessler-Archiv*, n.s. 35, no. 1 (1987): 221–47.

——. "The Iconography of Benin Brass Rings." *Tribus* 83 (1989): 59–70.

Nii Quarcoopome, E. "Pendant Plaques." In *The Art of Power*, edited by Paula Ben-Amos and Arnold Rubin. Los Angeles: Fowler Museum of Cultural History, UCLA, 1983.

Nyendael, David van. "Beschryving van Rio Formosa, andergesegt de Benin" ("A Description of the Rio Formosa, or, The River of Benin"). In William Bosman, *Neuwkeurige Beschryvinghe van de Guinese Goud-Tand-en Slave-kust*. Utrecht, 1704. English ed.: *A New and Accurate Description of the Coast of Guinea*. London, 1705; reprint edited by J. R. Willis, J. D. Fagg and R. E. Bradbury (London 1967).

Obayemi, Ade. "The Yoruba and Edo-Speaking Peoples and their Neighbors before 1600." In *History of West Africa*, 2d ed., vol. 1, edited by J. F. Ajayi and Michael Crowder. New York, 1976.

Obichere, Boniface I. "Benin City and the Royal Patronage of the Arts." In *Images of Power*, edited by Flora S. Kaplan. New York: New York University, 1981.

Österreichisches Biographisches Lexikon (ÖBL).

Palisot, Ambroise, Baron de Beauvois. "Notice sur le peuple de Bénin." *La Décade philosophique, littéraire et politique* 9, no. 12 (1801): 141–51.

"Papers Relating to the Massacre of British Officials near Benin and the Consequent Punitive Expedition," *Africa* 6 (London, 1897).

Pereira, Duarte Pacheco. *Esmeraldo de Situ Orbis* (1505). Edited by Raymond Mauny. Bissau, 1956.

Pina, Ruy de. *Chronica del Rey Dom João II*. Lisbon, 1712.

Pitt-Rivers, Augustus Henry Lane-Fox. *Antique Works of Art from Benin*. London, 1900.

Preston, George Nelson. "Reading the Art of Benin." In *Images of Power*, edited by Flora S. Kaplan. New York: New York University, 1981.

Primisser, Alois. *Übersicht der k. k. Ambraser Sammlung. Mit einem Anhang über die Ethnographischen Sammlungen der Kleider und Gerätschaften aus den Südsee-Inseln und aus Grönland*. Vienna, 1825.

Read, Charles Hercules, and Ormonde Maddock Dalton. *Antiquities from the City of Benin and from Other Parts of West Africa in the British Museum*. London, 1899.

Records and accounts from the Office of the Director of the Naturhistorisches Museum for the years 1890–1905. In *Archiv des Naturhistorischen Museums in Vienna* (INahiM).

Records of the Haus-, Hof- und Staatsarchiv in Vienna relating to the Naturhistorisches Museum (HHStA).

Records of the Museum für Völkerkunde in Vienna relating to the Benin Collection.

Roese, Peter M. "Erdwälle und Gräben im ehemaligen Königreich von Benin." *Anthropos* 76 (1981): 166–209.

——. "Das Königreich Benin — von den Anfängen bis 1485." *Anthropos* 79 (1984): 191–222.

——. "Die Hierarchie des ehemaligen Königreiches Benin aus der Sicht zeitgenössischer europäischer Beobachter." *Ethnographisch-Archäologische Zeitschrift* 29 (1988): 47–73.

——. "Neues Material im Zusammenhang mit dem möglichen Ursprung der Akori-Perlen, die als Handelsartikel aus Benin bekannt waren." In *Wiener Völkerkundliche Mitteilungen*. N. F. vol. 32, Vienna, 1990, 71–91.

Roth, Henry Ling. "Primitive Art from Benin." *The Studio* 15, no. 69 (London, 1898): 174–84.

——. "Notes on Benin Art." *The Reliquary and Illustrated Archaeologist* 4, no. 3 (London, 1898): 161–72.

——. *Great Benin: Its Customs, Art and Horrors*. Halifax, 1903.

Ryder, Alan Frederick Charles. "The Benin Missions." *Journal of the Historical Society of Nigeria* 2, no. 2 (1961): 231–57.

——. "A Reconsideration of the Ife-Benin Relationship." *Journal of African History* 6, no. 1 (1965): 25–37.

——. *Benin and the Europeans, 1485–1897*. London, 1969.

Sagay, J. O. E. *Benin and the British Invasions*. London, 1973.

Salvadorini, Vittorio A. *Le missioni a Benin e Warri nel XVII secolo: La relazione inedita di Bonaventura da Firenze*. Milan, 1972.

Schaefer, Stacy. "Benin Commemorative Heads." In *The Art of Power*, edited by Paula Ben-Amos and Arnold Rubin. Los Angeles: Fowler Museum of Cultural History, UCLA, 1983.

Schüz, Ernst. "Der problematische Ibis der Benin-Bronzen." *Tribus* 18 (1969): 73–84.

Schweeger-Hefel, Annemarie. *Afrikanische Bronzen*. Vienna, 1948.

——. "Zur Thematik und Ikonographie der geschnitzten Elfenbeinzähne aus Benin im Museum für Völkerkunde in Wien." *Archiv für Völkerkunde* 12 (Vienna, 1957): 182–229.

—. "Ein Elfenbeinblashorn aus Benin." *Archiv für Völkerkunde* 13 (1958): 227–35.

Shaw, Thurston. "Spectrographic Analyses of the Igbo and Other Nigerian Bronzes." *Archaeometry* 8 (1965): 86–95.

—. "Those Igbo-Ukwu Radiocarbon Dates: Facts, Fictions and Probabilities." *Journal of African History* 16, no. 4 (1975): 503–17.

Sidahome, Joseph E. *Stories of the Benin Empire.* London, 1964.

Sölken, Heinz. "Innerafrikanische Wege nach Benin." *Anthropos* 49 (1954): 809–933.

Strieder, Jakob. "Negerkunst von Benin und deutsches Metallexportgewerbe im 15. und 16. Jahrhundert." *Zeitschrift für Ethnologie* 64 (1932): 249–59.

Struck, Bernhard. "Chronologie der Benin Altertümer." *Zeitschrift für Ethnologie* 55 (1923): 113–66.

Sydow, Eckart von. "Das Panther-Ornament auf den Panzern von Benin: Zur Stilgeschichte der Benin-Platten." *Ethnologischer Anzeiger* 3 (1934): 231–38.

—. "Ancient and Modern Art in Benin City." *Africa* 11, no. 1 (1938): 55–62.

Talbot, P. Amaury. *The Peoples of Southern Nigeria.* 4 vols. London, 1926.

Teixeira da Mota, Avelino. "Novos Elementos sobre a acção dos Portugueses e Franceses em Benin na primeira metade do século XVI." *Proceedings of the Third International West African Conference* (1949): 245–54.

Tunis, Irwin Leonard. "Origins, Chronology and Metallurgy of the Benin Wall Bas-Reliefs." 2 vols. Ph. D. diss., University of London, 1979.

—. "The Benin Chronologies." *African Arts* 14, no. 2 (1981): 86–87.

—. "A Note on Benin Plaque Termination Dates." *Tribus* 32 (1983): 45–53.

Verger, Pierre. *Trade Relations Between the Bight of Benin and Bahia from the 17th to 19th Century.* Ibadan, 1976.

Vogel, Susan Mullin. "Art and Politics: A Staff from the Court of Benin, West Africa." *Metropolitan Museum Journal* 13 (1978): 87–100.

Wahliss, Ernst. *Die österreichische Porzellanindustrie: Die Grossindustrie Österreichs.* Vienna, 1898.

Webster, W. D. *Illustrated Catalogue of Ethnological Specimens, European and Eastern Arms and Armour: Prehistoric and Other Curiosities.* 4 vols. London, 1895.

Welsh, James. *See* Hakluyt, Richard.

Wilks, Ivor. "A Medieval Trade-Route from Niger to the Gulf of Guinea." *Journal of African History* 3, no. 2 (1962): 337–41.

Willett, Frank. "Ife and Its Archaeology." *Journal of African History* 1, no. 2 (1960): 231–48.

—. *Ife in the History of the West African Sculpture.* London and New York, 1967.

Wolf, Siegfried. "Bemerkungen zu drei Benin Gelbgussköpfen des Museums für Völkerkunde, Leipzig." *Abhandlungen und Berichte des Staatlichen Museums für Völkerkunde Dresden* 22 (Dresden, 1963): 109–34.

—. "Vogelgestaltiges Benin-Zeremonial-Gerät aus Elfenbein." *Abhandlungen und Berichte des Staatlichen Museums für Völkerkunde Dresden* 22 (Dresden, 1963): 135–41.

—. "Bronzeköpfe und Bronzeplatten der Benin-Sammlung in Mannheim." *Abhandlungen und Berichte des Staatlichen Museums für Völkerkunde Dresden* 25 (Dresden, 1966): 225–48.

—. "Neue Analysen von Benin-Legierungen in vergleichender Betrachtung." *Abhandlungen und Berichte des Staatlichen Museums für Völkerkunde Dresden* 28 (Dresden, 1968): 91–153.

—. "Elfenbein und Bronze: Vergleich zwischen Benin-Arbeiten verschiedenen Materials." *Abhandlungen und Berichte des Staatlichen Museums für Völkerkunde Dresden* 30 (Dresden, 1970): 151–214.

—. "Zum Problem der Frauendarstellungen in der Benin-Kunst." *Abhandlungen und Berichte des Staatlichen Museums für Völkerkunde Dresden* 31 (Dresden, 1971): 197–235.

—. *Benin: Europäerdarstellungen der Hofkunst eines afrikanischen Reiches.* Die Schatzkammer vol. 28. Leipzig, 1972.